Wonders of Creation

*Natural History Drawings
in the British Library*

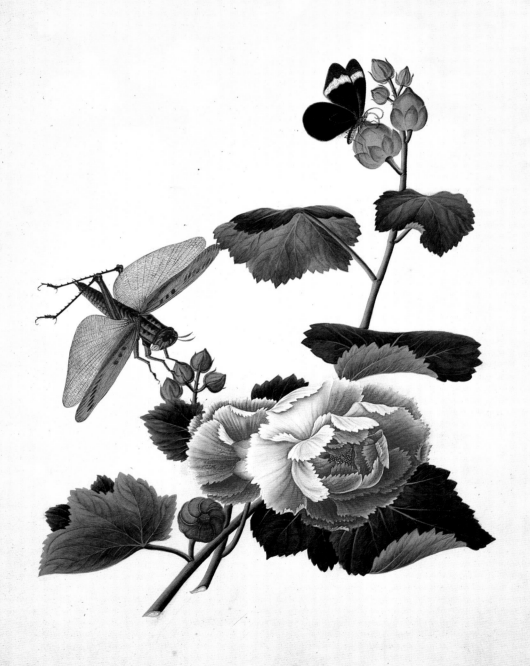

Wonders of Creation

Natural History Drawings in the British Library

Ray Desmond

THE BRITISH LIBRARY

© 1986 The British Library Board

First published 1986 by
The British Library
Great Russell Street
London WC1B 3DG

and 27 South Main Street,
Wolfeboro, New Hampshire 03894-2069

🔳 British Library Cataloguing in Publication Data
British Library
 Wonders of creation: natural history
 drawings in the British Library.
 1. Natural history in art 2. Drawing
 History
 I. Title II. Desmond, Ray
 743'.93 NC825.N3

ISBN 0-7123-0071-6

Library of Congress
Cataloguing in Publication Data applied for

Frontispiece Grasshopper and butterfly on hibiscus(?).
Album of drawings of flowers and insects.
Canton. Early 19th century.
NHD 43, folio 102. (*OILR*)

Designed by James Shurmer

Set in Monophoto Bembo (270)

Printed in England by Lund Humphries Ltd.,
Bradford

Contents

Acknowledgements

The illustration from the Sherborne Missal is reproduced by
kind permission of His Grace the Duke of Northumberland.
I am indebted to the following people for suggestions,
identifications and generous help when I called upon their services:
Dr A. Arnold, Mr P. Colston, Mrs A. Datta, Mrs J. Diment,
Mr J. Dransfield, Mr K. Gardner, Miss P. Gilbert, Mr J. Hill,
Miss D. Hills, Mr J. Losty, Mrs A. Payne, Dr W. T. Stearn,
Mrs A. Vale, Mr M. I. Waley, Mr A. Wheeler, Dr F. Wood.

Abbreviations of British Library Departments*

Dept of MSS Department of Manuscripts

DPB Department of Printed Books

IOLR India Office Library and Records

OMPB Department of Oriental Manuscripts and Printed Books

* [Nomenclature of Departments is given in the form current
in October 1985.]

Preface

IT IS NOT perhaps generally known or fully appreciated how numerous are the natural history items in the British Library. Many are dispersed throughout the shelves of the Department of Printed Books, the largest single collection being the library of Sir Joseph Banks (1743–1820) which has the only surviving copies anywhere in the British Isles of a number of important natural history works.

A few figures from printed books have been included as a visual comment on the text, but most of the illustrations are selected from original drawings in the Department of Manuscripts, the India Office Library and Records, and the Department of Oriental Manuscripts and Printed Books. Within the prescribed limits of words and plates an attempt has been made to outline the progress of botanical and zoological art, relating it to contemporary cultural and scientific ideas, and giving some prominence to leading practitioners and significant achievements.

As far as the scope of the collections will allow, drawings have been chosen to represent national and regional development, different aspects of natural history studies – plants, mammals, birds, fishes, insects, etc. – and examples of the work of some of the best artists. The selection inevitably reveals the strengths and weaknesses of the collections. Items that were once owned by an undivided British Museum in the nineteenth century are now housed in various departments of the present British Museum, and the British Museum (Natural History) at South Kensington, as well as in the British Library.

When Sir Hans Sloane died in 1753, his books, manuscripts, antiquities, natural history specimens, coins and medals formed part of the foundation collection of the new British Museum which was created by an Act of Parliament in the same year. Many of his manuscripts, now in the Department of Manuscripts, are devoted to medicine and natural history. There are, for instance, two volumes of superb drawings of spiders by Joseph Dandridge and Eleazar Albin, and drawings of insects by that insatiable collector of 'curiosities', Albertus Seba. Many of the great names in natural history have a niche in the Department of Manuscripts: for example, an album of fish drawings with annotations by John Ray, the father of English natural history, and a manuscript which his friend Francis Willughby bought from Leonhardt Baldner. Its miniatures of waterfowl, fish, amphibians, etc. are painted with a concentrated oriental precision, the colours miraculously retaining a pristine brilliance. The Department also boasts some of the finest herbals: an Anglo-Saxon manuscript with stylised figures; the Italian Codex Bellunensis whose illustrations confirm the steady progression towards naturalism, and its glorious culmination, the fourteenth-century Carrara herbal, the first herbal with drawings proclaiming botanical authenticity. Some drawings have been chosen to depict the mythology that dominated natural history in

medieval times – the legends of the mandrake and the barnacle goose, for example, and the extraordinary fauna of the bestiaries. As will be seen, the elephant presented the artists of these bestiaries with a challenge to their skill and scope for their imagination. They drew from hearsay and example and not from the privilege of direct observation that enabled the monk, Matthew Paris, to sketch an elephant with convincing accuracy.

For many scholars the Department of Manuscripts is an incomparable treasury of devotional works, and it is a matter of regret that space permits only a few plates: a glimpse of the flora generously dropped in the margins of the Hastings and the Huth Books of Hours; decorative detail in the Sherborne Missal and the Luttrell Psalter (it is interesting to compare the geese in the latter with the heraldic-like creatures in the tenth-century Chinese painting in figure 1); the sensitive lines and pale washes in Queen Mary's Psalter.

The drawings introduce us to some of the great events in history: John White's Swallowtail Butterfly which provides a link with Raleigh's ill-fated settlement in North America; or Francis Fletcher's sketches of the fish he saw during Drake's memorable voyage in 1577–80; or Sydney Parkinson's scene of yams and breadfruit in a bay in Tahiti, reminding us that he was the artist during much of Captain Cook's *Endeavour* voyage.

Sir Hans Sloane's oriental manuscripts are, appropriately, kept in the Department of Oriental Manuscripts and Printed Books. Only a few of this Department's treasures can be included: some exquisite miniatures from Persian and Indian versions of the *Khamsa* of Nizami; just three plates from what is probably the most complete and best illustrated early version of the *Baburnama*; and a token representation from one of the most important recent acquisitions, a fourteenth-century copy of the *Wonders of creation* by al-Qazwini.

The India Office Library and Records has equally choice items: for example, the album that Dara Shikoh, the eldest son of the Emperor Shah Jahan, presented to his wife, every miniature sumptuously mounted in a goldleaf border of plant and animal motifs; or the work of the Indian artist who drew a peregrine falcon for the ruler of Tangore and caught exactly the bird's aloof demeanour. The consistently high standards maintained by the artists employed by Lord Wellesley and General Hardwicke (most of the drawings of the latter are in the Department of Manuscripts) made selection of a few representative plates an almost impossible exercise. And then there are the Chinese artists in Canton who painted for European customers with such fluctuating skill and concern (but gave no cause for complaint with their delicate drawings of flowers and insects); from their work two examples have been selected.

The title of this book celebrates the astonishing diversity of the natural world; at the same time, many of the drawings could themselves qualify as examples of the wonders of creation.

1. Introduction

IT COULD be argued that the foundations of modern botany and zoology were laid by the artist rather than the scientist. The close observation of plants and animals in the drawings of Leonardo da Vinci, Albrecht Dürer or Pisanello found no match in the writings of their naturalist contemporaries. Hans Weiditz's accurate plant portraits in *Herbarum vivae eicones* (1530) tell the reader much more about their character than Otto von Brunfels's turgid text. This point of view may be disputed, but there would surely be general agreement with the bird painter George Edwards, that 'Natural History cannot, in any degree, be perfect without figures'.[1] John Ray, the seventeenth-century English botanist, observed that many people 'looked upon a history of plants without figures as a book of geography without maps'.[2] In 1837 Robert Wight, for whom illustrations were indispensable in his celebrated Indian floras, commented that

the insufficiency of language alone, to convey just ideas of the forms of natural objects, has led naturalists, ever since the invention of engraving, to have recourse to pictorial delineation to assist the mind through the medium of the senses; and, prior to the time of Linnaeus, not without good cause, since nothing could be more vague than the language then employed in description. Impelled by this cause, the number of figures some of the older writers published is truly astonishing.[3]

Over the centuries there has been established a venerable tradition of natural history illustration, beginning with primitive watercolours or woodcuts which frequently did little else but decorate the pages of early bestiaries and herbals. The adoption of more precise metal plate processes fostered a greater verisimilitude in published works. The golden age of fine flower and animal books came to maturity about the middle of the eighteenth century, lasting almost 100 years. It was a time when the study of natural history was being accepted as an essential component of a liberal education. In 1855 Charles Kingsley reported with evident satisfaction that 'books of Natural History are finding their way more and more into drawing rooms and school rooms, and exciting greater thirst for a knowledge, which, even twenty years ago, was considered superfluous for all but the professional student'.[4] Victorian families indulged in casual botanising during country walks, and many albums of pressed flowers testified to the industry of young ladies. Flower painting in particular, fostered by numerous manuals on the subject, was a fashionable recreation for the fair sex. For some, however, the painting of flowers transcended the prosaic copying of a pretty object and became

1. G. Edwards *A natural history of birds* 1743, p xiv.
2. J. Ray *Correspondence* 1848, p 155
3. Letter by R. Wight to *Madras Journal of Science* 15 October 1837.
4. C. Kingsley *Glaucus, or the wonders of the shore* 1855, p 7.

instead an ecstatic communion with Nature. William Henry Hunt, the Victorian artist, was once heard to exclaim: 'I almost tremble when I sit down to paint a flower'.

Flower painting is a contemplative art, and its practitioner is dedicated solely to the interpretation of beauty. In seeking to encapsulate beauty, he may employ the meticulous detail of a Jan van Huysum, or adopt the subjective generalisations of the Impressionists for whom flowers were a means of exploring chromatic variations. Henry Curtis was mindful of the lack of scientific discipline in the work of the conventional flower painter, when he indicated that the plates in his *Beauties of the rose* (1850–53) 'are attempted without the aid of a professed Artist, merely from the fear that liberal portraiture is often sacrificed to pictorial effect'.[5]

The flower painter whose primary concern is with scientific accuracy rather than with decorative display is more correctly designated a botanical artist. His techniques are subject to the requirements of the botanist. He must resist the temptation to which many Mughal and Chinese artists succumbed – the urge to create patterns at the expense of authenticity. It is axiomatic that the botanical artist must have some knowledge of botany. He must be well acquainted with the rudiments of flower morphology so that he could never perpetrate elementary howlers like drawing the wrong number of stamens or showing an inferior ovary when it should be a superior one. The significance of features like the angle of the hairs or the curvature of the stem must be appreciated, and he must be able to modify his drawing to emphasise or reveal such minute characters whose perception may demand an expertise with the microscope. He should be able to recreate a plant from dried herbarium specimens and accompanying sketches, an accomplishment in which the great Victorian botanical artist, W. H. Fitch, excelled. Georg Dionysius Ehret, on the threshold of his career as a botanical artist, found this a difficult achievement; in a living specimen, he pointed out, leaves twist and turn in various directions, a characteristic destroyed in a pressed specimen.

A faithful rendering of leaves is one of the hallmarks of a good botanical artist. John Ruskin was obsessed by the difficulties in drawing leaves: 'If you can paint one leaf you can paint the world'. More restrained in his comments, W. H. Fitch concurred: 'Leaves have been submitted to more bad treatment by the draughtsman than perhaps any other portion of the vegetable kingdom; they have been represented, or rather, misrepresented, in all kinds of impossible positions'.[6]

Speed in execution is vital to capture the flower in its pristine vigour before petals fall and leaves droop. The botanical artist soon learns that flowers and the seasons are not always co-operative. Dillenius, commissioned by James Sherard in the 1720s to paint the flowers in his garden, complained that he was often overwhelmed by a profusion of blooms to copy; some refused to flower at all; and occasionally, after he had made the seven-mile journey from his home in London, he arrived only to find that the ephemeral flower had died.

Oil paints are normally to be avoided by the botanical artist; his materials are

5. H. Curtis *Beauties of the rose* 1850, introduction.
6. *Gardeners' chronicle* 30 January 1869, p 110.

pencil, pen and ink and watercolours, which more readily give him the purity and delicacy that he seeks to achieve. Can one detect a deterioration in the freshness of Ehret's drawings after he began adding body colour to his watercolours? Van Spaendonck who had taught his pupils in Paris how to paint in gouache became a convert to pure watercolour because of its translucency and the ease with which colours could be blended.

All these restraints which can inhibit a botanical artist can produce a drawing correct in all its diagnostic details but barren of artistic merit. Goethe had misgivings about this necessary discipline. 'A great flower-painter is not now to be expected: we have attained too high a degree of scientific truth, and the botanist counts the stamens after the painter and has no eye for picturesque grouping and lighting'.[7]

Scientists have usually found it advantageous to have some artistic skills, not only to do their own sketches, but also to be better able to assess the competence of the professional artist. Charles Darwin regretted his inability to draw. The absolute need for scientific accuracy induced some botanists and zoologists to be their own artists. Botanists such as Sir William and Joseph Hooker, John Lindley, William Harvey and R. K. Greville were sufficiently talented to make their own drawings, and whatever their artistic limitations, these were usually compensated for by their greater understanding of botany. This versatility was applauded by Linnaeus. 'A painter, an engraver and a botanist are all equally necessary to produce a good illustration; if one of them goes wrong, the illustration will be wrong in some respect. Hence botanists who have practised the arts of painting and engraving along with botany, have left us the most outstanding illustrations'.[8] George Edwards, both an ornithologist and artist, endorsed this self-help principle.

For he that engraves figures from his own original drawings after nature, may always be supposed rather to correct the errors of such drawings of his own plates, than to fall short of their perfections, which is not the case when drawings are given to common engravers to be copied; for, though they may give them a softer finish in the copper, yet they generally fall short of the spirit of the originals: so that it is always a great advantage, in any work of Natural History, when the author can perform both the drawing and engraving parts with his own hand.[9]

More often than one would expect is this dual role of botanist or zoologist and artist encountered. J. J. Dillenius drew and etched the plates of his *Hortus Elthamensis* (1732) and *Historia muscorum* (1741). Mark Catesby, to save expenses, etched his drawings in his *Natural history of Carolina* (1729–47). Elizabeth Blackwell, too, combined the function of artist and engraver in her *Curious herbal* (1737–39). James Bolton, that paragon of self-instruction, taught himself botany, drawing and engraving. Most naturalists, however, were content to leave the drawing and its reproduction entirely in the hands of the artist and engraver, or to let him embellish their tentative and rudimentary sketches.

7. *Coversations of Goethe with Eckermann* 1984, p 327.
8. C. Linnaeus *Philosophica botanica* 1751, p 263. This English translation comes from F. A. Stafleu, *Linnaeus and the Linneans* 1971, p 78.
9. G. Edwards *Gleanings of natural history* part 2, 1760, pp xi–xii.

John Ruskin detected and denounced an insensitivity, amounting almost to sterility, in many purely botanical drawings. He contrasted

the mere botanist's knowledge of plants, and the great poet's or painter's knowledge of them. The one notes their distinctions for the sake of swelling his herbarium, the other, that he may render them vehicles of expression and emotion. The one counts the stamens, and affixes a name, and is content; the other observes every character of the plant's colour and form; considering each of its attributes as an element of expression, he seizes on its lines of grace or energy, rigidity or repose; notes the feebleness or the vigour, the serenity or tremulousness of its hues.[10]

His *Proserpina* (1878–86), a very idiosyncratic and rambling excursion through the elementary principles of plant identification, enlivened by frequent thrusts at what he considered to be the pedantry of professional botanists, includes a number of his supple plant portraits. There was no doubt in Ruskin's mind that his method of drawing flowers was the right one. He declared his sketch of the crested leaves of the lettuce-thistle to be

adequately enough rendered by perfectly simple means. Here I had only a succulent and membranous surface to represent, with definite outlines, and merely undulating folds; and this is sufficiently done by a careful and firm pen-outline on grey paper, with a slight wash of colour afterwards, reinforced in the darks; then marking the lights with white. This method is classic and authoritative, being used by many of the greatest masters, (by Holbein continually), and it is much the best which the general student can adopt for expression of the action and muscular power of plants. The goodness of such work depends absolutely on the truth of the single line. You will find a thousand botanical drawings which will give you a delicate and deceptive resemblance of the leaf, for one that will give you the right convexity in its backbone, the right perspective of its peaks when they foreshorten, or the right relation of depth in the shading of its dimples.[11]

What, then, are the desiderata of botanical illustration? Redouté recited them succinctly in the introduction to his *Choix des plus belles fleurs et des plus beaux fruits* (1827–33). He hoped that by studying Nature he had 'succeeded in the threefold combination of accuracy, composition and the art of colouring, the union of which alone can bring perfection to botanical painting'.

These three elements – accuracy, composition and colour – are also equally applicable to animal drawings. The natural link between flora and fauna extends to its manifestation in art. The plants in Maria Merian's *Metamorphosis insectorum Surinamensium* or Mark Catesby's *Natural history of Carolina* are more than a decorative background; each plate is an ecological synthesis. Someone once declared, with perhaps a hint of hyperbole, that if all the birds were removed from Audubon's *Birds of America* there would still remain an impressive flower book.

A good animal painter should have patience, curiosity and a respect, not a sentimental regard, for his subjects. To reproduce fluidity of movement, ripple of muscle and flow of hair is much more demanding than drawing a passive object like a plant. George Stubbs was convinced that a knowledge of anatomy would assist a better understanding of animals. When the anatomist, Peter Camper,

10. J. Ruskin *Modern painters* 2nd ed, p xiv.
11. J. Ruskin *Proserpina* 1878, vol 1, p 129.

praised his *Anatomy of the horse*, Stubbs replied: 'What you have seen is all I meant to do, it being as much as I thought necessary for the study of Painting'. Edmund Burke urged James Barry to emulate Stubbs: 'Notwithstanding your natural repugnance to handling carcasses, you ought to make the knife go with the pencil and study anatomy in real'.

Mark Catesby asserted he painted his birds 'while alive', Alexander Wilson sometimes had tame birds as models, Audubon drew from freshly killed birds, Lear sketched specimens in a zoo, and Gould used bird skins and stuffed specimens. Not having high-powered binoculars, all these artists were at a disadvantage in observing in the wild the birds they wished to paint. After Audubon had shot his specimens he had to work feverishly before the colours of eyes and feet faded. Where birds stare fixedly from paper or canvas, one may be sure that the artist had copied the glass eyes of stuffed specimens.

With a stuffed animal as his model, it was difficult for an artist to be scientifically accurate. Bewick discovered 'the very great difference between preserved specimens and those from nature; no regard having been paid to fix the former in their proper attitudes, nor to place the different series of the feathers so as to fall properly upon each other. This has always given me a great deal of trouble to get the markings of the dishevelled plumage; and, when done with every pains, I never felt satisfied with them'.[12]

John Gould noticed that the colours of mounted specimens of kangaroo in museums were 'very different from what they were while the animals were living, the continuous exposure to light, consequent upon their being placed in a museum, causing their evanescent colouring to fade'.[13] Recording the delicate and fugitive colours of fish was beyond the abilities of Patrick Russell's Indian artist. Russell wrote that the colours fade 'while the painter is adjusting his palette; and in the fine gradations from the most brilliant to the softer evanescent tints, nature, through boundless variety, ever maintains a certain harmony and characteristic simplicity in her transactions, that required a delicate pencil under more masterly guidance than my artist had pretensions to'.[14]

The portrayal of a creature in motion is a challenge that many artists evaded. Eighteenth-century bird painters usually depicted their birds perched pensively on an old tree stump; even the accomplished Archibald Thorburn admitted his inability to paint birds in flight and resorted to a standing position. Chinese artists who sold their pretty watercolours to eager Europeans were blissfully ignorant of the various postures of insects in flight.

Our animal and plant life has always been a source of infinite inspiration to artists. The success of their interpretation depended not only on their training and skills but also on contemporary attitudes towards Nature and the state of scientific knowledge. The following chapters trace the main lines of development and indicate some of the peaks of their achievement.

12. T. Bewick *My life* (Folio Society) 1981, p 138.
13. J. Gould *Mammals of Australia* 1863, vol 1, preface.
14. P. Russell *Descriptions and figures of two hundred fishes collected at Vizagapatam on the coast of Coromandel* 1803, preface.

2. The foundations of natural history drawing

ALL ART BEGAN with the paintings of Paleolithic man. The animals boldly daubed in reds, browns, yellows and emphatic blacks in the celebrated caves of south-western Europe are man's first visual record of the world about him. Not having yet discovered how to cultivate plants, he depended upon animals to survive. To succeed as a hunter he needed to know the habits of his prey, and this intimate knowledge of the animal world is revealed in the assurance with which these early artists painted powerful bulls, slender antelopes and horses in flight. Horses, bison, oxen and deer were the most frequently drawn, always with heads in profile and antlers and horns in a distorted perspective. The colours – manganese oxides, iron carbonates, ochres and charcoal – were applied to the walls with pieces of frayed bark, tufts of hair and even bare hands. These friezes of creatures, often overlapping, march resolutely across the contours of the rock face, fortuitous protuberances giving the animals a three-dimensional appearance.

Mesopotamia or Southern Iraq is generally believed to be the region where agriculture was first established and the domestication of animals began. Because they were easy to tame, sheep, goats, horses and cattle were among the first livestock. Painted about 3000 BC on a stucco wall in the tomb of Ne-fer-Maat at Medum is a flock of domesticated geese, probably greylag, being counted by their attendants. The landscape and wildlife in Egyptian murals show an awareness of the natural world: falcons, ibises, pigeons and waterfowl were patiently copied from life. The fishes carved on the temple wall at Deir-el-Bahri can be identified to species level. The remarkable reliefs in the temple at Karnak which record the spoils of the successful Syrian campaign of Pharoah Thutmose III in the fifteenth century BC include about 300 plants, although only a dozen are botanically recognisable. The Egyptians preferred to use plant forms such as the lotus, papyrus and palm as decorative motifs. The triple pipal leaf (*Ficus religiosa*) adorns Harrapan pottery in the Indus Valley civilisation. Plants such as the vine and acanthus were stylised elements in Greek design.

Plato's distinguished pupil, Aristotle (384–322 BC), led other Greek philosophers in investigating the natural world. His *Historia animalium*, *De partibus animalium* and other writings attempt a classification of the animal kingdom based on structure and habit. His primary division into Vertebrates and Invertebrates is still valid; he distinguished animals with red blood from those he designated bloodless; he described and named about 500 animals. When he died, he left his library to Theophrastus (c.372–287 BC), naming him his successor. If Aristotle is the father of zoology, then a similar honour must be bestowed on Theophrastus in the field of botany. He made a special study of the medicinal properties of plants and his *Enquiry into plants* is the earliest known herbal or collection of plant descriptions useful in medicine. It is not known whether it was illustrated, but

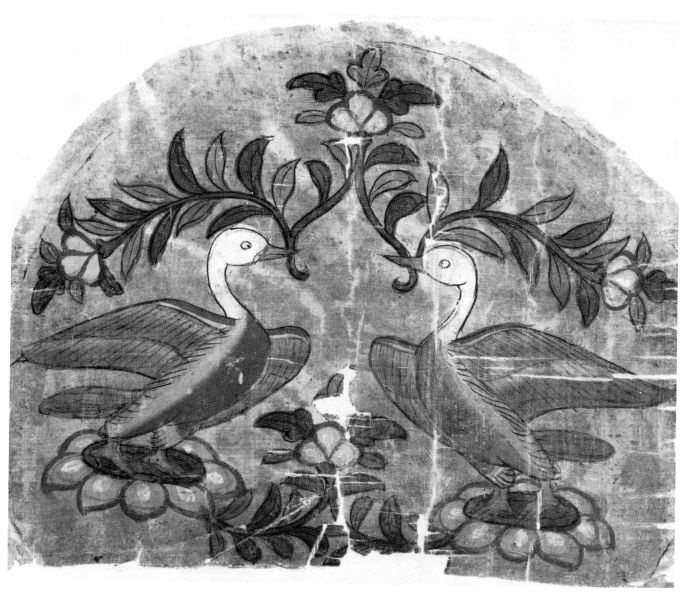

1 Geese and lotus. Scroll in Sanskrit and Khotanese. Dunhuang, Gansu, China. AD 943. Ch.c.001. (*IOLR*)

Pliny the Elder tells us that Greek herbals of the first century BC had coloured figures of plants. He mentioned three artists including Krateuas, a rhizotomist or herb collector, who was also physician to Mithridates VI, Eupator or King of Pontus (120–63 BC). Pliny had reservations about the reliability of these illustrations:

For they [*i.e.* Krateuas, Dionysius and Metrodorus] painted likenesses of the plants and then wrote under them their properties. But not only is a picture misleading when the colours are so many, particularly as the aim is to copy Nature, but besides this, much imperfection arises from the manifold hazards in the accuracy of the copyists. In addition, it is not enough for each plant to be painted at one period only of its life, since it alters its appearance with the fourfold changes of the year.[1]

1. Pliny *Natural history*. Translated by W. H. S. Jones. Loeb Classical Library, 1956, Book 25, iv.

The reputation of Krateuas, whom it is fitting to call the father of plant illustration, survives only in the reputation he exerted upon later writers such as Dioscorides.

Dioscorides, a Sicilian of Greek extraction, served as a physician in the Emperor Nero's Roman army during the first century AD. What he learnt about plants during his travels was incorporated in his *De materia medica* which owed a great deal to Theophrastus and Krateuas. His descriptions of the characters of plants were brief, sometimes imprecise and misleading. Some of his illustrations would most certainly have come from Krateuas. No contemporary version of his manuscript has survived, but it was copied many times, making it the most influential botanical work ever written.

One of the most distinguished of the Dioscoridian progeny, and a landmark in botanical art, is the *Codex Vindobonensis*, written and illustrated at Constantinople about AD 512. Its owner was Juliana Anicia, daughter of Flavius Anicius Olybrius who enjoyed a few brief months as Emperor of the West in AD 472. By the sixth century, when the anonymous Byzantine artist illuminated this manuscript, naturalistic plant illustration had become a lost art, having degenerated into diagrammatic formulae. The naturalism of its figures of plants was utterly alien to contemporary Byzantine art and they must therefore have been copied from much earlier sources. At the end of the Codex is the first illustrated treatise on birds, supposedly by Dionysius of Philadelphia. Many of the forty-seven birds can be recognised; the swan, the greylag goose and the pelican, for instance, are unmistakeable. The *Codex Neapolitanus*, compiled a century later, also used the same illustrative sources as the *Codex Vindobonensis*, but the figures are smaller and much simplified. Juliana Anicia's book, now one of the treasures of the National Library in Vienna, may be considered the parent of all illuminated medieval herbals. Unfortunately with repeated copying, the figures became remote from the originals that inspired them.

2 Gannet (?) diving. Giraldus Cambrensis *De topographia Hiberniae*. Late 12th century. Royal MS 13B VIII, folio 9. (*Dept of MSS*)

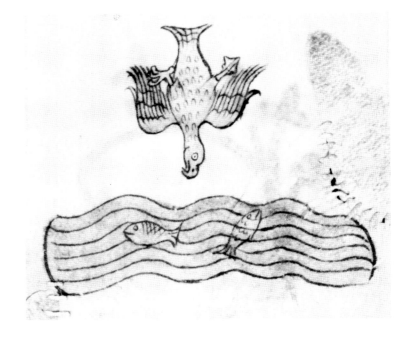

Gaius Plinius Secundus, or Pliny the Elder as he is better known, was a contemporary of Dioscorides. His *Natural history* was a digest of all the authors he had read but presented without any critical appraisal or selectivity. Nevertheless, it was the first serious attempt to comprehend the whole of Nature and included, for example, many more plants than Dioscorides mentioned.

The decay and dissolution of the Roman Empire was succeeded by the barbarism and unsettled times of the Dark Ages. Only in the comparative security of monastic life was it possible to contemplate Nature. While scientific thought suffered a decline in Europe, in Islamic countries it enjoyed a renaissance, fostered by the assimilation of ancient Greek culture. The writings of Aristotle and other Greek philosophers once again became accessible to the West in the twelfth and thirteenth centuries, through Arabic versions translated at Toledo in Spain and at the court of the Holy Roman Emperor, Frederick II, at Palermo in Sicily. One of the most assiduous translators in Toledo was Michael Scot whose Latin version of Aristotle's *Historia animalium* led to two important contributions to thirteenth century zoology: *De arte venandi cum avibus* (Art of falconry) by the Emperor Frederick II and *De animalibus* by Albertus Magnus, both containing personal observations of the animal world. The Welsh cleric, Giraldus Cambrensis, had seen at first hand some of the creatures he described in his *Topographia Hibernica* (1188) (figure 2). The foliage of hawthorn, vine, oak, maple, ivy and buttercup was confidently carved on the capitals in Southwell Minster by thirteenth-century sculptors who undoubtedly knew their plants well. The Italian artist and writer, Cennino Cennini (*b*.1370) advised the painter to 'copy [animals] and draw as much as you can from Nature, and you will achieve a good style in this respect'.[2] Thus it was the artist rather than the scientist who pioneered modern botanical and zoological studies. As painters gradually freed themselves from the constraints of religious art expressed in terms of symbolism and fable, their pictures acquired a greater degree of naturalism.

Tradition still governed the manuscript illuminator, whose training was founded upon the disciplined copying of earlier examples of his craft. Even he eventually felt the revitalising benefits of naturalism emerging in Northern Italy at the beginning of the fifteenth century. The vivid animal drawings of Giovanni de Grassi and the floral details in religious paintings were harbingers of this new vision of Nature. Much art was still subject to an inheritance of symbolism derived largely from the Bible and classical mythology. All cultures have always employed plants and animals as visual carriers of beliefs and moral concepts. Animals feature in the pantheon of deities in Ancient Egypt and in present day Hinduism. The lotus denoted the purity of Buddhist doctrines. The Christian church adopted symbols from pagan antiquity; the rose, for example, which symbolised Venus, Goddess of love, was transmuted into a holy token of pure love and sacrifice. Symbolism was indispensable to heraldry. By the sixteenth century such a prodigious confusion of symbols existed that a new discipline was born – iconology, or the interpretation of symbols. They remained a convention in art long after they ceased to have any theological or moral significance.

2. C. Cennini *The craftsman's handbook*. Translated by D. V. Thompson. 1954. Chapter LXX, p 49.

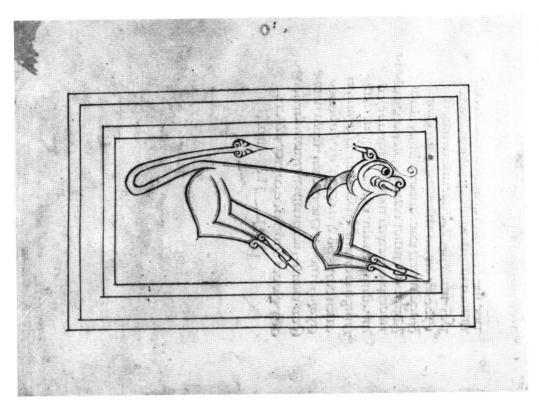

3 Lion of St Mark. *Gospel Book*. Ireland. 12th century. Harley MS 1023, folio 10v. (*Dept of MSS*) Only two of the symbols of the four evangelists remain in this manuscript: the eagle of St John and the lion of St Mark. It is not known whether the frame was meant to be coloured.

The bestiary or *Bestiarum*, the earliest medieval picture-book, provided most of the animal symbols. It was based on the *Physiologus* or 'Naturalist', a manuscript written in Greek in probably Syria or Alexandria between the second and fourth centuries. The unknown author consulted Aristotle's zoological writings to compile his description of forty-three animals in a text that is a blend of Christian allegory and indifferent science. It was translated into many languages including Latin, Armenian, Ethiopian, Syrian and most of the Romance and Germanic languages. When it was removed from the *Index* of heretical writings by Pope Gregory the Great, the Church used it as a commentary on an aspect of God's purpose as revealed through animals. In the Middle Ages the bestiary rivalled the Bible in popularity. Bestiaries were sometimes combined with illustrated herbals and competed with Books of Hours as the principal picture-books of the twelfth and thirteenth centuries. The need to observe a strict theological interpretation of the text inhibited the naturalistic drawing of animals, however. Convention demanded that the artist concentrated on those characteristics that represented certain moral ideas. Consequently the drawings were crude – often an indulgence in symmetrical patterns – painted with an arbitrary use of colour. Legendary monsters offered the artist's imagination the greatest scope; familar livestock none whatsoever; and birds were usually treated in a perfunctory manner.

Many of the creatures in the bestiary fauna are now known only to scholars, but the unicorn and the phoenix still retain a place in popular folklore. Pliny said the unicorn or monoceros was an antelope with cloven hoofs and its correct identity

4 Parandrus (top) and Yale (bottom). *Bestiary*. Durham? *c*.1200–10. Royal MS 12 C XIX, folio 30. (*Dept of MSS*) The parandrus possessed a chameleon-like facility for changing colour whenever it was frightened. Conrad Gesner believed that ancient authors erroneously wrote Parandrus for Tarandus, which was either the elk or the reindeer. Artistic licence has been indulged in the colouring of these two creatures; the Yale, for instance, has a pink body and green horns.

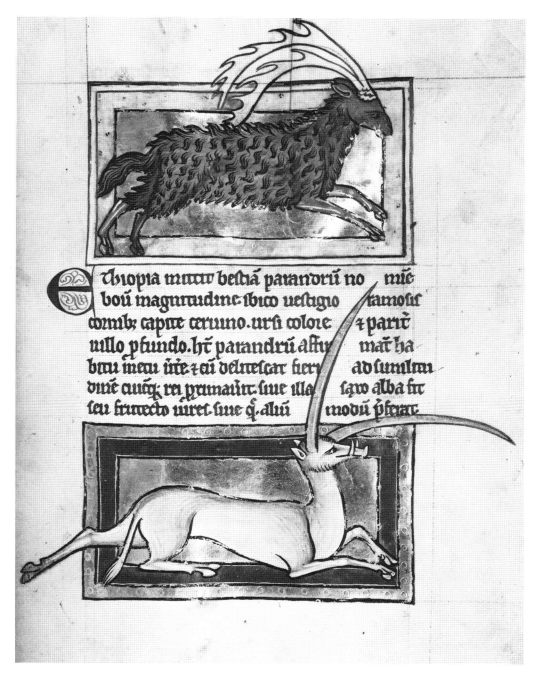

has puzzled generations of zoologists. Dr Wilma George is convinced that it is a species of oryx, once very common in Arabia and North Africa.[3]

The yale or eale, on the other hand, is a neglected creature (figure 4). Pliny's *Natural history* says it was 'the size of a hippopotamus, with an elephant's tail, of a black or tawny colour, with the jaws of a boar and horns more than a cubit in length capable of being moved and which in a fight are raised alternately and presented to the attack or sloped backward in turn as opportunity requires'. Clearly a formidable adversary in any combat. It was not mentioned in the

3. *Archives of Natural history* vol 10, part 2, 1981, p 188.

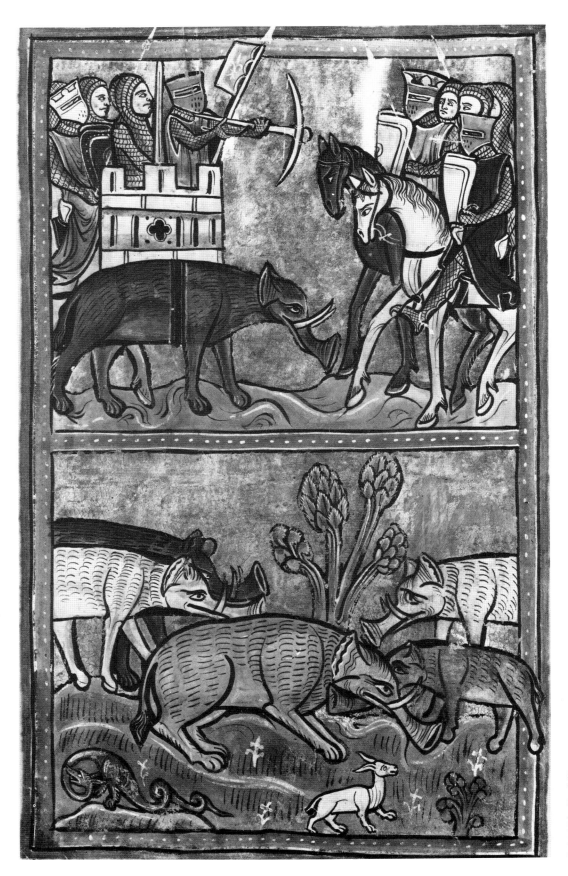

5 Elephants.
Top: at war. Bottom:
raising a fallen elephant.
Bestiary. South-East
England. *c.*1230. Royal
MS 12 F XIII, folio IIv.
(*Dept of MSS*)

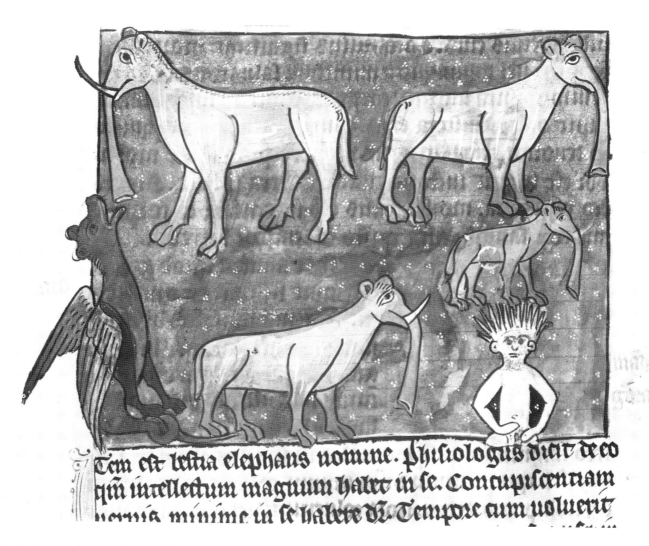

Tem est bestia elephans nomine. phisiologus dicit de eo
quū intellectum magnum halet in se. Concupiscentiam
uernia minime in se halete dr̄. Tempore cum uoluerit

6 Elephants and Mandrake. *Bestiary*. England. Late 13th century. Sloane MS 278, folio 48v. (*Dept of MSS*) According to one bestiary the elephant used the mandrake as an aphrodisiac before mating.

Physiologus, but by the twelfth century it had become a permanent resident in the bestiaries. It makes its farewell in Topsell's *History of foure-footed beasts* in 1658. Dr George, after rejecting various identifications such as gnu, mountain goat and deformed cow, settles for an Indian water buffalo.[4]

In any bestiary the elephant usually gets the longest account because of the accretion of legends surrounding it. One sympathises with the medieval artist, dependent entirely on written records, getting its anatomy ludicrously wrong. It became a hybrid of a horse, a pig and a dog, flourishing a trunk that looked like a flexible trumpet (PLATE 3; figures 5 and 6).

The best known of all legends concerns the barnacle goose – which reputedly emerged from *Lepas*, the Ship's Barnacle. The story was dismissed by the Emperor Frederick II in the twelfth century and by Albertus Magnus in the thirteenth century, but belief in it persisted. Giraldus Cambrensis and John Gerard claimed to have witnessed its miraculous birth: 'that which I have seene with mine eyes, and handled with mine hands, I dare confidently avouch, and boldly put

4. *Journal of the Warburg and Courtauld Institute* vol 31, 1968, pp 423–28.

.xuy.

quem fonte & conf eum euolat in altu usq; ad aere solis
& ibi incendit alas suas. similit & caligine oclox exurit
in radio solis. Tunc demu descendens in fonte tria uice se
mergit & statim renouatur in multo uigore alaru & sple
dore oculox. Sic & tu homo qui uestimentu habes uetus.
& caligant oculi cordis tui. qre spuale forme dni. & eleua
mentis oculos ad dnm qi est fons iusticie. & tunc renouabit
sicut aquile iuuentus tua. Asserit qq; qd pullos suos radus
solis obiciat. Et in medio aeris ungue suspendat. Ac siqs
repcusso solis lumine intrepidem oculox aciem in offenso
intuendi uigore seruaut is pbatur qd uitatem natire de
monstrauit. Qui u lumina sua radio solis inflexerit qsi
tegener & indignus tanto pre reicitur. nec estimatur edu
catione dignus qui fuit indignus susceptione. Non q au
acerbitate natire. sz iudicii integitate condepnat. Nec qi
suum abdicat sed quasi alienu recusat. Hanc tam ut
quibzdam uidetur regalis auis in clementia. plebeie auis
exusat clericia. Bernace.

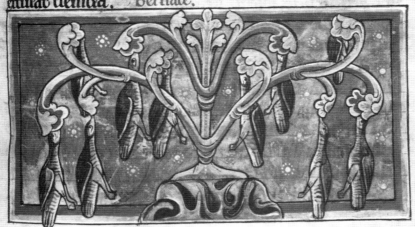

7 Barnacle goose. *Bestiary*. Salisbury? *c*.1230–40. Harley MS 4751, folio 36. (*Dept of MSS*)

downe for veritie'.[5] Even competent botanists such as Matthias de l'Obel and William Turner were not prepared to reject the story. Aldrovandi illustrated it in his *Ornithologiae* (1599) and as late as 1783 the last edition of Lonitzer's *Kreütterbuch* perpetuated the myth (figure 7).

The richness and diversity of animal forms in the bestiary influenced the decorative arts, especially in churches, which – from the roof bosses high up in the nave down to misericord seats in the choir stalls – were populated with this fabulous fauna.

The persistence of the belief in mermaids illustrates the length to which human gullibility can go. The creatures illustrated in figure 8 are accompanied by a note which solemnly states:

Baker and together with a man of the shore, had examined and found her to be entirely of the form of an other woman, or of a girl, and having kept her during the night on his boat, till he could get some bait for her, she had died on the next morning. He further stated, that at other times he had found such seamen, but half the size of this one, in the bellies of the cods, and some of them, which could not have long been swallowed up still very distinct.

William Munro, a sober schoolmaster of Thurso in Scotland was beguiled by the sight of a mermaid with white skin, blue eyes and long, light brown hair, sunning herself on the shore one memorable day in June 1809. Soon there was an epidemic of mermaid sightings off the Scottish coast. In 1822 people patiently queued outside the Turf Coffee House in St James's Street, London to inspect a mummified mermaid. Many of these gruesome specimens came from Japan where there was a profitable industry in making them for credulous occidentals.

In the Middle Ages biological research was usually centred on the monastaries or the universities where botany and zoology were an integral part of the medical curriculum. Albertus Magnus (1193–1280) taught at a number of German monastaries; his great work *De animalibus* (1255–70), not only synthesised the work of Aristotle, Pliny and others but also incorporated his own observations on plants, mammals and birds and his investigations into ecology and reproduction.

It would seem that the possession of a collection of exotic animals bestowed some distinction upon its owner. Over 3,000 years ago Queen Hatshepsat had monkeys, birds and a giraffe shipped from Somalia to Egypt. Ptolemy I formed a magnificent zoo at Alexandria; the Emperor Charlemagne had menageries at Aix-la-Chapelle, Nijmegen and Ingelheim; William the Conqueror kept a few foreign beasts at the Manor of Woodstock; in 1235 the Woodstock collection was transferred to the Tower of London where a menagerie survived until the formation of the Zoological Society of London in the nineteenth century. The Holy Roman Emperor, Frederick II, arrived in Ravenna in November 1231 with a retinue of elephants, camels, lions, leopards, falcons and bearded owls. Outlandish animals were elevated to status symbols and became desirable presents. In 1255 Louis IX of France gave the elephant he had brought back from his crusade to Henry III of England. It was taken to the Tower menagerie where Matthew Paris, a monk at St Albans, made several creditable drawings of it

5. J. Gerard *Herball* 1597, p 1588.

(figure 9). By the later Middle Ages there were few kingdoms or principalities without a menagerie of some sort. The accessibility of these menageries influenced animal art. The illuminator of the elephants, camels, giraffes and crocodiles in the Cocharelli manuscript (PLATE 4) probably sketched them in an Italian menagerie. Artists were specifically commissioned to draw them. Gozzoli, Cajano and Stradan painted the animals in the Medici-founded zoo in Florence; Louis XIV engaged the Flemish painter, Niçaise Bernaerts, to record the inmates of the menagerie at Versailles. John Caius found models for the animals described in his *De rariorum animalium* (1570) in the Tower menagerie. The Flemish painter Roelandt Savery (*c.*1576–1639) was kept extremely busy drawing the animals in Rudolph II's three menageries. In the Royal menagerie at Windsor, Jacques-Laurent Agasse painted white-tailed gnus and a Nubian giraffe for George IV.

Though the fauna of tropical countries attracted and excited the artist, the livestock and more familiar animals of the European countryside were not ignored. Often they are secreted in the small marginal decoration of illuminated manuscripts – the hounds, for instance, attacking a boar in Queen Mary's Psalter (figure 10), the geese in the Luttrell Psalter (figure 11) or the greyhounds pursuing a hare in the Sherborne Missal (PLATE 6).

Birds such as swans, peacocks, cranes and hawks were used both decoratively and symbolically in medieval manuscripts. Those in bestiaries were seldom better drawn than their animal companions, but by the mid-thirteenth century the

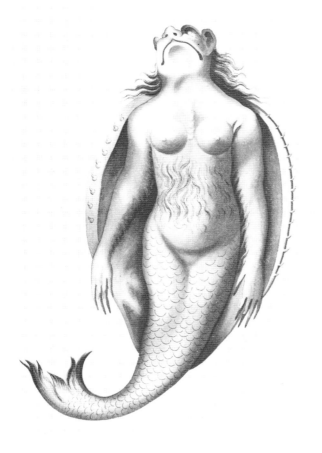

8 Left: Mermaid. Right: Manatee or Dugong. Late 18th or early 19th century. NHD 46, folio 53. (*IOLR*) The mermaid legend probably evolved from sightings of the manatee and dugong.

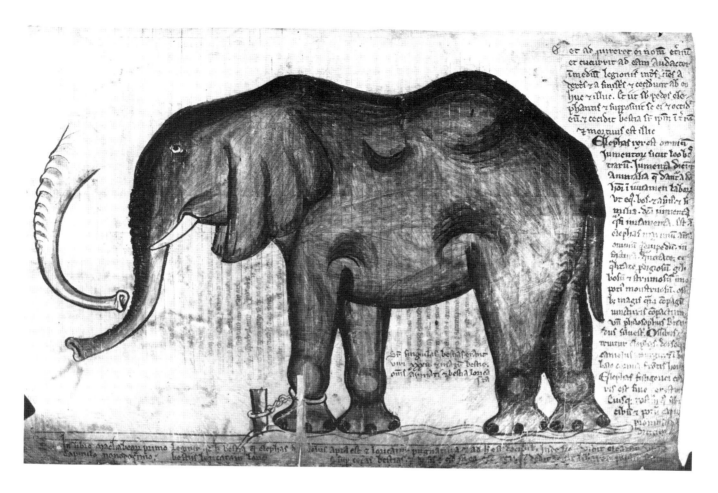

9 Elephant. Matthew Paris. *Liber additamentorum.* England. *c.*1255. Cotton MS Nero Dl, folio 169v. (*Dept of MSS*)

influence of the movement towards naturalism was felt especially in bird portraiture. Frederick II (1194–1250) spent about thirty years accumulating information for his great work on falconry, *De arte venandi cum avibus*. It questioned medieval dogma concerning the breeding, nesting, feeding and migration of birds. The Vatican copy of his manuscript has over 900 marginal illustrations of birds, particularly hawks, and the manner of their training. It has been described as 'the first zoological treatise written in the critical spirit of modern science' and stands apart from the main stream of bird illustration.

Birds were a popular motif in the marginal ornamentation of devotional works – colourful, conveniently small and easy to integrate into the foliage of border decoration. About 170 birds, more than half of which are recognisable, embellish the pages of the Sherborne Missal. The Dominican monk, John Siferwas, illuminated it about 1400 for Sherborne Abbey, and never before had birds been drawn so delicately and with such precision. Blackbird, finch, heron, lark, linnet, moorhen, pheasant and robin are all there and, moreover, carefully labelled.

More or less contemporary with the Sherborne Missal is a sketchbook entitled the *Monks drawing book*, now housed in Magdalene College, Cambridge. It is a collection of figure studies, animals and mythological creatures and has eight crowded pages of meticulously observed birds. M. R. James speculated that it was a pattern book of sketches by different artists to provide designs for decorating

books and embroidery. It is the only English medieval pattern book known to have survived. As medieval artists were conditioned to draw from existing works rather than from Nature, it was a sensible practice to collect together those subjects likely to be used again. These motifs tended to be copies of other drawings; the progenitors of some of the birds in the Magdalene College sketchbook have been recognised in earlier works. Such collections are generically called model-books. One of the finest examples is the sketchbook of drawings in silver-point and watercolour belonging to the painter-architect, Giovannino de Grassi (*d.*1398), now in the communal library at Bergamo. Several artists contributed the naturalistic drawings of animals and de Grassi himself used some of them in the prayerbook he illuminated for Gian Galeazzo Visconti. The dependence of artists on such aids is confirmed by the survival of so many of these model-books or of pages detached from them.

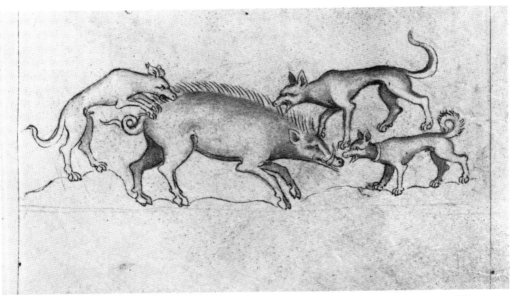

10 Hounds attacking a boar. *Queen Mary's Psalter.* Bruges? Early 14th century. Royal MS 2B VII, folio 145. (*Dept of MSS*)

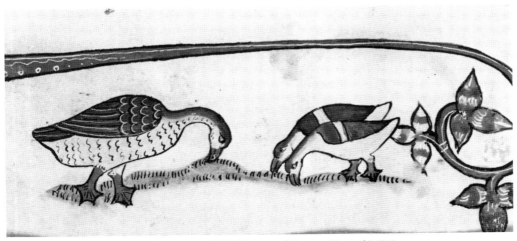

11 Geese. *Luttrell Psalter.* English. *c.*1340. Add MS 42130, folio 19. (*Dept of MSS*)

3. Flowers in religious art

THE INCIDENTAL portrayal of flowers, small animals, birds and insects in devotional books and religious paintings indicate the gradual trend towards studying Nature itself rather than working to a prescribed formula, slavishly copying existing designs.

Books of Hours, described by one scholar as 'the late medieval bestseller' constitute the largest single group of devotional manuscripts. As the personal prayerbooks of the wealthy who regarded them as precious objects, they had lavished upon them as much costly illumination as their devout owners could afford. Their production was not controlled by priests and consequently their decoration was very much a reflection of the wealth and status of their owners. Workshops and *ateliers* were established in the larger cities in France and the Low Countries to meet the demand for them. Their miniatures and decorative borders expressed secular as well as sacred themes, especially in the calendar where the monthly occupations were graphically depicted. Their diminutive size in no way inhibited extravagance of decoration or the imagination of the illuminators.

The miniatures in these manuscripts have rectangular borders composed of acanthus leaves or stylised foliage with a sprinkling of figures and animals. By the early fourteenth century this frame had evolved into an interlace of ivy or vine leaves with sinuous tendrils supporting various figures, animals and birds. The final stage in the evolution of marginal decoration was the making of the border into a window frame through which to view the miniature (figure 13). This optical illusion was sustained by enlarging the flowers, insects and other motifs dropped casually on the frame so that they seem to be nearer to the reader than the enclosed miniature, which recedes into the distance. By the mid 1470s Flemish illuminators at Ghent and Bruges had perfected a new *trompe l'oeil* technique of flowers and insects casting shadows against a coloured ground (PLATES 7 and 8).

Many of the floral motifs of the fifteenth-century illuminator were common flowers of the garden or countryside: violets, daisies, speedwell, primrose and so forth. A good number can be identified at least to generic level, and some, like *Crocus sativus* in a sixteenth-century German Book of Hours (PLATE 10) pose no problem, so correctly are they drawn. Yet these standards of fidelity to Nature were not always maintained; the artist who painted *Iris germanica* with such accomplishment in the Breviary of Queen Isabella of Castile lacked the same sure touch with the birds in the same miniature (PLATE 9). Insects, and in particular *Lepidoptera*, which were favourite motifs, could be accurately drawn if the artist took the trouble, but so often they were merely items in his repertoire, a symbol rather than a true likeness, conventionalised and unidentifiable.

Such criticism could never be levelled against the work of Jean Bourdichon (*c*.1457–1521), court painter to Charles VIII, Louis XII and François I. Perhaps his

12 Violet and butterfly. *Book of Hours*. Paris. 1515–20. Add. MS 35214, folios 47v and 48. (*Dept of MSS*) Unlike Flemish illuminators, most French artists preferred to leave flower heads on their stems.

best work and certainly one of the best-known of all the Books of Hours is the *Grandes heures* made for Anne of Brittany, Queen of France, about 1500–08. His floral borders are so carefully drawn that the manuscript is, in effect, an early florilegium. Unlike his Flemish contemporaries who preferred to make a pattern of cut flower heads, he included generous lengths of stems; but he was an artist, first and foremost, and therefore did not scruple about unnaturally twisting a stem to fit his design. The plants he used, over 300 in number, are labelled with their Latin and vernacular names. The *Grandes heures* has long been admired by botanists; the eighteenth-century French botanist Antoine de Jussieu presented a paper on it to the Académie des Sciences. Whatever one may think of the realism of the drawings in these devotional works, one is inclined to agree with Francis Klingender that they 'form a distinctive but inseparable part of that dream-imagery ... which so faithfully mirrors the moods and interests of the contemporary nobility and are ... like contemporary nature lyrics, the result more of an emotional poetic approach to nature than of any conscious scientific pursuit'.[1]

1. F. Klingender *Animals in art and thought to the end of the Middle Ages* 1971, p 427.

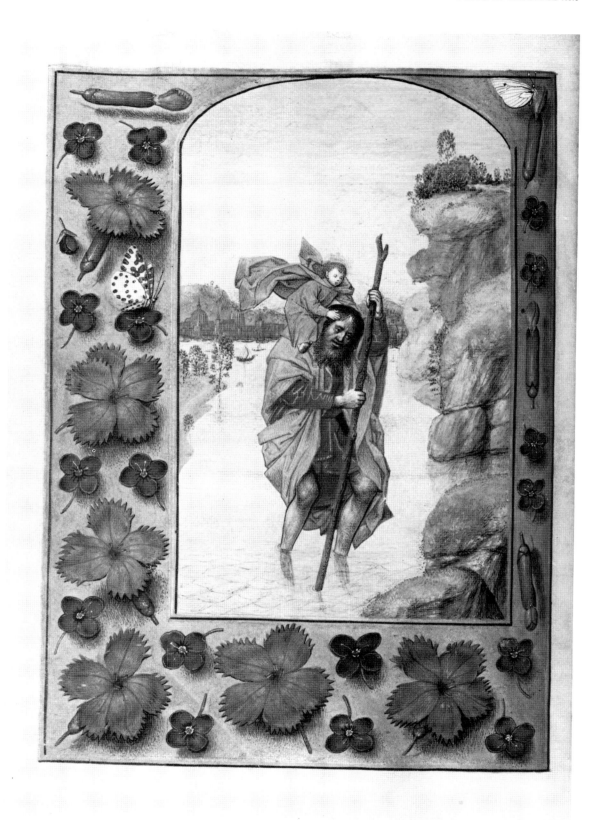

13 St Christopher and the Christ child (the facing page of PLATE 7). *The Hastings Hours*. Flemish. Late 1470s. Add. MS 54782, folio 48v. (*Dept of MSS*)
This illustrates the practice of using cut flower heads in border decoration.

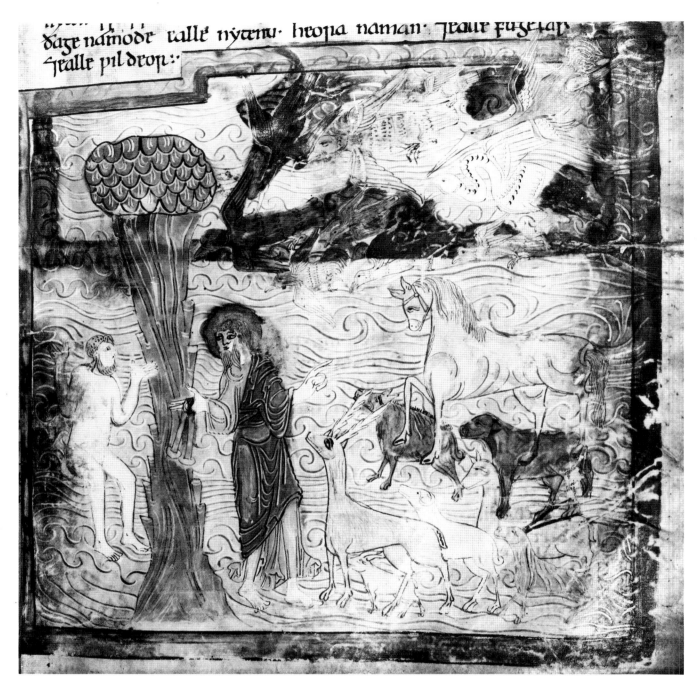

When religious art escaped during the fourteenth century from some of the
conventions that had shaped and directed it for so long, when artists were no
longer obliged to follow iconographic traditions, a freshness of vision and a
spontaneous interpretation of subject matter imbued their work. The themes
were the same but their rendition became less formal, more relaxed. Themes such
as the *Creation* (figure 14) or the *Flood* gave artists abundant scope to incorporate a
whole menagerie of animals in their compositions. In the Holkham Bible and
Queen Mary's Psalter a swan, owl, peacock, magpie and parrot hover above the
head of the Creator, and at his feet contented animals congregate – lion, elephant,

14 Naming of the animals.
God and Adam. Anglo-
Saxon. Second half of 11th
century. Claudius MS B.IV,
folio 6. (*Dept of MSS*)

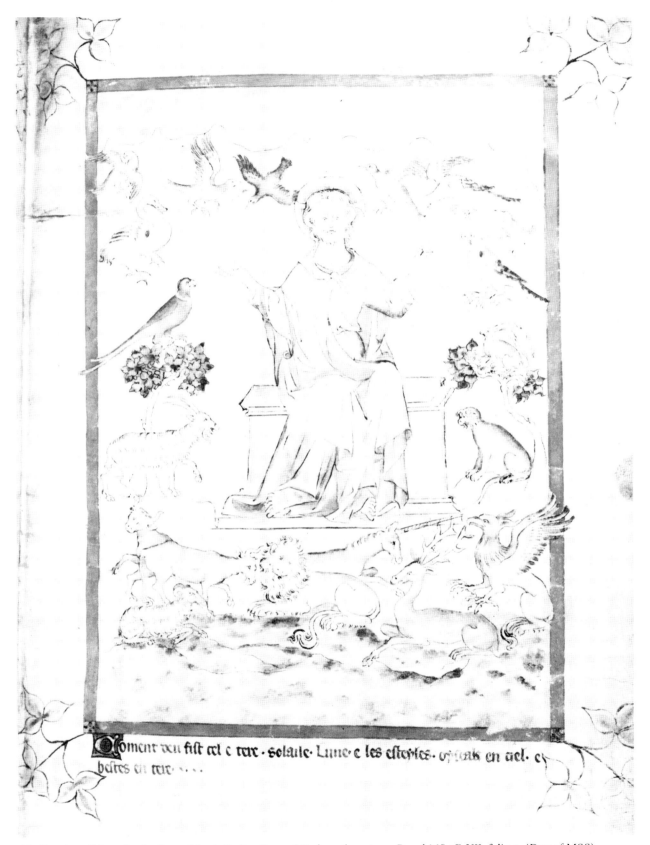

15 Creation of the animals. *Queen Mary's Psalter*. Bruges? Early 14th century. Royal MS 2B VII, folio 2. (*Dept of MSS*)

deer, bear, goat – even some inhabitants of the bestiaries, the griffin and the unicorn (figure 15). The birds are more lifelike than the animals which are drawn with a casual regard to scale or proportion. The charm of these drawings resides in their naivety. When Jacopo Bassano (c.1517/8–92) painted the *Flood*, he had no difficulty with his horses, cattle, dogs and miscellaneous livestock but was much less sure with foreign animals. Enjoying the Garden of Eden in Hieronymus Bosch's *Garden of Earthly Delights* triptych are an elephant and a giraffe and in the foreground a strange tree that could only have come from the artist's volatile imagination. The ox and the ass, depicted with capricious skill, frequent most of the Italian canvasses of the *Nativity*. Of all the hermit saints and their animal companions, St Jerome and his grateful lion lead in popularity; Cranach the Elder painted at least eight versions. Benozzo Gozzoli (c.1421–97) probably visited the Medicis' menagerie in Florence to draw the cheetahs he put into the *Journey of the Magi* in the Medici Chapel. The Infant Christ in Gozzoli's *Madonna and Child* clutches a goldfinch. According to legend, the red patch around its bill was its stigmata, so to speak, a recognition of the service it performed when it eased the crown of thorns pressing down on Christ's head. There are nearly 500 paintings in which the goldfinch is thus symbolically treated.

During the Renaissance subjects from classical mythology competed with religious themes. In *Primavera* by Sandro Botticelli (1445–1510), the flower lover has no difficulty in recognising at least thirty species of flowers growing in the grass or adorning the body of Spring. Botticelli, said Walter Pater, 'lived in a generation of naturalists, and he might have been a mere naturalist among them. There are traces enough of that alert sense of outward things which in the pictures of that period fills the lawns with delicate living creatures, and the hillsides with pools of water, and the pools of water with flowering reeds'.[2] The brothers Jan and Hubert van Eyck filled the lush meadows of their great Ghent masterpiece, the *Adoration of the Lamb*, with a carpet of iris, campion, dandelion, violet, lesser celandine and much more besides.

While still performing the role of incidental decoration, flowers were gradually becoming a focal point in paintings. The eye is arrested by the pot of white lilies in Robert Campion's mid-fifteenth-century *Annunciation with Donors and St Joseph*. Much more emphatic is the vase containing a red lily and white and blue irises next to a glass holding carnations and a sprig of columbine at the centre of the Portinari altarpiece by Hugo van der Goes (*fl.*1467–82). The flowers have symbolic resonance; the lily represents immaculate purity, the iris the celestial queenship of the Virgin Mary, the carnation the incarnation of Christ and the columbine the Holy Ghost. The thrusting stem and flower of *Iris germanica* is placed centrally against the sky in a painting by Albrecht Dürer. The title by which this painting is now known, *The Madonna with the iris*, stresses the prominence given to the flower in the composition. It was not to be, however, until the mid-sixteenth century when the German artist Ludger Tom Ring painted a pair of flowerpieces – lilies and irises in pots – that flowers were at last freed from their subordinate role in paintings.

2. W. Pater *Studies in the history of the Renaissance* 1893, p 56.

4. Herbals

EVEN THE MOST primitive tribes develop an expertise in plant-lore, an ability to recognise those plants valued for their healing properties. The Greeks had illustrated guides to assist in the identification of plants; their influence is discernible in some papyrus fragments of about AD 400 which depict comfrey and mullein and also give their Greek names. These guides to plants used for treating illnesses and injuries are known as herbals, a sort of pharmacopoeia. Their botanical content was meagre and in the Middle Ages was derived largely from a small group of Latin texts of which the two most important were the *De materia medica* of Dioscorides and the *Herbarium* of Pseudo-Apuleius. The earliest surviving copy of the *Herbarium Apulei*, a poorly illustrated work, was produced about the beginning of the seventh century, probably in Southern Italy or Southern France. Extracts from both Dioscorides and Pseudo-Apuleius are combined in an Anglo-Saxon herbal, now in the British Library (Cotton Vitellius C III; PLATE I). This Old English translation is one of the earliest examples of a European vernacular text. The drawings of plants and animals which accompany the 185 chapters are executed in thick blues, greens and browns. They may once have been reasonably accurate representations of plants, but repeated copying through a succession of manuscripts has reduced some of the figures to meaningless daubs. Furthermore, the artist or 'limner' sometimes could not resist the temptation to adapt a drawing in order to make it a pleasing pattern on the page.

This Anglo-Saxon herbal includes an illustration of the mandrake (*Mandragora officinarum*) with an account of the legend associated with it. Its roots, vaguely resembling the human figure, probably gave rise to the folklore surrounding it. It was believed to emit an unnerving scream on being pulled out of the ground, causing death or insanity to the unfortunate gatherer, a fate which could be avoided by a ritual incantation or, more reliably, by having it pulled up by a dog which went mad instead. The plant was valued as a powerful aphrodisiac. Theophrastus instructed that 'one should draw three circles round the mandrake with a sword, and cut it with one's face towards the West; and at the cutting of the second piece, one should dance round the plant and say as many things as possible about the mysteries of love'. The Anglo-Saxon herbal prescribed it for insomnia, madness, severe sweatings and gout; another English herbal of about AD 1200 (Sloane MS 1975; figures 16 and 17) extended its range of cures. It endorsed its benefits as a soporific but also recommended it for inflamed eyes, St Anthony's fire or erysipelus, snake bites and sores. Many illustrations of the mandrake show the figure with fingers and feet terminating in flourishing roots. Here the artist has drawn a naked figure with normal hands and feet. Everything else is conventional including the headdress of leaves and the dog tied to the plant. The reputation of

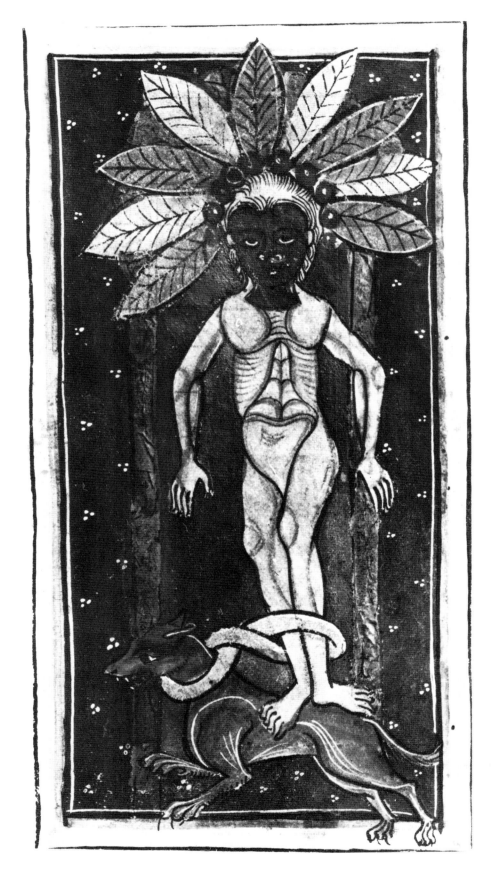

16 (*Left*) Mandrake. *Pseudo-Apuleius Herbarium*. England. *c*.1200. Sloane MS 1975, folio 49. (*Dept of MSS*)

17 (*Right*) Female mandrake and 'Thapsis'. *Herbal*. *c*.1200. Sloane MS 1975, folio 57. (*Dept of MSS*)

nem. omſcp durities ſoluunt. ꝛ
ſpargunt. ꝘꝘ

ꝘꝘ Eadem ſtigmata corporum ſepte
dieb; leuit infricata. ſine exulce
ratione detergunt. Eadem i cum ſa
le poſita. in ore diutius ſeruata.
appetitum edendi in omib; pſtat.
Radix ipiuſ. cum aceto ꝛta. igne
ſacrum curat. Cum melle ut cum
oleo ꝛ ꝛta. contra morſum ſerpen
tium pdeſt. Cum aqua. chyriadaſ
diſſoluit. Cum polenta: octorum
dolorem ſedat. Preterea de cortice
radicis ipiuſ. libre treſ. ꝛ ſex congia
uini dulciſ in amphoram mittun
tur ꝛ reponuntur: ut ad medicine
uſum maturetſcat. ꝛ ex eodem uino
chyatos treſ. ꝛ unciaſ quatuor. ꝛ ſt
mi unciam dabiſ ad bibendum.

hiſ quorum corp ꝓpt curam ſecandũ
eſt. ut hac potione ſop oratj. dolorẽ
ſecture ñ ſentiant. Mala autem ip
ſiuſ. ſi ut olefiriantur: ut edant. ſopo
rem. corp orem cp ita ut uo cem aufe
rant. faciunt. Succuſ quocp ex corti
ce ipriuſ radiciſ trite ex pſſuſ. un ua
ſe fictili poſituſ. in ſole. ut leni igni
culo coquat. ꝛ aſidue agitetur. donec
in mellis craſſitudinem coactuſ.
ptea in ſaluo loco. ad medicine u
ſum reponat. Radiceſ etiam ſicce
reſeruent. p libꝫ uſibꝫ p future. ad
feruoreſ ſcilicet octoꝛ. ad feruoreſ
uulnerum. ad duritiaſ ꝛ collectione
ſpargendaſ. ad ignem ſacrum ad
ſerpentis morſum. ad chyriadaſ ꝛ ad
articulorum dolorem. Potio autẽ
huiuſ herbe accipiꝛ. ut qui ſecatur
non ſentiat dolorem. Nom huiuſ
herbe. xvi. Thaſpis. aue aua.

this plant with such remarkable properties was preserved by generations of herbalists. Its legend was accepted, treated with scepticism, or rejected, and there were always nimble fingers willing to counterfeit what Nature could not provide but superstition demanded.

The plants in the British Library herbal (Sloane MS 1975; figure 17) have a geometrical symmetry that may have pleased the artist but could only have frustrated the reader. Stalks proceed centrally up each frame, stems of leaves balance each other like mirror images, roots often curve over the bottom border and a concentration of radiating lines at the top serve for an inflorescence. But soon Northern Europe was to respond to the work of scholars in Southern Italy and to a revival of naturalism in drawing.

The Norman kingdom of Southern Italy and Sicily was an important link with the Islamic world and, through Arabic scientific works, with the culture of Ancient Greece. The Greek text of Dioscorides which had been translated into Arabic in the mid-ninth century now appeared in Latin and was studied by the students at the new medical school at Salerno. It was at Salerno during the thirteenth century that Platearius wrote his *Liber de simplici medicina* which incorporated Greek, Arabic and Latin sources. The new interest in medical science stimulated by such activities at Salerno created a demand for reliable herbals and drawings of plants. Artists now began to use the local flora as subjects instead of relying on traditional plant portraits. An early fourteenth-century copy of Platearius's work in the British Library (Egerton MS 747; PLATE 2) is indicative of the change that was taking place. Otto Pächt, who has made a close study of this period, believes that the pictures

as represented by Egerton MS 747 cannot yet be counted as portraits in the full sense of the word; they are not based on studies exclusively drawn from life, but are rather the result of a careful comparison between painted models (of clerical origin) and life models. They contain a great mass of intimate observation of details, but for the plant as a whole they still fail to supply the organic connection of the parts. They either adhere to decorative pattern ... or else press naturalistic details into conventional plant schemes.[1]

The transition from formalism into naturalism becomes a reality with the Carrara herbal (Egerton MS 2020). If there were other manuscripts of a similar quality they have not survived or been discovered. The scribe of the Carrara herbal was an Augustinian monk, Jacopo Filippo, who may also have translated this Arabic herbal of Serapion the Younger (Ibn Sarabi) (c.AD 800). As the herbal belonged to Francesco Carrara the Younger, Lord of Padua, who died in 1403, it must have been written and illuminated before that date. The work of the anonymous artist is the first example we have of plants painted directly from Nature. The stems of melons in figure 18 flow with the vigour of spontaneous growth across the page, unrestricted by any border; tendrils curve naturally; and leaves marked with a light venation hang and droop as they would in the open air.

A number of the drawings were copied by Andrea Amadio in the Benedetto Rinio herbal, now in the Biblioteca Marciana in Venice, although many of his plant studies in this fifteenth-century work come directly from life. John Ruskin

1. *Journal of Warburg and Courtauld Institute* vol 13, 1950, p 29.

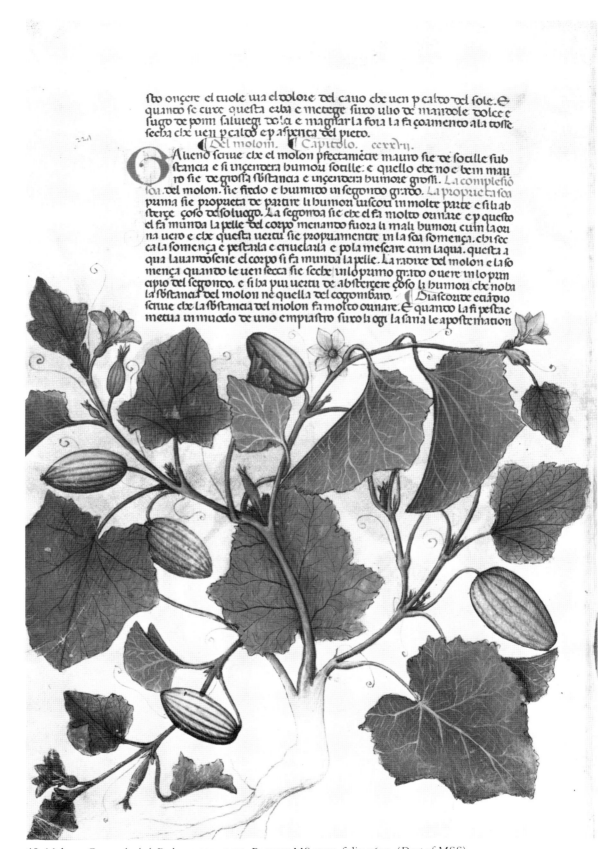

ſto onçere el tuole una el colore del cauo che uen p caldo del ſole. E
quando ſe cure queſta erba e metege ſuro ulio de mandole dolce e
ſugo de pomi ſaluiegi dola e magiar la foia la fa coamento ala toſſe
ſecta che uen p caldo e p aſperiea del pieto.

Del molon. Capitolo. ccrrlv.

O Aueno ſcrue che el molon pfectamiete mauro ſie de ſotille ſub
ſtancia e ſi uncendera humou ſotille: e quello che no e bem mau
ro ſie de groſſa ſbistancia e uncendera humore groſſi. La compleſiô
ſoi del molon. ſie fredo e buimido in ſegondo grado. La proprieta ſoi
puma ſie propucta de partire li humon uiſcoſi in molte parte e ſi li ab
ſterçe coſo delſo luogo. La ſegonda ſie che el fa molto ourare e p queſto
el fa munda la pelle del corpo menando fuora li mali humou cum laou
na uero e che queſta uertu ſie propuamentr in la ſoi ſomença. chi ſec
ca la ſomença e peſtaila e cruelaila e pola meſcare cum laqua. queſta a
qua lauandoſene el corpo ſi fa munda la pelle. La radixe del molon e la ſo
mença quando le uen ſecca ſie ſeche un lo puimo grado o uere un lo pun
cipio del ſegondo. e ſi ba pui uertu de abiſterçere coſo li humou che nota
la ſbiſtancia del molon ne quella del cocombaro. Diaſcoude ciáDio
ſcriue che la ſbiſtancia del molon fa molto ourare. E quando la ſi peſtar
metua in muodo de uno empiaſtro ſuro li ogi la ſana le apoſtemation

18 Melons. *Carrara herbal*. Padua. 1390–1400. Egerton MS 2020, folio 161v. (*Dept of MSS*)

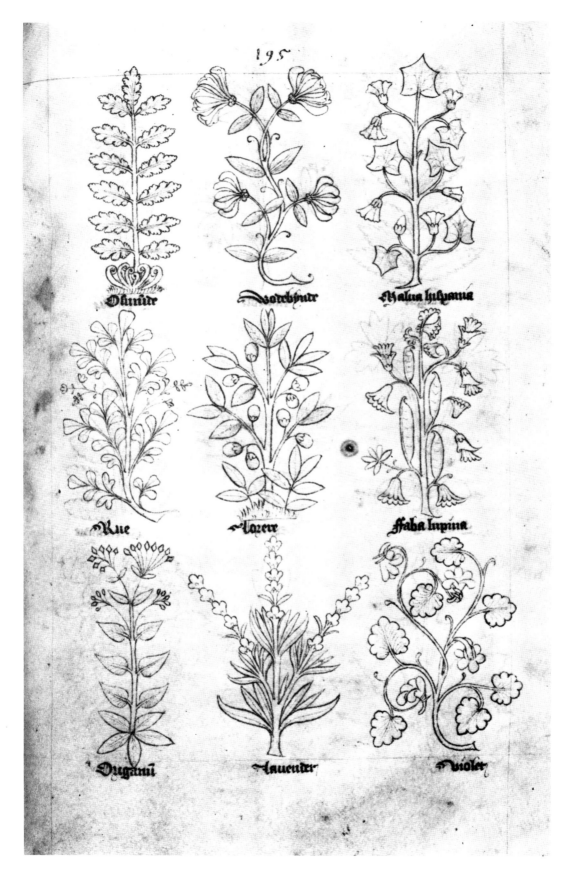

195

Olunur

Morchunr

Malua luchanta

Rue

Lorerr

ffaba lupina

Duganu

Lauentir

violet

19 Page from an album of pen-and-ink drawings of 68 wild flowers used for medicinal purposes. English. *c.*1450. Add. MS 29301, folio 52. (*Dept of MSS*)
Top line: Honeysuckle (centre), Mallow (right).
Middle line: Rue (left).
Bottom line: Fleabane (left), Lavender (centre).

thought so highly of its 'balanced and ordered symmetry of arrangement' that he had it copied for the benefit of his students.

In England meanwhile, artists were still happily drawing flowers that would have been more suitable for wallpapers and fabrics. The artist of the pen and ink drawings in figure 19 had a flair for design, but what is one to make of the so-called violet in the bottom right-hand corner which looks more like ivy-leaved toad flax? Or the plant above it – is it a broad bean? Not until the publication of illustrated printed books would there be any uniform standard and consistency in plant figures.

The invention of printing with movable type in the mid-fifteenth century did not lead to the immediate demise of manuscripts; on the contrary, both co-existed for many years with printers instinctively copying the format, layout and lettering of manuscripts. Woodcuts were used for marginal decoration and illustrations. The design drawn on the surface of softwood, such as pear or beech, was cut with a knife, those areas intended to print white being removed, leaving a pattern of lines on the printing surface. The inadequacy – even absence – of any scientific vocabulary, meant that botanical and zoological books of the fifteenth and sixteenth centuries depended a great deal on their illustrations.

The first woodcuts of plants and animals are to be found in the *Buch der Natur*, printed by Hans Bämler at Augsburg in 1475. Its author, Conrad von Megenberg, freely adapted the *Natura rerum* of Thomas de Cantimpré, written just over a century earlier. He did, however, add another fifty-nine plants to Cantimpré's 114; Book III describes animals, birds, fishes, snakes and mythological creatures like the mermaid and sea-monk. The crude woodcuts were taken from, or inspired by, the debased drawings in manuscript herbals and bestiaries.

Naples can claim the honour of printing the first herbal, *De viribus herbarum*, by Macer Floridus, in 1477; woodcuts were not added to this popular work until the Milan edition of 1482.

Johannes Philippus de Lignamine used a ninth-century copy of the *Herbarium* of Pseudo-Apuleius in the monastery of Monte Cassino for the first printed version in Rome in 1481. Many of the woodcuts were copied from the manuscript's illustrations.

The two herbals printed in Mainz by Gutenberg's partner, Peter Schoeffer, in 1484 and 1485, followed the current practice of complete reliance on degraded plant figures in manuscript herbals. The *Latin herbarius* (1484) discusses plants found in Germany, either in the wild or in cultivation, that were useful in herbal remedies. Its boldly executed woodcuts, 150 altogether, are meaningless decorations on the page. Nevertheless, the book became a bestseller in Italy and the Low Countries.

A different set of woodcuts were used in Schoeffer's *German herbarius* (1485), also (confusingly) called *Herbarius zu Teutsch, Gart der Gesundheit, German ortus sanitatis, Smaller ortus* and *Cube's herbal*. In the preface we learn from the person who conceived the book that he

caused this praiseworthy work to be begun by a Master learned in physic, who, at my request, gathered into a book the virtue and nature of many herbs out of the acknowledged masters of physic, Galen, Avicenna, Serapio, Dioscorides, Pandectarius,

Platearius and others. But when in the process of the work, I turned to the drawing and depicting of the herbs, I marked that there are many precious herbs which do not grow here in these German lands, so that I could not draw them with their true colours and form, except from hearsay.[2]

When he undertook a pilgrimage to the Holy Land 'in order that the noble work that I had begun and left incomplete should not come to nought, and also that the journey should benefit not my soul alone, but the whole world, I took with me a painter, ready of wit, and cunning and subtle of hand. . . . In wandering through these kingdoms and lands, I diligently sought after the herbs there, and had them depicted and drawn, with their true colour and form.' Nearly one-sixth of the 381 figures of plants and a few animals were obviously drawn from life; the larger woodcuts allow more detail to be incorporated. They represent the first significant step on the road to authentic botanical illustration. It is not surprising that printers in Augsburg, Basel, Lubeck, Strasburg and Ulm borrowed freely from it.

The compiler of the *Hortus* or *Ortus sanitatis* printed in Mainz by Jacob Meydenbach in 1491 was very much indebted to the *German herbarius*. Much of the text and about one-third of the woodcuts of plants were lifted from Schoeffer's book. Unfortunately, in redrawing the figures on a reduced scale, the copyist lost much of the vitality of the originals. The work enlarged its coverage to include zoology and mineralogy, the first printed work to embrace such a wide spectrum of Nature.

The first illustrated English herbal was printed in London in 1526 by Peter Treveris. The *Grete herball* was, in the main, a translation of the French *Le grand herbier*. It has many small woodcuts of animals, as well as of plants; sometimes the same figure is applied arbitrarily to different plants. The figure for the palm, for example, is also used for the tamarind. The book confirms what little progress had been made in botanical studies during the previous 1500 years: the same classical authorities are cited and the illustrations are lifeless derivatives. But the publication of Brunfels's *Herbarum vivae eicones* in 1530 was to give a new impetus to plant science, and it would be the artist and not the author who deserved the credit for it.

2. A. Arber *Herbals; their origin and evolution* 2nd edition, 1938, p 25.

5. The Renaissance

THE RENAISSANCE is a term loosely applied to the intellectual movement that had its beginnings in Italy in the fourteenth century with the rediscovery of classical texts, the revival of naturalism, new explorations in painting and literature and the gradual relaxation of the autocracy of medieval theology. Modern science had its roots in the sixteenth and seventeenth centuries when the inherited knowledge of the ancients was tested by empirical enquiry and direct observation. The systematic investigation of Nature provided the rationale for a faith in science which, it was believed, would at the same time reveal the glories of God. At first, scholars did not consciously set out to question or reject herbals and bestiaries, but myths were discredited and classical concepts re-evaluated as the physical world came under critical scrutiny. The exchange of information, specimens and drawings led to an international fraternity of prominent naturalists – men such as Gesner, Aldrovandi, Turner, Penny, l'Obel and Caius.

As well as sharing a common interest in Nature, these men were also united by medicine as a profession. The same aptitudes were required for both pursuits: good powers of observation, diagnostic skill, and a retentive memory. The best medical schools seemed to produce the largest number of naturalists. The Bohemian botanist, Adam Zaluziansky von Zaluzian, deplored the subordinate role of botany. 'It is customary to connect Medicine with Botany, yet scientific treatment demands that we should consider each separately'. He urged that botany should be 'unyoked from Medicine'.[1]

The medical school at Padua established the first chair in Botany in 1533. Professors of Botany also took charge of botanic or physic gardens where plants with medicinal properties were grown for demonstration and study. The Orto Botanico in Padua, founded in 1545 by a decree of the Senate of the Venetian Republic, is probably the first of such botanic gardens, but this priority is challenged by Pisa, a near contemporary. Other European botanical gardens quickly followed: Florence (1545), Zurich (1561), Lyons (1564), Rome (1566), Bologna (1567), and Montpellier (1593). In time they became important centres for new plant introductions from overseas; the American agave, for instance, was cultivated at Padua in 1561 and the potato in 1590. With this wealth of plants at their disposal, directors of botanic gardens were encouraged to devise new classifications to replace the traditional groupings of plants by medicinal uses. Andrea Cesalpino, Professor of Medicine and Director of the botanic garden at Pisa, selected fruit as a classificatory characteristic; l'Obel saw leaf structure as a principal feature. The first herbarium or collection of dried plants was assembled in Italy during the first half of the sixteenth century.

1. A. Z. von Zaluzian *Methodi herbariae, libri tres* 1592.

The Spanish and Portuguese conquests in the New World made significant contributions to this international botanical traffic. The first illustrated description of tobacco is found in Nicholas Monardes's *Joyfull newes out of the newe founde world* (1569; English translation 1577) which also depicted creatures like the armadillo. Garcia da Orta's account of Indian plants used as medicine or food and published in Goa in 1563, *Coloquios dos simples*, was translated into Latin by Clusius (*Aromatum et simpliciam aliquot medicamentorum apud Indos nascentium historia* (1567)) with woodcuts of those plants that could be bought in the market in Antwerp. Cristobal de Acosta, who met Orta in Goa, published his *Tractado* on his return to Spain in 1578. It was illustrated with woodcuts of tropical fruits and spices drawn from Nature. Broad Indian pepper, long Indian pepper, and Calicut pepper are figured in Leonard Fuchs's *New Kreüterbuch* (1543) and P. Mattioli had woodcuts of pepper, nutmeg, cardamom, cloves and rhubarb in his *New Kreüterbuch* (1563).

The sailors and merchants who brought back plants, animals, fossils, minerals and artifacts had no difficulty in disposing of them to owners of 'cabinets of curiosities', or Kunst- und Wunderkammern. The Tradescants in England, for example, had their 'Closet of Rarities' which later became the foundation collection of the Ashmolean Museum in Oxford. The formation of personal museums was a manifestation of the cultural climate of the times; enlightened patronage of the arts and sciences, especially in Italy, was another. The Grand Duke Francesco of Tuscany, for instance, financed some of Aldrovandi's collecting missions and allowed Jacopo Ligozzi to paint the exotic birds in his aviary.

By the middle of the fifteenth century flowers and animals were being sketched from life for incorporation in some larger composition. The flowers in the famous altarpiece by Gentile da Fabriano or the giraffe in Piero di Cosimo's *Vulcan assisted by Aeolus as teacher of mankind* presuppose preliminary sketches, but none has survived, in all probability because they were not valued for their own sake. Antonio Pisanello (*c*.1395–1455), an Italian painter from Verona, was the first major animal painter to free himself from medieval tradition by making an objective study of the external world. He found the animals, which he drew with a keen and dispassionate eye, in the countryside and also in the menageries of Italian noblemen. He never sentimentalised his subjects; like Hans Weiditz with flower illustrations, he conscientiously included all imperfections. His horses, for example, are not idealised in a classical sense; if they were emaciated and forlorn then that is precisely how he drew them. He patiently recorded movement and posture from various angles. More than any other artist before him he explored and exploited the potentialities of pen and pencil. His enormous outpouring of drawings, most of which are now in the Louvre, reveal such powers of imagination, versatility and scientific exactitude that for a long time they were thought to be the work of Leonardo da Vinci. Some critics prefer these drawings to the finished works for which they served as models. The horse in his *Vision of St Eustace* in the National Gallery in London is rather wooden, lacking vitality. It could also be said of this picture that its cohesion has been weakened by Pisanello's overcrowding of the small panel – stags, three breeds of dog, swans, pelicans,

herons, geese and even a hoopoe. Nevertheless, the consummate skill with which he has suggested hair and feather makes it one of the first important oil paintings of animals and birds.

We do not know whether Pisanello ever drew plants, but his great contemporary Leonardo da Vinci (1452–1519) certainly did. His restless spirit of enquiry and scientific curiosity encompassed architecture, sculpture, painting, anatomy, engineering and botany. Surprisingly, he did not draw many animals: only some studies of bears, dogs, horses, and a delightful page of cats playing and washing themselves, tense and alert in fear, relaxed in sleep. Like Stubbs and Géricault after him, he was obsessed by the beauty of form and the muscular power of horses and also, like Stubbs, he studied their anatomy.

During his youth in Florence he examined plants, probably while he was employed in the Semplici Garden in the Piazza San Marco. In a list he compiled in 1504 of his library is an 'erbolajo grande', possibly one of Peter Schoeffer's herbals. Botany was only one of the many fields he investigated in his ceaseless quest to discover and understand the laws of Nature. The sixth book of his *Treatise on painting*, on 'botany for painters', considers plant growth, the symmetry of Nature, the arrangement of leaves on the stem (phyllotaxy) as well as the texture of light and shadow and other technical matters more germane to painting. He knew that the age of a tree could be determined by the number of its annual growth rings, but commented that 'although these things do not serve paintings I yet will note them, so as to leave out as little about trees as possible'.

Landscape or plants provide an element in many of his paintings. Vasari said of the lost *Adam and Eve in the Garden of Eden* canvas, that it was 'a meadow in grisaille, containing much vegetation and some animals insurpassable for finish and naturalness'. The Louvre version of the *Virgin of the rocks* probably has the largest number of plants: *Aquilegia vulgaris, Cyclamen purpurascens, Jasminum officinale, Hypericum perfoliatum* and *Polemonum caeruleum* can readily be distinguished, although it is not so easy to decide the species of the Iris, the palm could be *Raphis* and the fern is far too vague. Generally speaking, the floral motifs in his paintings are far inferior to those in his drawings to which one must look for a proper assessment of his genius.

Lord Clark deduced that several of Leonardo's plant studies in the Royal Library in Windsor Castle were sketches from the lost *Leda and the swan*. Here there is little difficulty in identifying most of the plants to species level, so precise is Leonardo's draughtsmanship in red chalk, pen and ink. There can be no mistaking the Madonna lily (*Lilium candidum*) – which has prick marks indicating it was intended for transfer to a panel – but the corresponding painting has never been found or identified. The leaves of the 'Star of Bethlehem' (*Ornithogalum umbellatum*?) curve and flow with the same dynamic rhythm one perceives in his drawings of the movement of water.

Leonardo's dynamic sketches were as much an expression of his interest in science as a shorthand notation of ideas for development in projected paintings. He was producing these elegant botanical drawings at the very time when printed herbals were being embellished with crude woodcuts. The only artist of his day who combined similar skill with disciplined observation was Albrecht Dürer.

Dürer (1471–1528) was the first artist in Northern Europe to apply scientific principles to art. He was the son of a Nuremberg goldsmith from whom he may have acquired that dedication to precision and minute detail which the craft of a goldsmith demands. In 1494 he set up his own workshop as an engraver. It was not until the sixteenth century that plant portraiture came of age, no longer solely confined to the margins of illuminated manuscripts, or symbolically decorating religious paintings. Artists like Dürer went out into the fields seeking their subjects. Dürer deftly painted the outline of massive boulders in a quarry, adding a calligraphy of green strokes for tufts of vegetation; a wash of deep blue served for a pond in a pine wood and rapid flicks of the brush for a margin of reeds. He made an impressive ecological study of a clump of dandelion, plantain, yarrow, pimpernel and grasses.

Dürer drew animals with the same analytical detachment. On his first visit to Venice he sketched a sea crab found on the shores of the Adriatic, using white body colour to heighten the watercolour. He applied body colour, which he frequently used, with fastidious care in depicting the fur of a hare, one of his most popular animal studies. Nothing escaped his attentive eye: a solitary stag beetle, limp bodies of dead birds, a walrus head which he later converted to a dragon's head in an altarpiece. His concern for minutiae is evident in the glazing bars of a window reflected in the eyes of a tawny owl or in the compact layering of feathers with their subtle gradations of colour and texture.

Someone once wrote of Dürer that he 'approached life with a compass and a ruler'. Certainly his scientific inclinations did not extend beyond meticulous accuracy. He never investigated the underlying laws of the natural world. 'Such things', said Dürer, 'I hold to be unfathomable'. Convinced that the workings of Nature would always remain 'one of God's secrets', he was content humbly to acknowledge its sovereignty in his splendid drawings.

Hans Hoffmann who died about 1592 could be called Dürer's devoted disciple, so sedulously did he copy his *oeuvre* – the studies of dead birds, the stag beetle, the hare and the lion. He even essayed his own version of Dürer's *Great piece of turf*. His latter years were spent in Prague in the employment of that extraordinary monarch, Rudolph II, for whom culture was a compulsive mission in life.

Georg Hoefnagel (1542–1600) also painted exquisite miniatures of animals, birds, fishes and insects for Rudolph. Like Hoffmann, he found inspiration in Dürer's work, copying his stag beetle and hare. For Albrecht V, Elector of Bavaria, he illuminated a book of prayers and for Archduke Ferdinand of the Tyrol the bulky *Missale Romanum* from which some of the marginal decoration of beasts, birds and flowers were copied and engraved by his son in *Archetypa studiaque patris G. Hoefnaglii* (1592). His instinct for design comes through in a delicate watercolour, now in the Ashmoleum Museum in Oxford. The focal point of the drawing is a butterfly with outspread wings; above it rises the short stem of a pale yellow tulip, its edges lightly veined with pink; on either side a symmetrical display of tight rose buds and the curving stems of Aquilegea; finally the thoughtful disposition of a smaller butterfly, a beetle, a sinuous caterpillar, and a hovering dragonfly produces a marvellously integrated composition.

Hoefnagel's services were also sought by such connoisseurs as Archduke

Ferdinand in Munich. The importance of the role of European monarchs and princes as patrons of the arts needs to be stressed. Dürer worked at the courts of the Emperor Maximilian of Bavaria and Charles V, and another contemporary artist, Georg Flegel (1563–1638), carried out commissions for Maximilian and Archduke Ernst of the Tyrol. Flegel is remembered chiefly as a painter of still-lifes and for the flowers and fruits he added to the paintings of the Flemish artist Martin van Valckenborch. An incomplete album of his watercolours of flowers (now in the Staatliche Museen Preussischer Kulturebesitz in Berlin) testify to his undoubted skills.

Pre-eminent among a smaller group of notable scholars was Conrad Gesner (1516–65), physician, philologist and bibliographer – his researches into so many spheres of human activity made him a truly Renaissance man. He was born in Zurich, studied medicine, science and the classics at Basle, Paris and Montpellier, returning eventually to his birthplace to become its Chief Town Physician.

Modern zoology began with the publication of his great work, *Historia animalium* (1551–58), which attempted a comprehensive survey of the current state of knowledge in the animal kingdom. Four volumes were published during his lifetime; the final part on insects and reptiles appeared posthumously in 1587. He followed Aristotle's classification and emulated Pliny by giving data on habitat, physiology, diseases, diet, etc in his account of each animal. In his anxiety to be thorough, some of the errors and legends of classical and medieval authors were accepted. Where he was in doubt, inclusion rather than exclusion would appear to have been his guiding principle He provided many of the figures himself, but where he did borrow from other books and manuscripts he always scrupulously acknowledged his indebtedness. His rhinoceros inevitably had to be a copy of Dürer's ubiquitous woodcut. Due to this multiplicity of sources, the quality of the woodcuts varies considerably; many were drawn with a reasonable degree of accuracy and decorative dexterity, while others are positively archaic. In a number of copies the woodcuts were hand-coloured – 'for customers who are not deterred by the higher cost', as Gesner explained in his preface. He was the first zoologist to recognise the importance of illustrations in zoological studies and his *Historia animalium* with its thousand illustrations remained an authoritative work until the researches of Ray and Willughby a century later (figure 20).

Gesner had hoped to compile a companion work on botany. He received information and specimens from his innumerable European correspondents. In a letter of August 1563, he tells the botanist Jean Bauhin about an artist he had engaged. 'At this time I cannot occupy the artist with dried plants: he can scarcely now paint all the fresh and green examples: I put off the dried specimens until the Winter, when there will be no opportunity of getting the living'. He amassed about 1,500 watercolours and drawings of plants but his premature death at the age of forty-nine brought the project to an end. Gesner's pupil, Caspar Wolf, announced his intention of publishing them but the task proved too much for him. Eventually they were purchased by the Nuremberg physician and naturalist, Christoph Jacob Trew, in 1744. After Trew's death in 1769, the drawings and Gesner's notes completely disappeared and were only rediscovered in 1929 in an attic of the University Library at Erlangen.

LATINE Camelus, uel Camelus Bactriana. ITALICE Camello.
GALLICE Chameau. GERMAN. Kámelthier.

Ordo Secundus.

17

20 Bactrian camel (*Camelus bactrianus*). Woodcut. Conrad Gesner *Icones animalium quadrupedum viviparorum et oviparorum . . .*, Tiguri, 1553. 459 c 9 (1), plate 17. (*DPB*)

Another encyclopedist was Ulisse Aldrovandi (1522–1605), who cherished an ambition to write a compendium of all living things; however, only four of the fourteen volumes of his *Storia naturale* (1591–1688) came out during his life. He was Professor of Botany, and later of Natural History, at the University of Bologna, Director of the Orto Botanica, and owned a large library which included the *Carrara herbal*, now in the British Library (figure 18). Like Gesner, who was one of his many correspondents, he culled the works of Greek, Latin and oriental writers. Less critical, perhaps more credulous than Gesner, he included the fabled fantasies of the bestiaries. He took endless trouble over his printed illustrations which, on the whole, are better than Gesner's. The papers and collections which he bequeathed to the city of Bologna included 10,000 botanical drawings. For thirty years artists recorded his natural history collections and the plants in the local botanic garden. Aldrovandi approvingly said of one of his best painters, Jacopo Ligozzi (1547–1626), that he was 'a most excellent artist who has no other care day or night but to paint plants and animals of every kind'. Ligozzi drew with the skill of the artist and the discipline of the scientist: all his plant drawings (mostly in the Uffizi Gallery in Florence, of which he became Superintendent) are confident botanical statements.

The other leading taxonomic zoologists were the Frenchmen Guillaume Rondelet (1507–56) and Pierre Belon (1517–64). The fishes in Rondelet's *De piscibus marinis* (1554), mostly identifiable, show some progress in ichthyological illustration. With financial assistance from the Cardinal of Tournon, Belon travelled in the Levant from 1546 to 1549, observing and sketching people, places and animals. His major work, *Histoire de la nature des oyseaux* (1555), has a plate of a

skeleton of a man and a bird, a very early example of comparative anatomy. The artist, Pierre Goudet, depicts some of the birds with food in their beaks, possibly the first instance of this feature in ornithological illustration.

The modern era of zoology is said to have begun with Gesner and the beginnings of modern botany with Brunfels, or rather with the book of which he was the author. It was not, however, Brunfels's text of *Herbarum vivae eicones* (1530–36), taken from classical and medieval sources, often inadequate and sometimes inaccurate, that makes this book so significant; it was the plant illustrations by Hans Weiditz. Weiditz, a pupil of Dürer, was a member of an emerging class of professional German illustrators who included Hans Balding of Strasburg, Hans Behan of Nuremberg and Hans Burgkmair of Augsburg. Weiditz drew his plants with a refreshing honesty, even to the extent of faithfully reproducing their blemishes and deformities. Therein lies their one weakness: he drew an individual rather than the ideal plant representative of the species. Perhaps Brunfels was to blame for allowing imperfect specimens to be collected. He did admit to allowing Johann Schott, the printer, and Weiditz to 'fashion the cuts according to their whims', believing that illustrations were no substitutes for 'right truthful descriptions'. But the ease with which it is possible to identify so many of the species in this book is due to Weiditz's drawings rather than to Brunfels's descriptions. When some seventy of Weiditz's original bistre-pen drawings, painted in watercolour, were discovered in 1930, it was possible to appreciate how well the flexible lines of the woodcuts have preserved the nervous energy of Weiditz's artistry. One also discovers, with regret, that his useful diagnostic details of flowers, seeds, etc, often enlarged, were omitted from the published drawings. Nevertheless, they still amply justify the title of the book, 'Living portraits of plants' (figure 21).

The success of *Herbarum vivae eicones* – the plates were immediately pirated by the Frankfurt publisher, Christian Egenolph – conceivably encouraged Leonard Fuchs to proceed with *De historia stirpium*, which was published in Basle in 1542. It is now valued for the excellence of its illustrations although Fuchs's commentary, largely derived from Dioscorides, is more scholarly than that of Brunfels. He was never guilty of Brunfels's occasional mismatching of description and illustration. Again, unlike Brunfels, he exercised a firm control on the selection and execution of the drawings; sometimes flowers, leaves or other features would be adapted to clarify useful morphological characters.

Fuchs knew exactly what he was trying to achieve with the illustrations, as his prefatory remarks make abundantly clear:

As far as concerns the pictures themselves, each of which is positively delineated according to the features and likeness of the living plants, we have taken peculiar care that they should be most perfect, and, moreover, we have devoted the greatest diligence to secure that every plant should be depicted with its own roots, stalks, leaves, flowers, seeds and fruits. Furthermore we have purposely and deliberately avoided the obliteration of the natural form of the plants by shadows, and other less necessary things, by which the delineators sometimes try to win artistic glory: and we have not allowed the craftsmen so to indulge their whims as to cause the drawings not to correspond accurately to the truth.

Albrecht Meyer drew the plants according to these rigorous precepts; Heinrich Fullmaurer copied the drawings on to the wood; and Veit Rudolph Speckle, 'by far the best engraver of Strasburg', according to Fuchs, engraved them. Fuchs, impressed by the results of their collaboration, had their portraits added at the end of the book – the first time that any artists and engravers had been so honoured.

The large woodcuts, over 500 in number, generously fill the folio pages, but some figures were truncated or distorted to fit within the margins of the page. The thin, wiry outlines of the woodcuts suggest that they were intended to be coloured by the purchaser. They are excessively fragile compared with the bold, thick lines of Weiditz's drawings. Weiditz was a more accomplished artist than Meyer. He regarded plants with affection; Meyer with clinical calm. But this is perhaps being unfair to Meyer who was subject to Fuchs's requirements. Fuchs insisted on illustrations that would satisfy botanists – 'artistic glory' was irrelevant. That he succeeded so well in this aim is substantiated by the constant use made of his blocks for more than 200 years.

William Turner, the 'Father of English botany', was one of the many authors who gratefully used Fuchs's woodcuts. His *Herbal* (1551–62), written in English, was illustrated, in the main, with figures from the 1545 octavo edition of Fuchs.

John Gerard (1545–1612), barber-surgeon, one-time Superintendent of Lord Burghley's gardens in London and Hertfordshire, is remembered today as the author of a substantial quarto, the *Herball* of 1597. His publisher, John Norton, obtained most of the 800 woodcuts from Tabernaemontanus's *Eicones plantarum* (1590) which themselves had been reproduced from the works of Fuchs, Bock, Mattioli, Dodoens, Clusius and l'Obel. When Thomas Johnson revised Gerard's *Herball* in 1633, he replaced the figures with blocks obtained from Plantin in Antwerp.

There was a profitable European market, both legitimate and unauthorised, in the use of woodblocks. Printers naturally preferred to purchase, borrow or copy blocks rather than be put to the expense of cutting their own. Blocks were sometimes used with a complete indifference to their relevance. Gerard's figures did not always correspond to the plants described in the text; the *Grete herball* (1526) sometimes employed the same block for different plants.

The largest collection of woodblocks was held by Christopher Plantin (1520–89), the greatest printer of his day. With sixteen printing presses and a workforce of 150 men, he made his workshop in Antwerp a very successful commercial enterprise. Plantin had an affection for illustrated books; none of his fellow printers could equal his output of engravings on wood and copper. His first illustrated book was Pierre Belon's *Les observations de plusiers singularitez et choses memorables* (1555). The woodcuts, copied from the French edition of 1553–54, were the work of Arnaud Nicolai, who joined Plantin's team of engravers.

An interest in science and gardening made Plantin a sympathetic and co-operative printer for the botanists Dodoens, l'Obel and Clusius. The Belgian botanist, Rembert Dodoens, wished to produce a Latin version of his *Cruydeboeck* which had been printed by Van der Loe. Plantin agreed to provide as many woodblocks as Dodoens needed and the author committed himself to collect as many as possible of the living plant specimens and to supervise the work of the

Ochsen zung.

21 *Anchusa officinalis.*
Woodcut. Otto von
Brunfels *Herbarum
vivae eicones.*
Strasburg, 1530–36.
547 m2(1), p. 112.
(*DPB*)

illustrators. The outcome of this harmonious relationship was *Frumentorum,
leguminum, palustrium et aquatilium herbarum ... historia* (1566). Pieter van der
Borcht of Malines, who had probably been introduced to Plantin by Dodoens, at
that time a doctor in Malines, executed the sixty plant drawings. Until his death in
1608, he remained one of Plantin's most valued artists. Over 2,000 of his botanical
drawings were housed in the Preussische Staatsbibliothek in Berlin, many being
the originals of Plantin's woodblocks. In Wilfrid Blunt's estimation they form
'the most important corpus of sixteenth century flower paintings in existence'.[2]
His skill as a painter impressed Clusius who wrote to a friend in 1567: 'J'ai trouvé
un peintre dont je suis content. Plasse à Dieu que le graveur soit aussi exact'.[3]

Many woodcuts in sixteenth-century herbals are coloured, and Agnes Arber
has proved convincingly that this was not necessarily the work of their owners.[4] It
has been conjectured that Hans Weiditz's watercolours were also used as a pattern
by the publisher for coloured copies of Brunfels's *Herbarum vivae eicones*. The
Plantin archives record the names of three women whom the painter employed to
colour copies of the botanical works he printed. The austere lines of the figures in
Fuchs's *De historia stirpium* invite colouring. Dr Arber noticed a close similarity in
the tinting of two coloured copies of this book, suggesting they had been
coloured by the publisher. Hand-colouring became routine with copper
engravings in the seventeenth century.

2. W. Blunt *The art of botanical illustration* 3rd edition, 1955, p 65.
3. E. Roze *Charles de l'Escluse* 1899, p 52.
4. A. Arber *Nature* vol 145, 1940, pp 803–04.

6. The seventeenth century

WHEN LORD HERBERT of Cherbury wrote that he believed 'it is a fine study and worthy a gentleman to be good botanic, that he may know the nature of all herbs and plants',[1] he was not propounding an original or radical thought. By the 1640s, when he penned that comment, natural history was well on the way to becoming an acceptable pastime for the young college graduate, the inquisitive physician, the country squire and the village parson. Thomas Johnson, Gerard's admirable editor, and his friends, indulged in field excursions – the first to neighbouring Kent in July 1629 – and published slender lists of the plants they discovered, the first British local floras. It is hoped they did not follow Lord Cherbury's advice and tear from 'some good herbal all the icones together with the descriptions of them' to facilitate the identification of the plants they saw on their excursions. Plants were now being studied for themselves as well as for their healing properties.

A preference for experimental research rather than a docile acceptance of the authority of the classics led to the founding in 1601 of one of the first scientific academies in Europe – the Accademia dei Lincei in Rome. France had its Académie des Sciences in 1666. The Royal Society for Improving Natural Knowledge, formed in London in 1660, was granted a royal charter of incorporation by Charles II two years later. Its Fellows, at home and abroad, became the pioneers of scientific investigation, and its *Philosophical transactions* the means of publishing their discoveries. The microscope, replacing the primitive magnifying glass, revolutionised biological research. Just as Copernicus and Galileo were revealing the mysteries of the heavens with their telescope, so the miniscule world of bacteria and protozoa was being disclosed by the microscope. Robert Hooke (1635–1703) was appointed Curator of the Royal Society in 1662 and one of its Secretaries fifteen years later. His scientific reputation and dedication helped to transform it from a group of dilettanti into a professional body commanding world-wide respect. The plates in his *Micrographia* (1665), engraved with impressive dexterity, delineate such minutiae as the sting of a nettle and the compound eye of a fly.

Between 1673 and 1723 the *Philosophical transactions* printed nearly 200 letters from Antony van Leeuwenhoek (1632–1723), a self-taught Dutch microscopist, who found a teeming world of creatures in a drop of water. Two papers reporting microscopic investigations were submitted to the Royal Society in 1672. One, entitled *The anatomy of vegetables begun*, was contributed by the physician Nehemiah Grew (1641–1712). This paper combined with other research was revised in his book *The anatomy of plants* (1682), with many fine illustrations. The other paper was entitled *Anatome plantarum* and its author was Marcello Malpighi

1. Lord Herbert of Cherbury *Autobiography*. Edited by W. H. Dicks, 1888, p 36.

(1628–94), a professor of anatomy at Bologna. Grew, Malpighi and Hooke, using comparatively simple lenses, examined the structure of animals and plants and established the new discipline of microscopic anatomy. The most able anatomist of the century was Jan Swammerdam (1637–80), who dissected insects and minute organisms with the steadiest of hands manipulating the sharpest of instruments. After his death, his papers were bought by a fellow Dutchman, Hermann Boerhaave, who published them in 1737 in two magnificent volumes under a most apt title, *Biblia naturae* (The Bible of Nature). The copper plates are a tribute to the skill of the engraver who succeeded so well in reproducing the delicacy of the fine lines of Swammerdam's dissections.

Otto von Brunfels listed fewer than 260 species of plants in *Herbarum vivae eicones* (1530); just under a hundred years later Gaspard Bauhin's *Pinax theatri botanici* (1623) described about 6,000. This spectacular increase in the number of plants – and also of animals – for examination encouraged the formulation of new schemes for their systematic arrangement. Foremost among English botanists in this search for order in Nature was Robert Morison, Professor of Botany at Oxford, and John Ray, who, for much of his life, was vicar at the little village of Black Notley in Essex. Both were influenced by Andrea Cesalpino's *De plantis* (1583), which postulated the grouping of plants by certain characters of the reproductive organs.

Ray and his pupil and companion, Francis Willughby, resolved to write a comprehensive account of natural history, Willughby undertaking animals, birds, fishes and insects, and Ray, the plants. To this end, they travelled together through Britain and Europe collecting data. While they were in Strasburg, Willughby purchased Leonhardt Baldner's album of drawings of waterfowl, fishes, and insects, now in the British Library (PLATE 11). They were the first British naturalists to disregard medieval superstition and legend. 'We have wholly omitted what we find in other authors concerning ... hieroglyphics, emblems, morals, fables, presages or aught else appertaining to divinity, ethics, grammar or any sort of human learning; and present ... only what properly relates to natural history'.[2] The partnership was sundered by Willughby's death at the early age of thirty-six, and Ray, with characteristic resolution, sorted and expanded Willughby's notes for publication in *Ornithologiae* and *Historia piscium* (PLATE 12). The latter work exemplifies Ray's independence of thought; he was never prepared to accept absolutely the opinions of others, not even the notable researches on fishes by Gesner and Rondelet. He devised a classification based on natural features and clarified the concept of genus and species.

'It is a world also to see how manie strange hearbs, plants and annuall fruits, are dailie brought unto us from the Indies, Americans, Trabrobane [Ceylon], Canarie iles, and all parts of the world. . . . There is not almost one noble man, gentleman, or merchant, that hath not great store of these floures'.[3] Thus wrote William Harrison during Queen Elizabeth's reign. The New World was the main source of this botanical migration, a substantial trickle in the sixteenth century, a deluge

2. F. Willughby *Ornithologiae*. Edited by J Ray, 1678, preface.
3. F. J. Furnivall (*editor*) *Harrison's description of England in Shakespeare's youth*, Part 1, second book, 1877, pp 325–26.

22 *Designs of plants done with a pen by Mr John James, a surgeon about 1680 in Barbary with the Morisco & English names & descriptions, given to Mr Petiver by Mr John Thorpe an Apothecary in Wapping. Some of them Mr Petiver engraved in his Gazophyl [acii naturae et artis. London, 1702–09].* Sloane MS 4009, folio 21. *(Dept of MSS)*
James, who said his figures were 'drawne in this booke, as fully as I could observe of them', was enslaved in Barbary for nearly twenty years.

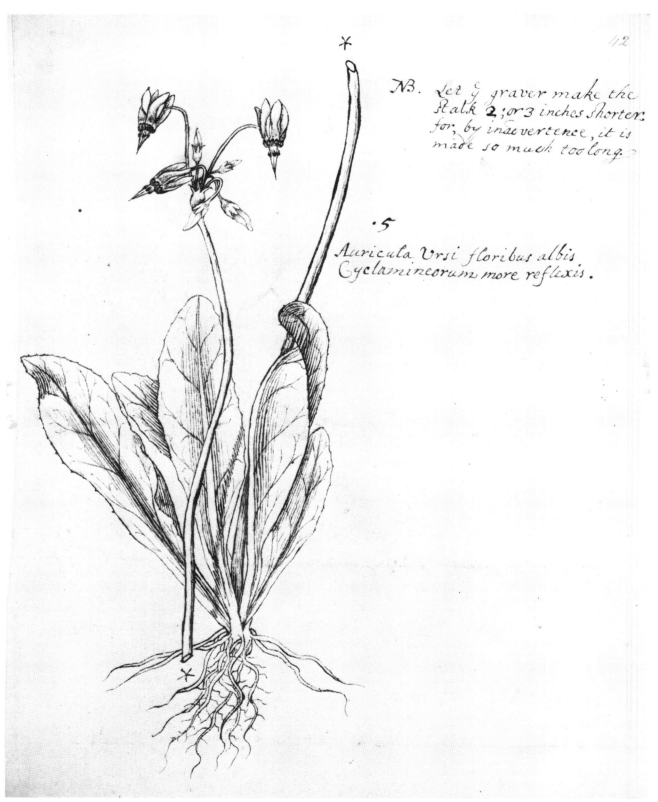

42

NB. Let y graver make the Stalk 2, or 3 inches shorter. for, by inadvertence, it is made so much too long.

·5

Auricula Ursi floribus albis Cyclamineorum more reflexis.

23 American Cowslip (*Dodecatheon meadia*). *Papers and draughts of the Reverend Mr Banister in Virginia sent to Dr Henry Compton Bishop of London and Dr Lister (?) from Mr Petiver's collection. c.*1679. Sloane MS 4002, folio 42. (*Dept of MSS*)
Bishop Compton, who received the American Cowslip from Banister in 1704, successfully grew it in his garden at Fulham Palace.

thereafter. Thomas Harriot, one of Raleigh's early colonists, brought back plants; John Tradescant junior made three productive excursions to Virginia; John Watts collected for the newly-formed Chelsea Physic Garden; and was it with self-interest that Henry Compton, Bishop of London and keen gardener, sent John Banister, a competent botanist, as a missionary to Virginia? His candidate has been called America's 'first resident naturalist'. For fourteen years Banister sent plants and his drawings of them to his fortunate recipients in England – Bishop Compton, whose garden soon had one of the finest collections of North American plants, John Ray and members of the Temple Coffee House Botanic Club (the first natural history society in Britain, founded about 1689). He was accidentally shot in 1692, thereby achieving immortality as an early martyr in the cause of botany (figure 23).

The flora of America, the Middle East, the Cape, India and South East Asia found its way to the newly formed botanic or physic gardens (Oxford (1621), Edinburgh (1670), Chelsea (1673)) and also to private gardens. English gardens of the early Stuart period were enclosed, divided into compartments by hedges of privet or quick-set; flowers were used as infillings in complicated knots fashioned from clipped shrubs. The grander gardens had mounts, mazes and fanciful topiary. But flowers were soon to dictate horticultural taste. A new class of gardener, the 'florist', arrived to breed improved varieties of anemone, auricula, carnation, hyacinth, polyanthus, ranunculus and tulip, according to stringent standards of excellence (figure 24). William Lawson's *A new orchard and garden* (1618), included his 'The countrie housewife's garden', the first book written specifically for women gardeners. With John Parkinson's *Paradisi in sole Paradisus terrestris* (1629), horticultural literature starts in earnest. His aim was to select from available garden plants 'the chiefest for choyce, and fairest for shew', to create 'a garden of delight and pleasure'. He grew many of the 780 plants he described in his own garden in Long Acre: lilies, tulips, narcissi, hyacinths, irises, carnations, campanulas, a great number of composites and flowering shrubs. Over a hundred pages of the book are given over to rather mediocre woodcuts. John Rea, a nurseryman of Kinlet in Shropshire, had no great opinion of them. The preface to his own book explain the absence of illustrations: 'As for the cutting the figures of every plant, especially in wood, as Mr Parkinson hath done, I hold to be altogether needless; such artless things, being good for nothing unless to raise the price of the book, serving neither for ornament or information'.[4]

Nurserymen and seedsmen multiplied as the demand for garden plants grew, and some, like Emanuel Sweert, who issued an illustrated catalogue in 1612, evidently prospered. Sweert, a Dutch florist, had at one time been Praefectus of Rudolph II's gardens (it is amazing how many naturalists and horticulturalists had connections with this German Emperor). His catalogue, as its title suggests – *Florilegium amplissimum et selectissimum* – was essentially a florilegium, a picture book mainly of bulbous and liliaceous plants. The engravings are poorly executed but superior work could not reasonably be expected in a sale catalogue; many of the figures were copied from other books. Nevertheless, its appeal as a florilegium resulted in several reprints, the last in 1655.

4. J. Rea *Flora: seu, de florum cultura ... or a complete florilege, furnished with all the requisites belonging to a florist* 1665.

124 Of the Historie of Plants. L I B. I.

‡ 5 *Narcissus medio-purpureus flore pleno.*
Double floured purple circled Daffodill.

6 *Narcissus minor serotinus.*
The late flouring small Daffodill.

7 *Narcissus medioluteus.*
Primrose Pearles, or the common white Daffodill.

8 *Narcissus medioluteus polyanthos.*
French Daffodill.

9 *Nar.*

24. *(Left)* Narcissi. Woodcuts. John Gerard *The herball or generall historie of plantes . . . very much enlarged and amended by Thomas Johnson*, London, 1633. W 4712, p. 124. *(IOLR)*

25. *(Right)* Crown Imperial *(Fritillaria imperialis). Anonymous drawings of plants grown in English gardens. c.*1684. Add. MS 5282, folio 161. *(Dept of MSS)*

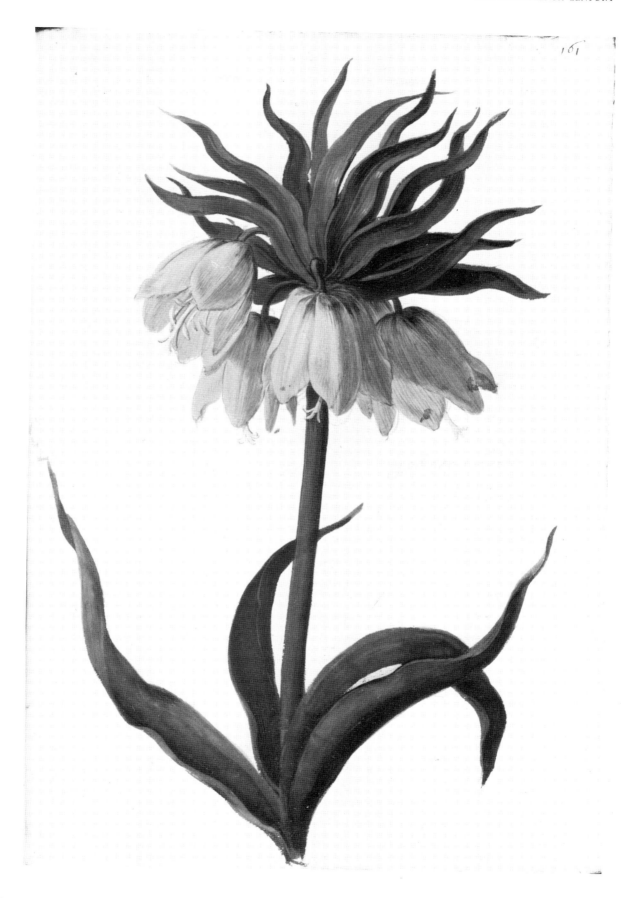

From about the middle of the sixteenth century new metal engraving processes were challenging the dominance of woodcuts, particularly in books depicting architecture, fashions, emblems, maps and town plans. The publisher of Salviani's *Aquatilium animalium historia* (1554–58) chose copper plate engraving as the medium for reproducing its drawings of fish. Pietro di Nobili's *Herbal* (c.1580) was one of the earliest botanical works to adopt the new process. Just a few years later, when Clusius was seeking a woodcutter to provide illustrations for his *Rariorum plantarum historia* (1601), there was only one left in business in the whole of Frankfurt. Plantin, who had made his reputation with woodblocks, became one of the first metal engravers in the Low Countries. The woodcut yielded to the greater flexibility of the engraved or etched line.

In both engraving and etching highly-polished sheets of copper are used for the design. In engraving, the craftsman cuts the design with a burin which allows him to vary the depth and width of the line. When a plate is etched, the copper plate is coated with an acid-resistant ground of wax and asphaltum. The design is drawn through the ground with a blunt needle revealing the copper plate beneath. Repeated immersion in a bath of acid and applications of varnish control the depth of the etched line, which can vary from a gossamer-like thinness to broad strokes. Both processes are often used on the same plate.

Hans Sibmacher tested the capabilities of copper-engraving with the small rondels he executed for Joachim Camerarius's *Symbolorum et emblematum ex re herbaria desumptorum centuria* (1590). The modest but botanically accurate illustrations in Fabio Colonna's *Phytobasanos* (Naples 1592) and the bolder portraits in Pierre Vallet's *Le jardin du très Chrestien Henry IV* (Paris 1608) are etched, with some assistance from the burin in the latter work.

In Frankfurt, Theodor de Bry, his son Johann and his nephew Johann Israel found time during the production of their successful travel book series, *Collectiones peregrinationem* (1590–1634), to publish *Florilegium novum* (1611) in which eighty-seven plates are engraved with great verve. The last revision of this book, *Florilegium renovatum et auctum*, was published in 1641 by de Bry's son-in-law, Matthäus Merian, the father of Maria Sybilla Merian who painted such ravishing pictures of insects.

The word 'florilegium' describes a category of books where the plates matter more than the text. The earliest florilegia were albums of paintings which their owners had specially commissioned as a record of rare and favourite flowers in their gardens. The advent of copper-engraving with its more sympathetic interpretation of line made it possible for such florilegia to be appreciated by a bigger audience. Adrian Collaert's *Florilegium* (c.1590) and Vallet's *Le jardin du très Chrestien Henry IV* pioneered this new class of flower illustration; the *Hortus Eystettensis* (1613) was its apotheosis. Nothing that followed could ever quite approach the grandeur of its conception or the extravagance of its production. Johann Konrad von Gemmingen, Prince-Bishop of Eichstatt, 1595–1612, spent a small fortune on it but died a year before the two massive folios were published. The task fell to Basil Besler, an apothecary of Nuremberg and Director of the Bishop's garden. Over a period of sixteen years, boxes of plants were despatched to Besler for copying. Besler also supervised the work of the engravers, of whom

there were at least six. More than 1,000 plants from the Bishop's garden were portrayed on 374 copper plates divided into the four seasons of the year. The choreographic control of the sweeping, swirling rhythms of the entire plant – root, stem, leaves and flowers – give a vitality and brilliance to floral art never encountered before. The work, evidently planned to impress, did not fail in this objective (figure 26).

Nothing could be less like the *Hortus Eysettensis* than the small oblong *Hortus Floridus*. Crispin de Passe, a member of a family of Dutch engravers, who engraved the copper plates, referred to it affectionately as his 'first fruites'. It was published with a Latin text in Utrecht in 1614. It illustrates through the seasons the flowers cultivated in Holland; naturally, bulbous plants predominate. Some of the flowers are shown from a worm's eye view with a snail or beetle diligently exploring the ground and with perhaps a solitary insect poised above the flower or bud. Within a year, French and English versions brought the quiet charm of these plates to a wider audience. In the English edition the reader is told how to paint the plates 'even to the liffe' in the 'most exquisite manner and methode'. Jean Franeau appropriated some of Crispin de Passe's drawings for his *Le jardin d'hyver* (1616). Its title 'The winter garden' hints that its illustrations of summer flowers were intended to be enjoyed during the long winter months.

Theatrum florae, published anonymously in 1622, was much later discovered to be the work of Jean Rabel, a painter of portraits, landscapes and designs for the ballet. The engravings do little credit to his original watercolours populated with fragile butterflies and jewelled insects. Some of Rabel's paintings were early contributions to the *Collection des velins*, or paintings on vellum, now occupying more than 100 albums in the Muséum National d'Histoire Naturelle in Paris.

Gaston d'Orléans, younger brother of Louis XIII, created a botanic garden and menagerie at Blois and about 1646 engaged the artist Nicolas Robert to paint on vellum some of his plants and animals. Amongst Robert's earlier commissions had been a set of superb flower studies for the *Guirlande de Julie*, perhaps the finest of all florilegia, for Baron de Sainte-Maure's fiancée. On Gaston's death in 1660, his collection of vellums was bequeathed to his nephew, Louis XIV, and four years later Robert was appointed 'peintre ordinaire de Son Majesté pour la miniature'. One of his duties was to paint twenty-four watercolours on vellum a year; when he died in 1685 he had added 727 paintings (475 were of flowers, the rest of birds–flowers and birds were to remain the most popular subjects until the eighteenth century, when animals were more frequently featured). When the Académie Royale des Sciences embarked on a complete history of the plant kingdom, they selected Robert and the engraver, Abraham Bosse, to produce the plates. Bosse died in 1676 and Robert carried on alone until he was joined by Louis de Châtillon; by 1692, 319 life-size engravings had been made and were published without any text in 1701. It was not until 1788 that a text was written to join the plates in the three volumes of *Recueil des plantes*. The eminent Dutch flower painter, Gerard van Spaendonck, judged it the most beautiful flower book ever published.

Jean Joubert who succeeded Nicolas Robert as royal miniature painter made his mandatory contributions to the collection of vellums. His talented assistant,

Claude Aubriet (1665–1742), so impressed the Professor of Botany at the Jardin du Roi, Joseph Pitton de Tournefort, that he was engaged to do the floral dissections in Tournefort's *Elémens de botanique* (1694). This book, a milestone in plant taxonomy, owed its success partly to a perfect partnership between author and illustrator. Tournefort took Aubriet with him on a botanical exploration in the Near East because 'without this help of Drawing, 'tis impossible any account thereof should be perfectly intelligible'. Shortly after his return to France in 1702, after two years travelling with Tournefort in the Levant, Aubriet succeeded Joubert as 'peintre en miniature'. In this well-earned appointment he worked industriously, always observing his annual quota of vellums, but concentrating on his new love, Lepidoptera, for a work that unfortunately was never completed.

The Jardin du Roi where Aubriet and Tournefort did so much of their work became an important centre for scientific research in France. Proposed in 1626, the Jardin Royale des Plantes Médicinales was established in the Faubourg Saint-Victor in Paris in 1635. The original physic garden graduated to a botanic garden, to which was added a zoo. Many distinguished scientists studied its collections of plants and animals: the botanists Tournefort, de Jussieu and Vaillant; the zoologists Buffon and Lamarck; the palaeontologists Brongniart and Cuvier. Its contribution to art is the incomparable *Collection des vélins*, a repository of the exquisite paintings of Robert, Joubert, Aubriet, Bassepart, van Spaendonck, Redouté and others. The progress made in natural history, particularly during the seventeenth and eighteenth centuries, owes a great deal to this one institution in Paris.

Zoological research lagged behind botany for much of the seventeenth century. The mythological creatures of the bestiaries – the lamia, unicorn, mantichore and hydra – were accorded serious treatment by Edward Topsell in *The historie of foure-footed beasts* (1607). But then Topsell (1572–1675), a curate, was not a naturalist or even a casual observer of Nature; he relied entirely on literary sources. He translated and freely adapted the first two volumes of Gesner's *Historia animalium*; his dissertation on the diseases of horses could not have been written without the assistance of the books on horsemanship by Thomas Blundeville and Gervase Markham. His woodcuts are reasonably faithful but cruder copies of Gesner's illustrations. His next book, *The historie of serpents* (1608) is also indebted to Gesner. A second edition of his *Foure-footed beasts* (1658) included a translation of Thomas Mouffet's *Theatrum insectorum* (see page 62).

The copper engravings of statuesque animals in Johann Jonston's *Historia naturalis de quadrupedibus* (1650–53) suggest an uncertain knowledge of their anatomy. Far more reliable are the engravings in Claude Perrault's *Mémoires pour servir a l'histoire des animaux* (1671–76) which was paid the dubious compliment of being frequently plagiarised by other publishers. The metal engravings (done on brass, according to John Ray) in Francis Willughby's *Ornithologiae* (1676), were at least original, probably copied from paintings acquired by Willughby on his European travels. Like so many animal engravings of this period they lack animation, but they are more than adequate for identification purposes. Some of the plates in Ray's elegantly produced *Historia piscium* (1686), were drawn from dried specimens in the Museum of the Royal Society; fresh specimens of the

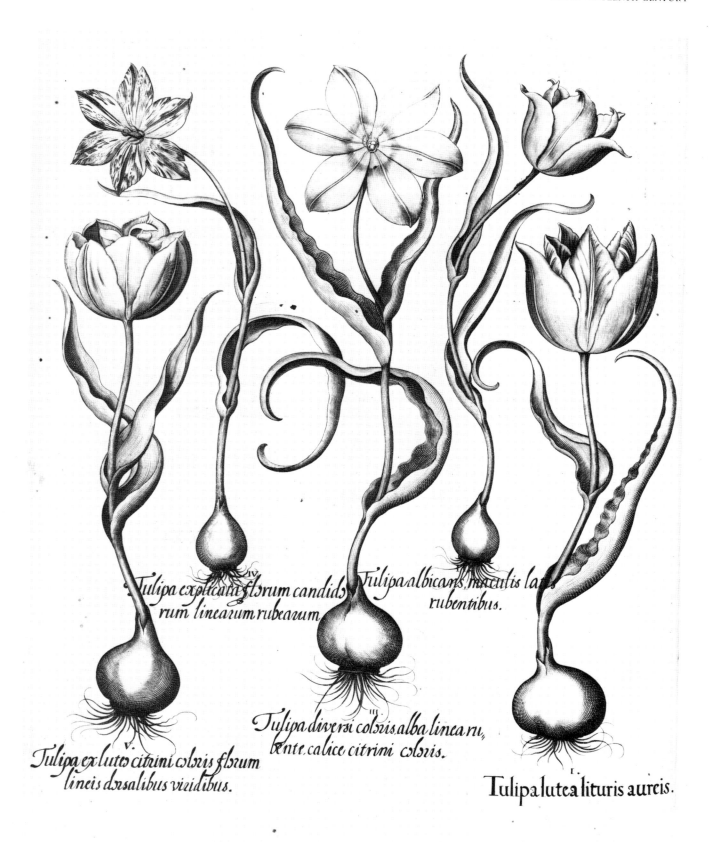

Tulipa explicata florum candidorum linearum rubearum.

Tulipa albicans, maculis latis rubentibus.

Tulipa ex luteo citrini coloris florum lineis dorsalibus viridibus.

Tulipa diversi coloris alba linea rubente, calice citrini coloris.

Tulipa lutea lituris aureis.

26 Tulips (line engraving). B. Besler *Hortus Eystettensis*, Nuremberg, 1613. Vol. 1, Quarto ordo, folio 4. 460.h.19. (*DPB*)

commoner species such as dab, flounder, halibut and plaice were obtained from London fishmongers; other figures were copied from those in Salviani's *Aquatilium animalium historiae* (1554).

The earliest published figures of insects are the coarse woodcuts of ants, gnats, fleas, lice, caterpillars, etc in the *Ortis sanitatis* (1491). For acutely observed and sensitively drawn insects in fifteenth-century art one has to search the illuminated borders of devotional manuscripts or, in the sixteenth century, a specially commissioned work like the *Four elements*, which Hoefnagel painted for Rudolph II. Hoefnagel's influence is apparent in the small studies of insects and flowers by the Flemish artist, Jan van Kessel (1626–79). Numerous competent woodcuts elucidate the text of Aldrovandi's *De animalibus insectis libris VII* (1602). The incidental insects in seventeenth-century Dutch flower compositions are superior to much that can be found in contemporary books.

The Reverend Thomas Penny (*c.*1530–1588), 'a second Dioscorides for his singular knowledge of plants',[5] devoted the last fifteen years of his life to studying insects. He had the good fortune to acquire the unpublished entomological researches of Conrad Gesner and Edward Wotton. To these papers he added data and drawings from contemporary naturalists such as Clusius, Bauhin and Camerarius. A particular scoop was the acquisition of copies of drawings by John White of North American insects (figure 27). On his death all these records together with his own notes passed to his friend Thomas Mouffet (1553–1604). Within a year of Penny's death Mouffet, with commendable efficiency, had sorted and arranged them for publication. Why the book did not appear is a matter for speculation. Perhaps Mouffet was distracted by the demands of a very successful medical practice or deterred by the appearance of Aldrovandi's *De animalibus insectis*. After his death, the manuscript was purchased by Sir Theodore de Mayerne, who finally got it printed in 1634. *Insectorum sive minorum animalium theatrum* has about 500 woodcuts, not all well drawn, and of little use for identification. They were redrawn when the book was translated into English by John Rowland and bound with Topsell's *History of foure-footed beasts* (1658). Many species of butterflies, which got the biggest share of the illustrations, can be recognised. Though one can appreciate the reason for C. E. Raven's conviction that 'Penny's work, despite the sad accident of its delayed publication, is the true foundation of entomology',[6] it was, nevertheless, Jan Swammerdam with his incredibly skilful dissections of insects who is the first scientific entomologist.

Francis Barlow (1626–1704) is now remembered as an etcher and engraver rather than as 'a well-wisher to the art of Painting' as he himself preferred to be thought. In his diary for 19 January 1656, John Evelyn records a visit to 'Barlow, the famous painter of Fowls, beasts and birds'. His ability to integrate his animal studies in an appropriate landscape setting distinguishes *Barlow's birds and beasts in sixty-seven excellent and useful prints* (1655). He was the progenitor of a distinct school of professional artists who specialised in sporting paintings and prints.

This enjoyment of the open air and the familiar countryside was celebrated in Dutch landscapes. Adriaen van de Velde (1636–72) and Aelbert Cuyp (1620–91)

5. J. Gerard *Herball* 1597, p 564.
6. C. E. Raven *English naturalists from Neckam to Ray* 1947, p 191.

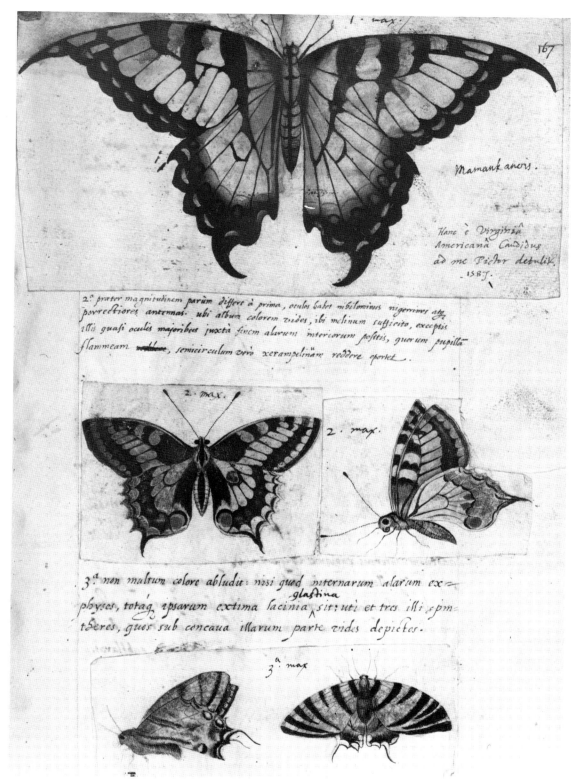

27 Top: Swallowtail Butterfly *(Papilio glaucus)*. Centre: *Papilio machaon.* Bottom: *Eurytides*? Thomas Penny and Thomas Mouffet *Insectorum sive minimorum animalium theatrum.* Late 16th century. Sloane MS 4014. *(Dept of MSS)* Copies of drawings by John White stuck in the manuscript. Thomas Penny noted against the Swallowtail Butterfly: 'the painter White [Candidus] brought this back to me from American Virginia 1587'. These and other White drawings of insects were included in the book when it was published in 1658.

painted contemplative cattle with an insight and compassion that has seldom been excelled. The *Young bull* painted by Paulus Potter (1625–54) when he was only twenty-two is still a favourite with visitors to The Hague, astonished by his dexterity in rendering the shaggy head of the bull and the wiry wool of the goats. Canvases of domestic and wild fowl earned Melchior Hondecoeter (1636–95) the epithet 'Raphael of the birds'.

Roelandt Savery (1576–1639), a Flemish artist who worked in Holland, also indulged in fashionable landscape, but found a niche in flower and animal painting. His flowerpieces are usually inhabited by a community of insects, with the occasional frog or lizard for company. Another Flemish artist, Frans Snyders (1579–1657), also produced the remunerative flowerpiece but animals and scenes of the hunt were his *métier*. He had an admirable reciprocal arrangement with Rubens; he added flowers and animals to Rubens's pictures and Rubens supplied the figures in his canvases.

Flower painting, which had become a distinct genre during the seventeenth century, was a lucrative living in Flanders and Holland and the fashion spread to Italy and Spain where Mario Nuzzi (1603–73) and Juan de Arellano (1614–76) were its leading practitioners. Gradually flowers emancipated themselves from their symbolic role in religious paintings to become the sole object of a canvas. Flemish and Dutch artists made flower compositions their speciality and dynasties of flower painters emerged. There was, for instance, that remarkable family, the Brueghels, who painted with such prodigious energy: Jan Brueghel the Elder (1568–1625) and his son Ambrosius Brueghel (1617–75); Abraham (1631–97), the son of Jan Brueghel the Younger; and Jan van Kessel (1626–79), the grandson of Jan Brueghel the Elder. All the three sons of Ambrosius Bosschaert the Elder (1573–1621) inherited their father's floral talent: Ambrosius Bosschaert the Younger (1609–45), Abraham Bosschaert (*c.*1613–43) and Johannes Bosschaert (1610–*c.*1640).

By reference to individual flower studies and sketches that they had already made, these artists composed marvellous bouquets of flowers of all seasons in a baroque exuberance of shape and colour. The artificiality of such compositions is, however, obvious: the blooms are perfect, the symmetry is contrived, the formula well-tested – terracotta pots or glass vases, fallen petals on a marble table top, hovering or crawling insects, a clutch of speckled bird eggs, a sea shell or a solitary snail, glistening beads of water. When Samuel Pepys admired a flowerpiece by Simon Verelst (1644–*c.*1721) in 1669 he confided to his diary his astonishment: 'the drops of dew hanging on the leaves so I was forced again and again to put my finger to it to feel whether my eyes were deceived or no'. The décor of a room in the Age of Elegance was not complete without a flowerpiece by Jan van Huysum (1682–1749), the 'Phoenix of flower painters'. Rachel Ruysch (1664–1750) indulged in an asymmetrical arrangement: vases off-centre, stems twisting sinuously or sweeping diagonally across the canvas, and leaves folding and drooping in rhythmic patterns. Women artists all over Europe were establishing reputations for themselves and flower portraiture became their speciality: Holland had Rachel Ruysch, England Mary Moser, France Louise Moillon, and Italy Margharita Caffi.

7. The golden age

ANIMALS AND PLANTS were being newly discovered at such a rate that the main thrust of biological research in the eighteenth century was directed towards their identification, description, naming and illustration. It was the Swedish naturalist Carl Linnaeus (1707–78) who had the intellect, energy and dedication to dare attempt the daunting task of reducing chaos to order. His amazing facility for absorbing facts and assessing their relevance enabled him to construct a classification of plants based upon the number and disposition of their sexual organs, that is, stamens and pistils. This artificial grouping offered a comparatively easy method for their identification. He also adopted brief and convenient bionomials (genus followed by the name of species) in place of long and often inconsistent descriptive phrases which no-one could possibly remember. Thus *Narcissus foliis ensiformibus, floris nectario rotato brevissimo* became the delightfully terse *Narcissus poeticus*. His *Species plantarum* (1753) and *Genera plantarum* (5th edition 1754) constitute the basis for modern botanical nomenclature and his *Systema naturae* (10th edition 1758) performs the same service for the naming of animals. He boasted, with little modesty but justifiable pride, 'Deus creavit, Linnaeus disposuit' (God created, Linnaeus arranged).

The influence of Linnaeus is incalculable. His pupils spread his teaching throughout Europe, and they died in Surinam, Venezuela, Guinea, and Arabia collecting specimens at the behest of their master. Linnaeus's *Fundamenta botanica* and *Philosophia botanica* were essential reading for Goethe, patiently seeking the underlying unity which he believed existed in the plant kingdom. He acknowledged his debt to Linnaeus in a letter to Zelter in 1816: 'With the exception of Shakespeare and Spinoza I know no other of the dead masters who has made such an impression on me'. Linnaeus transformed the scientific and popular study of natural history. Enthusiasts formed societies, national and local. In the British Isles, for instance, the 1770s and 1780s saw the formation of the Society for the Investigation of Natural History in Edinburgh, the Society for Promoting Natural History in London, and local groups in provincial towns such as Eccles and Lichfield. The Linnean Society of London, now the privileged custodian of Linnaeus's library and botanical and zoological collections, held its first meeting in the Marlborough Coffee House on 26 February 1788.

There were also other factors that elevated the status of natural history and made botany in particular, as one writer put it, 'a fashion and a recipe for physical and moral health'. One potent influence was the romantic movement which swept Europe. Jean-Jacques Rousseau, a seminal figure in this movement, and himself an amateur botanist, urged the study of botany as a means of communicating with the essential spirit of Nature. Enlightened patronage, to which many illustrated works of natural history owed their existence, played its

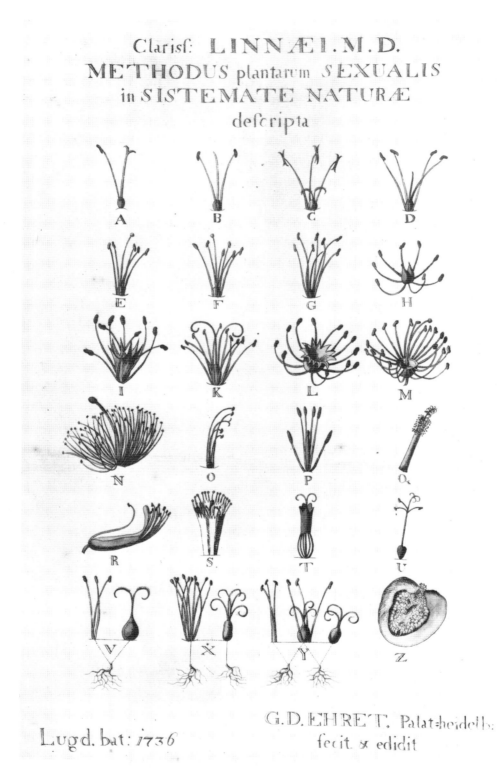

Clarisf: LINNÆI. M.D.
METHODUS plantarum SEXUALIS
in SISTEMATE NATURÆ
defcripta

Lugd. bat: 1736

G.D. EHRET. Palat=heidelb:
fecit & edidit

28 G. D. Ehret. Broadsheet illustrating Linnaeus's sexual system of plant classification. 1736. C.161.d.5,1. (*DPB*)
This hand-coloured line engraving figures the twenty-three classes of flowering plants, based upon the number, relative length etc., of stamens; the 24th class was allocated to *Cryptogamia* or non-flowering plants. Only two copies of this broadsheet have ever been traced; the one reproduced here is bound in Sir Hans Sloane's copy of Linnaeus's *Systema naturae*, 1735.

part. Sir Hans Sloane and Sir Joseph Banks in England, the Empress Josephine in France and the Emperor Francis I in Austria were all distinguished patrons.

With an eye on the economic utilisation of natural resources, the British and Dutch East India Companies encouraged their officers to study the fauna and flora of their Asian domains, thus making possible such lavishly illustrated works as William Roxburgh's *Plants of the coast of Coromandel* (1795–1820). Such books were a response to a demand from a sophisticated public for large extravagantly-produced books which artists and engravers were willing and able to satisfy, thereby ushering in the golden age of botanical and zoological art.

Thomas Robins the Elder (1716–70) who painted gardens in England's West Country and elsewhere, framing his pictures in rococo garlands of flowers, birds, insects and shells, and his son, Thomas Robins the Younger, who advertised in 1787 'pictures of exotic plants and insects', were typical of the artistic talent available to rich clients. Sometimes the talent was dormant. When the Dutch flower painter Everhardus Kychius was engaged in 1703–05 by Mary, Duchess of Beaufort to paint plants in her garden at Badminton, it was discovered that her under-footman, Daniel Frankcom, possessed some skill in drawing. So the Duchess had Kychius teach him the rudiments of painting; shortly afterwards Frankcom 'made shift to paint som aloes' and when a copy of Maria Merian's *Metamorphosis insectorum Surinamensium* came into his hands he improved his talent by industriously copying her plates.

Garden owners were always looking out for artists to make pictorial records of choice or rare blooms. Johann Jacob Dillenius (1684–1747) was persuaded to leave Germany in 1721 by William Sherard to work on a revision and continuation of Gaspard Bauhin's *Pinax* (1623). William's brother, the apothecary, James Sherard (1666–1738), induced Dillenius in 1725 to take on the responsibility of describing the plants in his garden at Eltham in Kent, his previous gardener, Thomas Knowlton, having 'left in a huff'. The result of seven years' labour was disclosed to the world in 1732 with the publication of the *Hortus Elthamensis*, figuring 417 plants engraved with impeccable accuracy on 324 plates (figure 29). In his preface, Dillenius explained that 'the figures, except where otherwise indicated, are all drawn from life and to the natural size. Let those who know the plants, and are not ignorant of pictorial art, be their judge; for my own part I am satisfied that I have taken every care to make them accurate, and when I was certain that they were correctly drawn, I was prepared to undertake the work of engraving, however tedious, so that they might be accurately printed'. Not only did he engrave his own drawings, but he also hand-coloured some of the copies.

John Fothergill (1712–80) had an unrivalled garden of rare and exotic plants in thirty acres at Upton in Essex where he employed a team of artists including Georg Ehret, Simon Taylor and Ann Lee. On his death the bulk of his botanical drawings (more than 1,000) were bought by the Empress Catherine II of Russia.

No book on the plants of any garden ever had such distinguished collaborators as the *Hortus Cliffortianus* (1738). George Clifford was an Anglo-Dutch financier, a Director of the Dutch East India Company, with a garden and menagerie near Haarlem. Linnaeus, attracted by the reputation of his garden, paid Clifford a visit and was subsequently handsomely recompensed for writing an account of the

plants there. While Linnaeus was thus occupied, the young Georg Ehret, destined to be one of Europe's most eminent botanical artists, showed Clifford some of his drawings. Clifford, impressed, engaged him to illustrate some of the plants Linnaeus was describing. Such a partnership could hardly fail to produce a great work, especially when the engraver was Jan Wandelaar who had so competently interpreted Aubriet's drawings in Vaillant's *Botanicon Parisiense* (1727). A new departure in botanical illustration was the addition of floral dissections. The era of great flower books was imminent.

The importation of large quantities of ornamental plants and a rich clientele eager to buy them, ensured the prosperity of the nursery trade. At the beginning of the eighteenth century the partnership of George London and Henry Wise at Brompton Park in Kensington was about the only nursery of any consequence in London. Within a few decades they were joined by Christopher Gray at Fulham, Thomas Fairchild at Hoxton and Robert Furber at Kensington, and other firms were springing up elsewhere in the country. Some indication of their wealth and enterprise is afforded by the catalogues and gardening manuals they issued. Furber got the Flemish artist, Peter Casteels (1684–1749), already established in England as a painter of flowers and birds, to draw the plates for his *Twelve months of flowers* (1730–32), the first de luxe nurseryman's catalogue published in England. Each plate, illustrating a vase of flowers displayed in the traditional flowerpiece idiom, represented the plants in bloom for that particular month. The majority of the plates were engraved by Henry Fletcher and were hand-coloured. The success of this catalogue occasioned a further twelve plates depicting fruit, again from designs by Casteels. They were so popular that other publishers issued their own versions, often adding insects for good measure.

In the 1720s Furber and other London nurserymen formed the Society of Gardeners. At their monthly meetings 'each person of the Society brought all the several kinds of plants, flowers and fruit in their various seasons, which were there examined and compared by all the persons present'.[1] The lack of consistency in plant names was a constant irritant to them and their customers and a register of names and descriptions was an obvious remedy. After this register had been in existence for some years it was agreed to publish it in a series of volumes with coloured plates. Only the first part of the *Catalogus plantarum* (1730), a slim volume on trees and shrubs, was ever published. Jacob van Huysum (c.1687–1740), the son of Justus van Huysum the Elder, the father of a family of flower painters, did the drawings which were engraved by Henry Fletcher and Elisha Kirkall. The plates, not noted for any artistic merit, are of interest because they were printed in colour from a single plate. Jacob van Huysum and Kirkall were illustrating at the same time another botanical work, the *Historia plantarum rariorum* (1728–37), by the Professor of Botany at Cambridge, John Martyn.

Johann Teyler (1648–98/9) in Holland was the first to make colour prints from metal plates, with his engravings of flowers and birds. Teyler confined himself to engraving and etching whereas Kirkall in England also added mezzotinting to his plate. A mezzotint is made by roughening the surface of a copper plate with a tool

1. *Catalogus plantarum* 1730, p x.

P.39.　　　F.38.　　　T.XXXIV.

After Chenopodii folio, annuus, flore ingenti speciofo. Elop. China delatus

29 China Aster
(Callistephus chinensis).
Copper engraving.
Johann Jacob Dillenius.
Hortus Elthamensis,
London, 1732, plate 34,
X1083. *(IOLR)*

having a curved, serrated edge (the rocker). Gradations of tone are achieved by smoothing down the roughened surface with a burnisher. A rocker was used in Martyn's *Historia plantarum rariorum* to shade leaves, stems and flowers. Some of the plates were inked with a dabber in different colours and the print touched up by hand; most, however, were printed solely in green. Kirkall used brown and green in the seven plates he did for the *Catalogus plantarum*; the fourteen by Henry Fletcher were hand-coloured.

In Germany J. Weinmann, in his *Phytanthoza iconographia* (1737–45), also experimented with coloured printing from single impressions. Many of the 1,025 copper plates were engraved in line, but mezzotinting was also frequently applied. Normally the printed colours were restricted to no more than two, others being added by hand. Hand-colouring persisted until lithography offered an alternative method in the nineteenth century. Hand-colouring was sometimes done by the artist, usually for de luxe copies or as a result of financial considerations. It was not unusual for members of the artist's or engraver's family to help in this way. Women and girls were normally employed as cheap labour on this mechanical task. Salomon Schinz got children at an orphanage to colour the plates in his *Anleitung zu der Pfanzenkenntnis* (1774).

With copper plate engraving now so well established, woodcuts were almost an anachronism. William Salmon's *Botanologia; The English Herbal* (1710) with its indifferent woodcuts was one of the few botanical works to remain loyal to this now superseded process,[2] which, nevertheless, was to enjoy a revival in the nineteenth century.

Salmon's book was also among the last of a long line of herbals. The oddest member of this diminishing band was Mrs Blackwell's *Curious herbal, containing five hundred cuts of the most useful plants, which are used in the practice of physick*, a poignant memorial to marital devotion. She undertook this book, drawing the plants (mainly those in the Chelsea Physic Garden), engraving the plates and hand-colouring them herself, hoping by its sales to secure the release of her husband from a debtor's prison. From 1737 to 1739 it appeared in weekly parts, each with four plates, costing one shilling plain or two shillings coloured. It proved a successful venture and her husband gained his freedom.

David Garrick had John Hill in mind when he enclosed the following couplet in a letter to Dr John Hawkesworth:

For Physick or Farces, his equal there scarce is
His Farces are Physick, his Physick a Farce is.

Sir John Hill (1716?–75) – Gustavus III of Sweden conferred the Order of Vasa upon him, hence his knighthood was a courtesy title – was a man of many parts: doctor, journalist, playwright, botanist and gardener. His *British herbal* (1756–57), like Mrs Blackwell's *Curious herbal*, came out in weekly parts. A number of artists and engravers were involved in the preparation of the plates which possess neither artistic nor scientific merit. It was either this work or Hill's *Useful family herbal* (1754) that Erasmus Darwin had in mind when he reported 'I believe I forgot to

2. H. L. Duhamel du Monceau's *Traité des arbres et des arbustes* (1755) was illustrated with the woodcuts used by Mattioli a century earlier.

China Aster.

30. China Aster *(Callistephus chinensis).* E. or J. Brooke. *Pen and ink drawings with grey wash of English garden flowers with descriptive notes of the plants. c.1780.* Add. MS 41682, folio 38. *(Dept of MSS)*
Seeds of this Chinese plant were first sent to Paris in 1728. Single and double varieties became very popular – 'very few of our gardens are without it', observed Mr Brooke.

tell how Dr Hill makes his herbal. . . . He has got some wooden plates from some old herbal, and the man that cleans them cuts out one branch of every one of them, or adds one branch or leaf, to disguise them. This I have from my friend Mr G—y, watchmaker, to whom this printmaker told it, adding "I make plants now every day that God never dreamt of" '.[3]

No-one made such unkind remarks about the small accurate etchings in *Assistant plates to the materia medica* (1786), written by William Curtis. The artist and engraver are not known but the plates could have been the work of James Sowerby who was in Curtis's employ at that time.

William Curtis (1746–99) sold his London practice as an apothecary about 1770 to concentrate on natural history. According to R. J. Thornton, his first biographer, 'he conceived the sublime notion of giving a complete Natural History of the British Isles, with plates of each object, not upon a neat diminutive scale, but one that was equally just, magnificent and noble like our Empire – one truly worthy of the British Nation'.[4] To this end he had hundreds of drawings of birds and animals made. The first stage of this grandiose scheme was to be a comprehensive British flora of which the *Flora Londinensis* (1777–98), describing plants growing within ten miles of London, was the first instalment. Unfortunately it foundered through lack of support, but it ranks as one of the really great flower books of the age. The plates, portraying the plants life-size, were executed by a team of artists and several people were employed as colourists. The degree of accuracy achieved in these plates of British plants has seldom been surpassed. Far more successful financially was Curtis's *Botanical magazine*, launched in monthly parts in 1787. Its *raison d'être* was the description and illustration of the 'most ornamental foreign plants, drawn always from the living plant, and coloured as near to nature, as the imperfections of colouring will admit'.[5] The colouring consists of rather basic washes, which was all that could possibly be expected with sales exceeding 3,000 copies of each issue.

Curtis's success probably encouraged James Sowerby to publish an *English botany*, also in monthly parts, each with twelve plates, in 1790. The Suffolk botanist T. J. Woodward was confident that because 'The paper, print and execution of the plates is so much superior to Curtis' ',[6] there could be no doubts about its success. Sowerby also shared this conviction and in 1814 when he brought it to a conclusion he had drawn and engraved 2,592 plants.

The *Botanical magazine* and similar flower books were plundered for floral designs to paint on porcelain. Chelsea Red Anchor ware, for example, was decorated with what are sometimes called 'Sir Hans Sloane's Plants' borrowed freely from Philip Miller's *Figures of the most beautiful, useful and uncommon plants described in The Gardeners Dictionary* (1755–60). The 300 plants which are figured were selected from the Chelsea Physic Garden of which Philip Miller was Curator. Sir Hans Sloane was the garden's patron and benefactor, and this

3. B. Henrey *British botanical and horticultural literature before 1800* vol 2, 1975, p 94.

4. R. J. Thornton 'Life and writings of the Late Mr William Curtis' *In* W. Curtis *Lectures on botany* vol 3, 1805, p 16.

5. *Botanical magazine* vol 1, 1787, preface.

6. Linnean Society. Manuscript correspondence and miscellaneous papers of Sir James Edward Smith, vol 18, folio 98.

connection doubtless gave rise to the misleading phrase 'Sir Hans Sloane's Plants'. Some of the plates chosen by the Chelsea factory had been drawn by Georg Ehret. Evidently approving of his work, they also copied other drawings by him in C. J. Trew's *Plantae selectae*.

Georg Dionysius Ehret (1708–70), born in Heidelberg, the son of a market gardener, started his working life as a journeyman gardener. At the age of twenty he received his first artistic commission – drawing plants for the apothecary Johann Wilhelm Weinmann. His drawings, or adaptations of them, were later reproduced, unacknowledged, in Weinmann's *Phytanthoza iconographia* (1737–45). A few years later his work came to the attention of Christoph Jacob Trew (1695–1769), the leading physician in Nuremberg. At that time Nuremberg was the principal centre in Germany for natural history publishing and illustration. Trew was a pivotal figure amongst German naturalists. He employed artists; purchased drawings, including Besler's illustrations for the *Hortus Eystettensis*; published part of Conrad Gesner's botanical manuscripts and drawings; and sponsored a German edition of Elizabeth Blackwell's *Curious herbal*. Recognising Ehret's talent, he advised him to express in his drawings of flowers, not only their obvious beauty, but also their structure and form. Trew included some of Ehret's drawings in his *Plantae selectae* (1750–73) and *Hortus nitidissimus* (1750–72). Linnaeus, congratulating Trew on these books, wrote: 'The miracles of our century in the natural sciences are your work of Ehret's plants, Edwards' work of birds and Roesel's of insects, nothing equal was seen in the past and will be in the future'. Ehret settled in England in 1736, married Philip Miller's sister-in-law, taught flower painting to the wives and daughters of the gentry, and enjoyed the patronage of rich collectors. His election as a Fellow of the Royal Society was public recognition of the scientific worth of his art. He drew and engraved the exotic plants in *Plantae et Papiliones rariores* (1748–62). But his engravings fail to do justice to his watercolours. He preferred painting on vellum, finding its smooth surface receptive to body colour. Technically one cannot fault Ehret: his accuracy is impeccable, his instinct for composition is flawless, yet a cold brilliance pervades his work. All the same, whatever slight reservations one might have about his work, his stature and influence are undeniable. John Ellis, who owned some of his paintings, mourned his death in correspondence with Linnaeus: 'I suppose you know Ehret is dead. We have nobody to supply his place in point of elegance'.[7] And no-one did replace him until the Austrian artist Francis Bauer settled at Kew about 1790.

Francis Bauer (1758–1840), already an experienced flower painter when he visited England in 1788, was persuaded by Sir Joseph Banks to become resident botanical artist at Kew Gardens, at that time royal property. Sir Joseph, as President of the Royal Society and unofficial adviser to the King on the management of Kew Gardens, was the great entrepreneur of the British scientific world. His conviction that a good botanical garden, such as he intended Kew to be, needed the services of a botanical artist prompted him to engage Bauer, paying his salary from his own pocket and making provision in his will for its

7. Letter of 28 December 1770. *In* Sir J. E. Smith *Correspondence* vol 1, 1821, p 255.

continuance. Until his death thirty years later, Bauer patiently and tirelessly recorded new plant introductions in the gardens at Kew. One of his earliest and finest works, *Delineation of exotick plants cultivated in the royal garden at Kew* (1796–1803) present some of the Ericas or heaths collected in South Africa by the Kew gardener, Francis Masson. There is no text, which was, in any case, rendered superfluous by these explicit drawings. 'Each figure is intended to answer itself every question a botanist can wish to ask, respecting the structure of the plant it represents; the situation of the leaves and flowers are carefully indicated, and the shape of each is given in a magnified, as well as in a natural size. The internal structure of the flower . . . is also, in all cases, carefully displayed'.[8] Immaculate in their fastidious detail, conveyed with all the deftness of a miniaturist, the Ericas are also decorative in their presentation. Bauer excelled in analytical drawing, using the microscope as adroitly as any scientist. His *Strelitzia depicta* (1818) must surely rank among the most delicate lithographs ever produced. The lines of the drawings are barely visible and the gradations of colour merge imperceptibly. His last work, *Genera Filicum* (1838–42), suffered a metamorphosis under the lithographic pencil of W. H. Fitch who destroyed that intrinsic fragility characteristic of all Bauer's paintings.

Unlike his brother Francis, Ferdinand Bauer (1760–1826), a landscape and animal painter, was not prepared to opt for a quiet, sedentary life. In 1786 he readily joined John Sibthorp, Professor of Botany at Oxford, on his tour of Greece and the Middle East, to make drawings of landscape and vegetation. Bauer had a reverence for and a knowledge of plants which came through in the striking freshness of his watercolours. Over 900 plants were engraved for the *Flora Graeca* (1806–40), another landmark in botanical iconography. He contributed forty-one plates to A. B. Lambert's *Genus Pinus* (1803), and what dynamic linear patterns his erupting and cascading pine needles make! Goethe exclaimed: 'it is a real joy to look at these plates, for Nature is revealed, Art concealed'.

Drawing masters were now much in demand, and when the talents of their pupils could not cope with portrait or landscape painting, there was always the less exacting skill (or so it was believed) of flower painting to be taught. There were those who thought that women's aptitudes fitted them best for this branch of art. George Brookshaw introduced his *New treatise on flower painting* (1816) with the admission that 'the general inclination of ladies for flower painting, added to the great progress many have made in attaining the art, is a convincing proof, that the taste, or genius, for this pleasing amusement is not confined to the male sex: on the contrary, I am inclined to think, that ladies would sooner arrive at perfection than men, were they at first taught its proper rudiments'. At the time he wrote this, a number of women were trying to make a living out of flower painting. There was Margaret Meen, whom the botanist, T. J. Woodward, had introduced to William Curtis as 'a young lady of Bungay settled in London for the purpose of teaching flower and insect painting, in both of which her performances are very capital'.[9] Her *Exotic plants from the royal gardens at Kew*, in a combination of etching, aquatint and hand-colouring was published in 1790.

8. Preface.
9. W. H. Curtis *William Curtis 1746–1799* 1941, p 55.

74

Mary Lawrance taught flower painting for a half guinea a lesson plus a guinea 'entrance fee'. A successful artist, her popularity was inexplicably increased by the publication of *A collection of roses from nature* (1799). Her limp and lifeless drawings were not improved by coarse etching and poor colouring. Redouté – the 'Raphael of roses' – deplored her inaccuracy: 'on a great number of occasions the painter has sacrificed truth for picturesque patterns'. Mrs E. Bury, who liked drawing lilies and related flowers, was encouraged by her friend William Swainson, the zoologist, to publish them. The result was the grand folio, *A selection of Hexandrian plants belonging to the natural orders Amaryllidae and Liliaceae* (1831–34) (the class Hexandria, for plants with six stamens, comes from Linnaeus's classification). There is a lack of subtlety and refinement in her brushwork which is not particularly amiss in portraying rather flamboyant plants such as the lily and Amaryllis. She was very fortunate in her choice of engraver, Robert Havell, whose aquatint interpretation of her work is of the highest quality.

At the beginning of the nineteenth century aquatinting was still in vogue. A tonal variation of etching, said to have been invented by Le Prince in France, it was introduced to England by Paul Sandby in 1774 in *Twelve views in aquatinta from drawings taken on the spot in South Wales*. The word 'aquatint' comes from *aqua fortis*, the acid used to etch the copper plate whose surface has been covered with a granulated resin. The drawing is made in outline on the plate, any highlights being stopped out with varnish which is also used to control the depth of etching. The quantity of printer's ink held in the irregularly-grained surface of the plate determines the tonal quality of the print.

S. T. Prideaux hailed George Brookshaw's *Pomona Britannica* (1812), as 'one of the finest colour-plate books in existence',[10] an extravagant claim which it would be difficult to sustain. But it cannot be denied that Brookshaw's large aquatints of richly coloured fruits, emphatic against a velvety brown background, make an immediate visual appeal. Equally assertive in chromatic resonance is Samuel Curtis's *Monograph on the genus Camellia* (1819). In France, aquatint was used for the 600 or so plates in Pierre Bulliard's *Herbier de la France* (1780–95). A much more modest production, William Hooker's small folio, *Pomona Londinensis* (1818), contains some of the most attractive of all botanical aquatints. These fine-grained plates with judicious stippling admirably convey the surface texture of apples. The limpid green of the leaves contrasts favourably with Brookshaw's brash rendering of foliage. Except in the hands of a master engraver, there is a hint of heaviness in aquatinting which makes it not the most appropriate medium to express the lightness and transparency of flowers.

Aquatinting was used to great effect in that most singular curiosity of botanical art, Thornton's *Temple of Flora* (1799–1807). Robert John Thornton (*c*.1768–1837) qualified as a doctor of medicine but its practice and teaching alone did not satisfy his fertile mind. In 1798 he delivered the *Philosophy of medicine* in five volumes; the following year he disposed of the *Philosophy of politics*, but it was his *Philosophy of botany*, as he sometimes called it, which dissipated his family inheritance and was his ruination. It was offered as 'a British trophy in honour of

10. S. T. Prideaux *Aquatint engraving* 1909, p 295.

Linnaeus', and grandiloquently entitled, *A new illustration of the sexual system of Linnaeus*. The third part of this folio folly was the celebrated *Temple of Flora*. The work was hampered from the outset by its author's imperial vision. He commissioned painters, engravers and versifiers; chose the finest and largest paper; had a fanfare of three allegorical frontispieces; inserted elaborate calligraphic sub-titles; and, in consequence, beggared himself before he was half way through his prestigious publication.

Thornton wanted to combine the achievements of British botany and art in a series of opulent engravings based on oil paintings specially done for the occasion. Dedicating the work to Queen Charlotte, whom he hailed as 'Patroness of Botany and of the Fine Arts', Thornton convinced himself that in this publishing venture the nation's honour was at stake. His mode of publication was similar to that adopted by J. Boydell for his huge illustrated edition of Shakespeare's works, which staggered through nineteen years to completion. Boydell invited well-known artists to paint scenes from Shakespeare's plays; the canvases were displayed in his specially-created Shakespeare Gallery, and afterwards engraved for the published work.

Thornton's claim that 'all the most eminent British artists have been engaged', was hardly substantiated by the employment of Pether, Reinagle, Henderson and Sydenham Edwards. The paintings of these relatively minor artists were displayed in the Linnaean Gallery which Thornton opened in 1804 in New Bond Street in London. His selection of engravers was more discriminating: Warner, Earlom and Stadler were among the dozen or so engaged in making the plates. Thornton directed that each plant portrait should be put into a suitable scenic setting. 'Each scenery is appropriate to the subject', he explained. 'Thus in the *night-blowing Cereus*, you have the moon playing on the dimpled water, and the turret-clock points XII, the hour at which the flower is in its full expanse. In the *large flowering Mimosa*, first discovered on the mountains of Jamaica, you have the humming birds of that country, and one of the aborigines struck with astonishment at the peculiarities of the plant' (figure 31). This theatrical treatment, mildly ridiculous though it may now seem, was quintessential romanticism. The malevolent presence of the *Dragon Arum* must have thrilled many readers of Gothic horror novels.

The engravings, painted in colour and finished by hand, were usually in line and stipple, with aquatint or mezzotint expertly applied to the background. Nowadays botanists tend to ignore the *Temple of Flora* and artists are amused by its pretensions. In trying to promote the sale of his book, Thornton quoted approvingly from the poet James Thomson –

... Shall Britons in the field
Unconquer'd still, the better laurel lose?
In *Finer Arts* and *Public Works* shall *they*
to Gallia yield?

'Gallia' was also capable of the grand gesture. Napoleon supported the publication of splendid books that stood comparison with those initiated by Louis XIV. These were sent as presents to foreign sovereigns and learned societies as

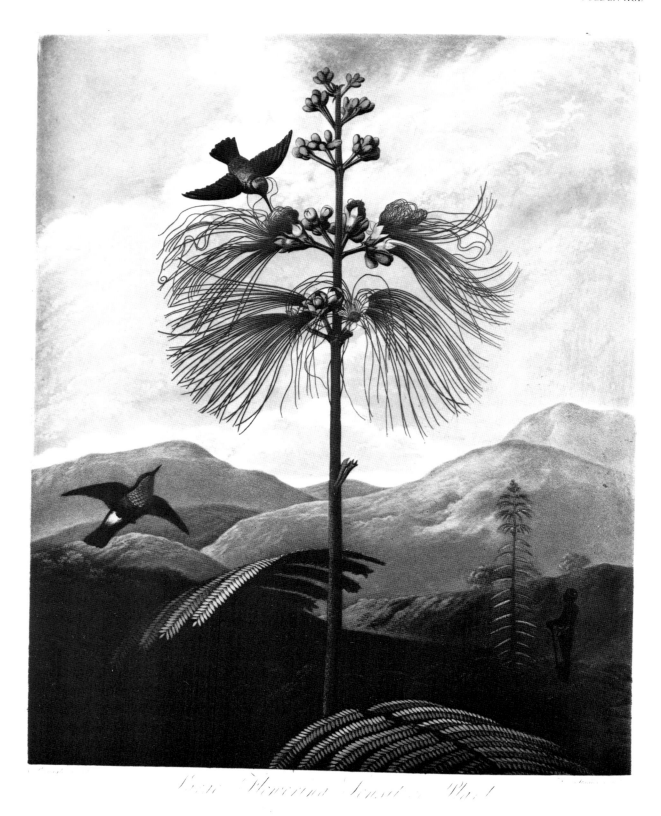

31 'Mimosa grandiflora; or, large-flowering sensitive plant' *(Calliandra grandiflora)* and humming birds. R. J. Thornton *New illustration of the sexual system of Carolus von Linnaeus . . . and the Temple of Flora*, London, 1799–1807. 10. Tab. 40 *(DPB)* This plate was engraved in a combination of aquatint, stipple and line engraving by Stadler after a painting by Reinagle.

evidence of the magnificence of the Republic. A number of large paper copies of Redouté's *Les Liliacées*, scrupulously coloured by the artist himself, were purchased by the French government as presentation copies 'pour donner a l'étranger une juste opinion de la superiorité de l'école Française'.

With the botanical paintings of a Redouté or the bird paintings of a Levaillant, French illustrated books during the early nineteenth century attained a pinnacle of excellence. This remarkable galaxy of artistic ability was nurtured by the Dutch artist and teacher, Gerard van Spaendonck (1746–1822), Professor of Natural History Iconography at the Muséum National d'Histoire Naturelle in Paris. In 1793 he was allowed to enlarge the existing establishment of one botanical artist by the appointment of two zoological artists. Nicolas Maréchal and Henri-Joseph Redouté filled the latter posts while Henri-Joseph's brother, Pierre-Joseph Redouté, became the botanical artist. Van Spaendonck gradually changed the longstanding practice of using gouache as the medium for the *collection des vélins* to pure watercolour. He also encouraged stipple engraving, where tonal values are achieved by a massing of dots on the copper plate made by a stipple needle and roulettes with multiple points. It is said that Redouté learnt stipple engraving in England where its leading exponents were Bartolozzi and Schiavonetti. It is inexplicable that stipple, which offers an unrivalled delicacy, was never taken up seriously in flower engraving in England. English flower engravers usually combined it with line-engraving for tonal effects as in Samuel Curtis's *The beauties of Flora* (1806–20) or George Brookshaw's *Groups of flowers* (1819). One has to look at the stipple-engraved floral plates of Redouté, Bessa, Turpin, Prévost, and Sainte-Hilaire in France to see the capabilities of this process.

Pierre-Joseph Redouté (1759–1840) was the best-known of van Spaendonck's assistants, and although some of his contemporaries were unquestionably his equal in artistic skill, they lacked his knack or luck in attracting patrons – including all the French queens from Marie Antoinette in the 1780s to Marie Amélie in the 1830s. He had travelled through Belgium, Holland and Luxemburg as an itinerant painter before arriving in Paris in 1782. There he had the good fortune to meet van Spaendonck and Charles-Louis L'Héritier, the two men to whom he owed much of his later success. L'Héritier, a judge and an amateur botanist, taught him floral dissection and how to illustrate diagnostic characters with a proper regard for minute detail. In A.-P. de Candolle's *Plantarum historia succulentarum* (1798–1837) (perhaps better known by its French title *Histoire des plantes grasses*), he tried for the first time the technique of applying several colours to a single plate, afterwards retouched by hand. As the 'official painter' to the Empress Joséphine, he did the drawings and supervised the work of the seventeen engravers for *Jardin de la Malmaison* (1803–05), an account of the plants in her favourite garden. This sumptuous production and the 503 plates for *Les Liliacées* (1802–16) constitute the finest flowering of his genius In a prospectus for *Les Liliacées*, Redouté affirmed that 'The plants ... will be drawn, engraved and coloured as true to nature as science may desire, and, what is even more difficult, with all the pictorial richness with which nature has adorned them. Numerous experiments and a long search for the engraving method best suitable for colour printing, have shown me that art makes it possible to retain the magnificence and

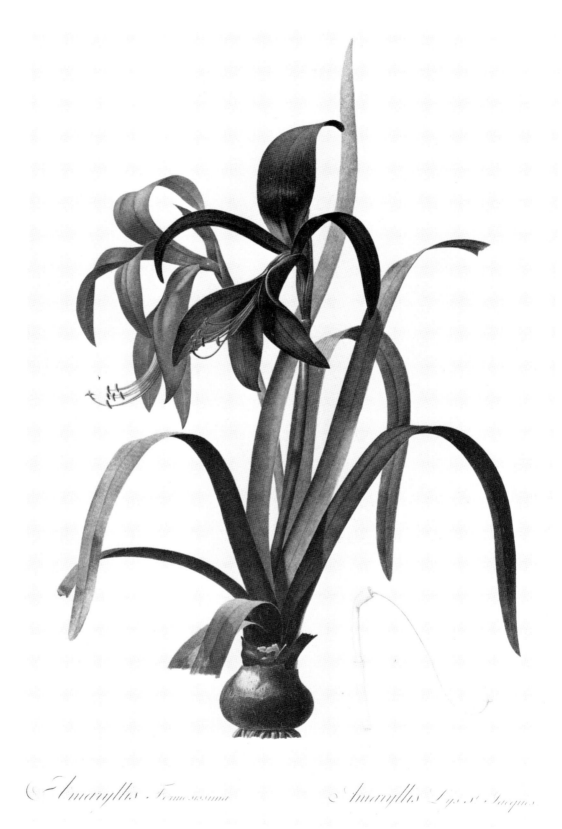

Amaryllis . Formosissima *Amaryllis Lys. S.t Jacques*

32 Jacobean Lily *(Sprekelia formosissima)*. Coloured stipple engraving. Pierre Joseph Redouté *Les Liliacées*, Paris, 1802–08, vol 1, 5. X443. *(IOLR)*

the manifold nuances which one admire in these flowers'. Nothing was neglected in the production of these eight folio volumes: the proportions of plate and page are perfect, the presswork is without blemish, the retouching by hand is masterly, especially in those copies Redouté attended to himself (figure 32). *Les Roses* (1817–24), his most popular work, is, in a way, Redouté's acknowledgement of Joséphine's patronage of flower painting.

Pierre Jean François Turpin (1775–1840), self-taught, was equally at ease painting large or small pictures. Goethe wished his services had been available when he was writing *Metamorphose der Pflanzen* (1790). The influence of van Spaendonck can be detected in his work and in that of J. L. Prévost, whose hallmark was the glistening dewdrop so beloved of the Dutch and Flemish schools. When van Spaendonck died in 1822 his professorial post was abolished, and two new posts of Maître de Dessin were created in its place, Redouté being appointed for botanical art, and Nicolas Huet for zoological art. Francis Bauer, Redouté and Turpin all died in 1840 and with them passed a distinguished epoch of flower painting which affirmed truth at the same time as it celebrated beauty.

The invention of lithography by Aloys Senefelder in 1798 heralded a radical departure from the basic principles of graphic reproduction which had endured for some 300 years. Lithography, which literally means stone-writing, is based on the chemical antipathy of grease and water applied to a porous stone. It differs from relief (woodcut) and intaglio (copper engraving) printing, in being a surface or planographic process. The artist draws with a greasy chalk on the surface of a polished stone, usually limestone, which after damping with water is covered with printer's ink. The ink, rejected by the water-saturated stone, is accepted by the greasy chalk drawing. The stone is then ready for printing.

Ackermann, the foremost London publisher of aquatint books, became interested in the process. One of his botanical books, *Eidodendron* (1827–32) by H. W. Burgess, had the lithographs printed by Charles Hullmandel who had been taught by Senefelder himself. At the outset, Hullmandel used the lithographic press of Francis Moser and John Harris who in 1818 had reproduced the drawings in Francis Bauer's *Strelitzia depicta*. In this book, one of the first to adopt lithography, the new process is handled in a tentative, almost a hesitant, fashion. The soft lithographic outlines which so lightly touch the paper serve mainly as a shadow for deft hand-colouring. The large dissections of the *Strelitzia*, magnificent though they be, do not take advantage of the texture peculiar to lithography. For the artist, the process meant emancipation from the bondage of the engraver. In the confident hands of the Victorian botanical artist, W. H. Fitch, lithographs had an immediacy and spontaneity usually encountered only in original works of art. One is not surprised when Francis Bauer confessed to Sir William Hooker, Professor of Botany at Glasgow University: 'I certainly prefer the lithographs, as for coloured plates they are much better than line engravings'.[11] This enthusiasm was not universally shared. John Ruskin decreed: 'let no lithographic work come into the house'. John Lindley apologised for the plates in his *Illustrations of orchidaceous plants* (1830–38):

11. Royal Botanic Gardens, Kew. Archives. Francis Bauer to Sir William Hooker, 3 May 1837.

It has been found indispensable to represent Mr Bauer's drawings by means of lithography instead of engraving on copper; and unfortunately the former art, even in the most skilful hands, is seldom adapted to high finish or delicate touch; when executed by a mere amateur (as part of the plates have been), it is still less calculated for such an object. It is however hoped that the principal facts explained by the drawings have been truthfully represented, and that the defects of some of the plates as works of art will not be prejudicial to them as illustrations of science.[12]

The broken or dotted line characteristic of lithography was to the liking of Noel Humphreys, artist, designer, and one of the country's leading exponents of chromolithography. He commended the soft image produced by the chalk line in Nathaniel Wallich's *Plantae Asiaticae rariores* (1829–32), contrasting it with 'the cold effect of aquatinta shades . . . and the harshness of line-engraving on copper or steel'.[13] He condemned the spectacular plates in *The Orchidaceae of Mexico and Guatemala* because of 'the outlining of the petals of some of the most delicate flowers with *ink*; which detracts much from the wax-like delicacy of some of the most beautiful species. . . . A fine *chalk* outline would produce a much more true and beautiful effect'.[14]

In this criticism one detects the pedantry of the purist. Who cannot be impressed, overwhelmed indeed, by James Bateman's elephant folio, *The Orchidaceae of Mexico and Guatemala* (1837–43)? Most of its life-size drawings were executed by Mrs Withers and Miss Drake. On this monumental scale the plates could not be other than bold and commanding. Any stylistic differences the artists might have displayed were levelled out by the efficient and impersonal lithography of M. Gauci, who redeemed his reputation after his failure with Lindley's *Illustrations of orchidaceous plants*. H. G. Bohn, the London publisher and bookseller, called it 'the most splendid botanical work of the present age'; without a doubt it is the largest botanical work of any age, botany's riposte to Audubon's gigantic *Birds of America*.

For centuries bird portraiture had always lagged behind flower portraiture, the result, perhaps, of more attention having been given to plants as a source of drugs; there were also the practical frustrations of trying to paint a subject that seldom remained still. Bird books did not really come into their own until the opening years of the nineteenth century, although there were some notable exceptions.

One of the earliest was the *Natural history of Carolina, Georgia, Florida and the Bahama Islands* (1729–47) by Mark Catesby. Mark Catesby (1683–1749) made two visits to North America, in 1712–19 and again in 1722–26, where he collected plants and animals for Sir Hans Sloane, William Sherard and other naturalists in England. Many of the plates in this remarkable book, which also includes fishes, snakes, insects, crustaceans, etc, depict more than 100 species of birds in association with the plants on which they feed. Catesby's interest in botany sharpened his perception of ecological habitat; its incorporation in his compositions was the first time it had been attempted on this scale, and anticipates the bird studies of

12. Preface.
13. *Gardener's magazine* vol 14, 1838, p 172.
14. *Ibid*, vol 14, 1838, p 174.

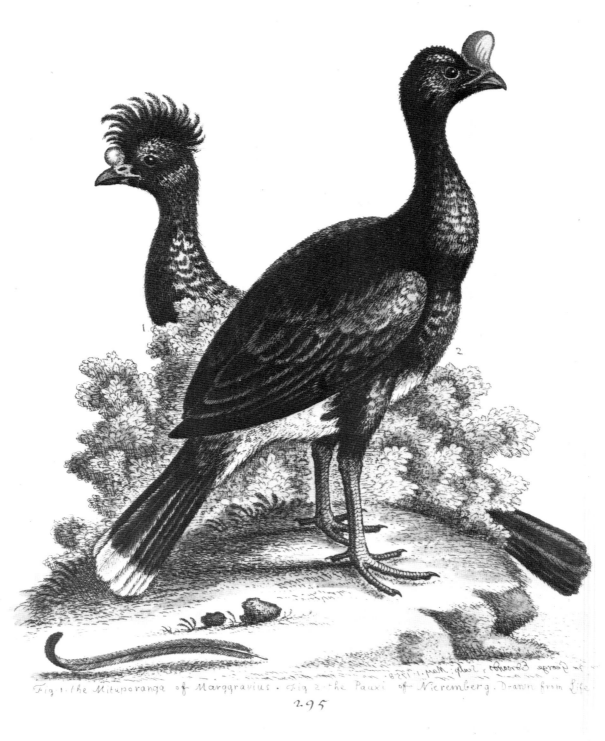

33 Left: Great Curassow *(Crax rubra)*. Right: Northern Helmetted Curassow *(Crax pauci)*. George Edwards *Gleanings of natural history*, London, 1806, part 2, plate 295. 683 L7. *(DPB)*

Curafo & Curkew Birds Ed. 295

34 Sydney Parkinson. Sketches of two birds adapted from plate 295 in Edwards's *Gleanings of natural history* (see figure 33). Add. MS 9345, folio 13v (*Dept of MSS*)

Alexander Wilson and Audubon. In the preface to the book, which he illustrated and engraved single-handed, he reveals that 'In designing the Plants, I always did them while fresh and just gathered: and the Animals, particularly the Birds, I painted them while alive (except a very few) and gave them their Gestures peculiar to every kind of Bird'. Unfortunately, his aspirations often fell short of his ability to interpret: his birds in motion lack conviction; some were patently drawn from the awkward poses of mounted specimens. He is superficial in the expression of detail as, for instance, in the markings on plumage. He was aware of his limitations: 'As I was not born a painter, I hope some faults in perspective and other niceties may be more readily excused, for I humbly conceive plants and other things done in a flat, though exact manner may serve the purpose of natural history better in some measure than in a bold and painter-like way'.

Whatever their defects, his drawings are indisputedly superior to those of Eleazer Albin, whose *Natural history of birds* (1731–38) was appearing about the same time. Details of Albin's life are scanty. We know he was a teacher of drawing and watercolour with entomological interests (PLATE 17) and flourished about

1713–59. His claim that he drew from 'live birds' is not validated by the results. His birds, nearly always depicted in profile, lack animation. The colouring of the plates, in which his daughter Elizabeth assisted, is arbitrary. Sometimes totally different species have identical beaks. George Edwards was emphatic about his incompetence: 'What birds Albin himself drew from nature, are all in the self same attitude, he never drawing any but in one posture. Such as are varied a little from his general rule are all borrowed draughts [*e.g.* from Willughby's *Ornithologiae*] as my experience has confirmed to me in many of them'.[15] Notwithstanding these shortcomings, the book enjoyed a French edition in 1750.

George Edwards (1694–1773) was taught etching by his friend Mark Catesby to reduce the cost of the plates in his *Natural history of uncommon birds* (1743–51). He sought to make a virtue of this necessity, arguing that an engraver mistaking 'some little bends and turns of strokes for the lapse of a pencil' might correct them and in the process 'rob a figure of what the author designed as its chiefest distinguishing mark'.[16] Only the artist could be fully alert to those crucial details that differentiated species. He maintained that he drew from live birds wherever possible, but when he was compelled to copy dried and stuffed specimens he always had sketches of the living bird at hand to ensure a natural posture. This posture, however, had to show all those features that distinguished a species, and 'such actions, turns, and fore-shortenings, which make up the agreeable variety of masterly compositions' were omitted (PLATE 20).

Edwards influenced other bird artists such as Peter Paillou, who specialised in birds of prey and game-birds. He contributed bird plates to Thomas Pennant's *British zoology* (1761–66). Edwards, in fact, was the dominant authority on ornithological illustration. Chelsea porcelain figured his birds; and when Andien de Clermont painted some murals at Syon House for the Duke of Northumberland in 1752, he relied on Edwards's plates for most of his birds. When, later, Sydney Parkinson wished to get some experience in drawing birds he turned to one of the best works available to him, Edwards's *Gleanings of natural history* (figures 33 and 34).

John Abbot (1751–*c*.1840), a Londoner, emigrated to Georgia in 1773, where he spent the rest of his life observing and recording the wild life of the woods of Bulloch County. Completely self-taught, he learnt from the published works of other naturalists; Albin showed him how to illustrate life cycles and to compose insects on a page; from Catesby and Edwards he adopted plant backgrounds and bird poses. But gradually, as his knowledge of wild life and his skill with pencil and brush developed, he abandoned stylised backgrounds for more naturalistic compositions and his positioning of birds and insects on the page became less symmetrical and contrived. As a bird painter he was never more than competent (figure 35); his abiding reputation rests on his consummate watercolours of the metamorphosis of insects.

Mark Catesby has been called the father of American ornithology and many naturalists regard Alexander Wilson (1766–1813), rather than Audubon, as the founder of modern ornithology in North America. The son of a Scottish weaver,

15. G. Edwards *Natural history of uncommon birds* part iv, 1751, plate 170.
16. *Ibid*, vol 2, 1747, p 112.

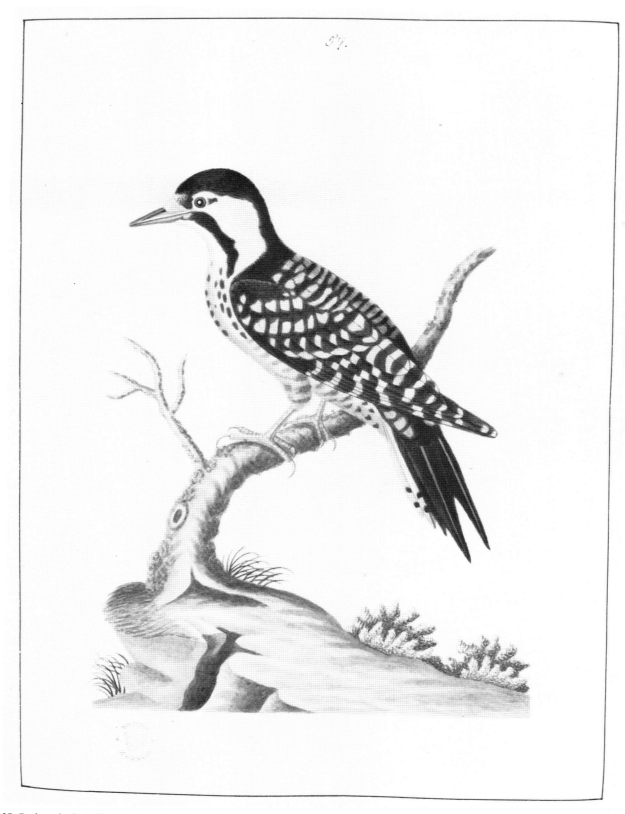

35 Red-cockaded Woodpecker *(Dendiocopus borealis)*. John Abbot *Drawings and natural history of the birds of Georgia in America*, 1804. Egerton MS 1137 vol 1, folio 59. *(Dept of MSS)*

he emigrated to America where he became a school-teacher and a pioneer ornithologist. Only a person possessed of his tenacity and courage could have persevered in the self-imposed task of collecting and mounting birds, describing and painting them, in preparation for his *magnus opus* on American birds. The nine volumes of *American ornithology* (1808–14) was at that time the most ambitious publishing venture ever attempted in North America. Wilson himself canvassed for subscribers and saw most of the volumes through the press (he died just a year before the last volume appeared); he even hand-coloured many of the plates, but this self-reliance principle stopped short of engraving them. With Catesby and Edwards obviously in mind, he questioned the desirability of the author being his own engraver as well as artist. The author, not possessing the skill of a professional engraver, would be better engaged in drawing and in collecting data. 'Every person who is acquainted with the extreme accuracy of eminent engravers, must likewise be sensible of having the imperfections of the pencil corrected by the excellence of the graver'.[17] Wilson's birds are stiff and his compositions lack elegance, but these faults are redeemed by scientific integrity. Charles Robert Leslie, who became a successful painter and Royal Academician in England, recalled 'the extreme accuracy of his drawings and how carefully he had counted the number of scales on the tiny legs and feet of his subjects'.[18]

On one of his peregrinations seeking subscriptions for his book, Wilson met John James Audubon (1785–1851) in Louisville. Audubon, seeing a sample of Wilson's art, resolved to bring out a book of his own bird paintings, and years of financial difficulties and other frustrations did not deflect him from that goal. He got no support from the Philadelphia Academy of Natural Sciences, and Alexander Lawson, the engraver of Wilson's book, was openly hostile: 'I will not engrave them.... Ornithology requires truth and correct lines – here are neither'. Only in England did Audubon find the appreciation he desperately craved. William Lizars of Edinburgh aquatinted the first few plates; the project was then taken on by Robert Havell, father and son, in London.

The 435 hand-coloured aquatints of *Birds of America* (1827–38) illustrate over a thousand individual birds, all life-size – hence the need for such a huge format (figure 36). Audubon preferred to draw freshly killed specimens wired in lifelike poses, but occasionally had to resort to skins and stuffed models. He was not above copying from his rival, Alexander Wilson; birds on seven of his plates are taken from *American ornithology*. Most of the floral backgrounds were done by other artists. The dramatic animation of his compositions come as a revelation after the formality and frozen poses of Catesby, Edwards and Wilson. He knew how to orchestrate colour, boldly exploiting brilliant hues but never losing control of the overall harmony. Scientific exactitude sometimes suffered. As Peter Scott has pointed out, 'the resemblance to the living bird was often rather tenuous'.[19] There have been greater bird painters but few have painted with such panache.

Audubon was French by birth and it was in France that a remarkable school of bird painters flourished. Foremost amongst them was François-Nicolas Martinet

17. A. Wilson *American ornithology* vol 1, 1808, p 7.
18. C. R. Leslie *Autobiographical recollections* 1860, p 163.
19. *Archives of natural history* vol 12, no 1, 1985, p 173.

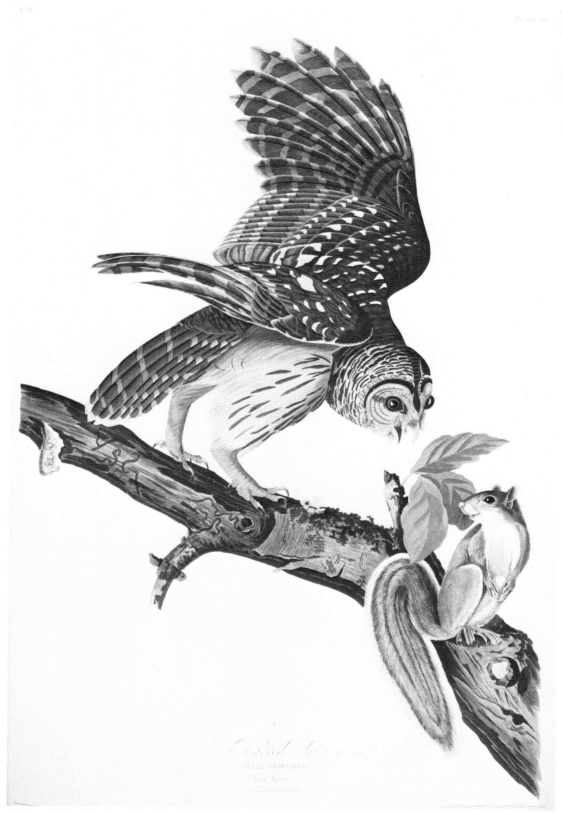

36 Barred Owl *(Strix varia)*. Coloured aquatint. John James Audubon *Birds of America*, London. 1827–38, vol 1, plate 46. NL Tab 2. *(DPB)*

(*fl*.1760–1800) who provided most of the bird figures for Buffon's ten-volume *Histoire naturelle des oiseaux* (1771–86). The bird books of the French naturalist and traveller François Levaillant (1753–1824) stand comparison with Audubon's great work. His *Histoire naturelle des oiseaux d'Afrique* (1796–1808), *Histoire naturelle des Perroquets* (1801–05) and *Histoire naturelle des Oiseaux de Paradis* (1801–06) proclaim the superiority of French engraving. Jacques Barraband was his favourite artist. Exceptional care was always bestowed on the colouring of all these magnificent books. And nowhere is this more apparent than in *Oiseaux dorés ou à reflets métalliques* (1802) by Jean-Baptiste Audebert and Louis Jean Viellot. Gold was used to touch up highlights on the plates and twelve copies even had the text printed in gold.

Placed besides such opulence, a wood-engraving becomes a model of puritanical restraint. Yet wood engraving was to stage a revival when Thomas Bewick (1753–1828) applied to wood the skills and techniques he had learnt during his apprenticeship as a copper engraver. He modified the traditional woodcut by substituting hard boxwood for soft wood. He also engraved on the end grain of the wood. The common birds of the countryside which he knew so well were engraved with all 'the fidelity and animation'[20] of which he was capable.

His *History of British birds* (1797–1804) was admired by Audubon who visited him when he was seeking an engraver in England in 1827. 'The old gentleman and I stuck to each other, he talking of my drawings, I of his woodcuts'.[21] Audubon shrewdly forecast that Bewick would ultimately be recognised 'in the art of engraving on wood what Linnaeus will ever be in natural history, though not the founder, yet the enlightened improver and illustrious promoter'.

William Swainson (1789–1855) from childhood had a passion for Nature and 'every moment . . . was divided between drawing and collecting'.[22] The volume of natural history books appearing in England and France suggested to him the possibility of a career writing and illustrating accounts of the world's fauna. To reduce costs he learnt lithography, which he employed to reproduce his drawings in his *Zoological illustrations* (1820–23), the first English publication with hand-coloured lithographs of birds. Swainson drew with the lithographic chalk the same refined line he had used for copper engravings; he had not yet realised the freedom and flexibility that lithography offered. Nonetheless, the book was favourably reviewed in the *Edinburgh philosophical journal* which observed that 'The discovery of taking impressions from drawings upon stone has furnished a powerful instrument to naturalists whose drawings in former times were mangled by the ignorance of engravers'.[23] Swainson was an unsure pioneer; it needed the confidence of a Gould to make the most of the potentialities of lithography which endured as a medium for bird illustration until as recently as G. M. Mathew's *Birds of Australia* (1928–36.

When Swainson received his copies of Edward Lear's book on parrots which

20. T. Bewick *History of British birds* 6th Edition, 1825, introduction.
21. J. J. Audubon *Ornithological biography* 1831.
22. W. Swainson *Taxidermy* 1840, p 339.
23. *Edinburgh philosophical journal* vol 4, 1821, p 209.

was coming out in part numbers, he wrote congratulating him, singling out two plates for special praise, the 'New Holland Palaeernis' and the red and yellow macaw. 'The latter is in my estimation, equal to any figure ever printed by Barraband or Audubon, for grace of design, perspective or anatomical accuracy'.[24] Like Swainson, Edward Lear (1812–88) decided to become a zoological illustrator. After filling the role of a poor relative to botany for so long, zoology was at last coming into its own. The Linnean Society of London formed a Zoological Club in 1822, followed by the Zoological Society of London three and a half years later. The Surrey Zoological Gardens opened at Kennington in 1831. From the 1770s the Exeter 'Change in the Strand had been the home of a commercial menagerie under different managements. There the Swiss painter Jacques Laurent Agasse could be found making preliminary sketches for his animal paintings; and a precocious young Edwin Landseer was given every facility by its proprietor to draw the lions. The parrots in the aviary at London Zoo provided Edward Lear with his living models.

The large format of *The illustrations of the family of Psittacidae or parrots* (1830–32) dwarfed Swainson's modest octavo book. Lear lithographed the forty-two plates, translating the grain of the stone into tones and textures appropriate to plumage, claws and beaks. His birds had not yet completely discarded the formal eighteenth-century pose. In drawing them with conscious regard to detail, Lear never overlooked the personality of the bird. Perhaps the only criticism to be made of these splendid drawings is that they are portraits of individuals rather than of types. He was only twenty years old when he received public acclaim as a brilliant bird painter; he was even compared favourably with Audubon. Lord Derby invited him to Knowsley to draw the animals in his menagerie, then the largest in England. There he spent five happy and productive years, becoming an intimate friend of the family (figure 37).

While parts of Lear's book of parrots were coming out, the first issue of *A century of birds ... from the Himalaya Mountains* (1831–32) was published. Lear claimed that he drew some of the foregrounds for Mrs Gould who illustrated the book for her husband, John Gould (1804–81). Gould certainly employed Lear to assist his wife in the drawings for *Birds of Europe* (1832–37) and his monographs on toucans and trogans. Gould depended on his wife and other artists like Lear, William Hart, Henry Richter, and Josef Wolf to interpret and elaborate his sketches and copious notes. He introduced innovations such as depicting male and female birds on the same plate, and including chicks, nests and eggs. Though he was not an expert ornithologist, his forty volumes with nearly 3,000 lithographs earned him the name 'Bird man'. That remarkable output could not have been maintained without someone of his capacity for sustained work, entrepreneurial flair and, above all, an ability to inspire those whom he employed.

By comparison with books on flowers and birds, those on animals were less spectacular, often rather drab. Insects, being more colourful, were the source of attractive drawings and engravings. Moses Harris's *The Aurelian* (1758–66), Dru Drury's *Illustrations of natural history* (1770–82) and Edward Donovan's *Insects of*

24. V. Noakes *Edward Lear 1812–1888* 1985, p 82.

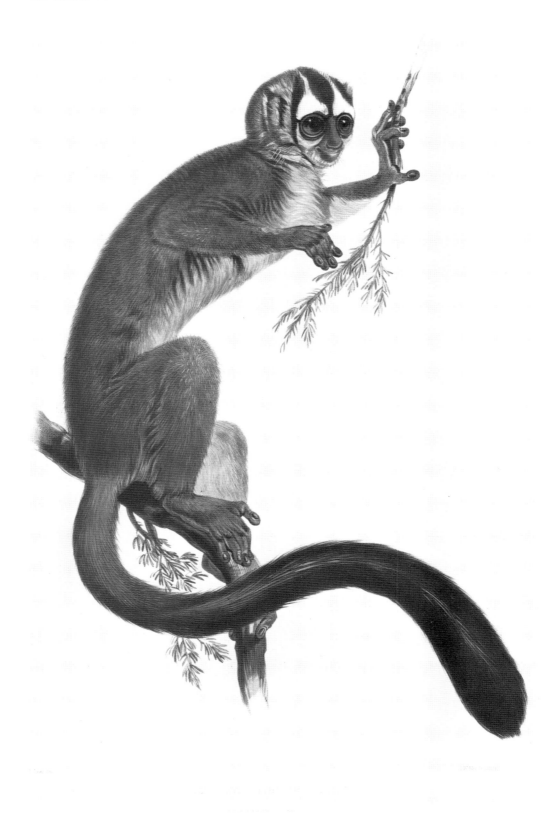

37 Night 'ape' *(Aotus trivirgatus)*. Lithograph. John E. Gray *Gleanings from the menagerie and aviary at Knowsley Hall*, Knowsley, 1846, plate 1, X1005. *(IOLR)*
One of the seventeen plates of mammals, birds and tortoises drawn by Edward Lear.

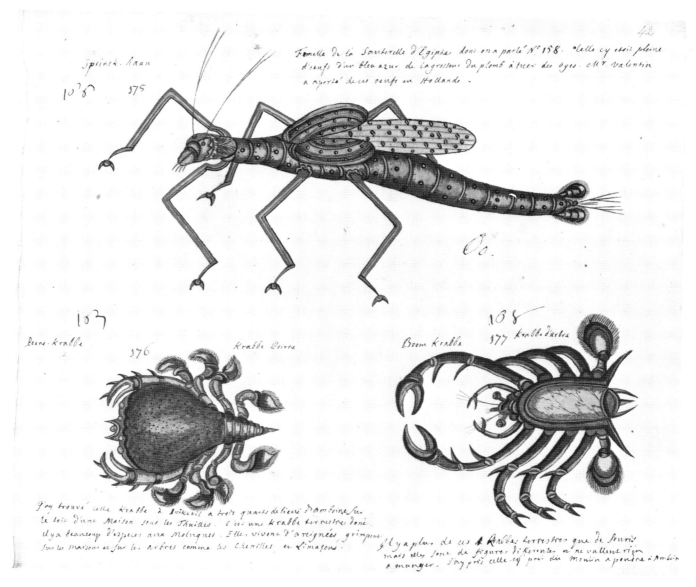

38 Louis Renard. Watercolour drawings for his *Poissons, ecrevisses et crabes; histoire naturelle des plus rares curiositez de la Mer des Indes,* 1718–19. Add. MS 5268, folio 42. *(Dept of MSS)*

India (1800–04) capture their metallic brilliance and iridescence. Roesel von Roesenhof's training as a miniaturist gave him a confident expertise in copying minute creatures. The plates in his *Monatlich herausgegebene Insecten-Belustigung* (1746–61), which he both drew and engraved, rank among the finest of the eighteenth century. A similar measure of praise can be bestowed on the delightful frogs in his *Historia naturalis Ranorum* (1758). His colouring has a subtlety, conspicuously absent in the gaudy plates of Louis Renard's *Poissons, ecrevisses et crabes* (1718–19) (figure 38). The naivety and crudity of Renard's drawings become apparent when placed next to the plates in Marcus Bloch's *Ichthyologie ou histoire naturelle, génerale et particulière des poissons* (1785–97). These plates (some of which have touches of gold and silver) qualify as some of the most beautiful engravings ever made of fishes.

Every age has its status symbol: freak mutations of tulips were prized by the Dutch in the seventeenth century; tropical orchids fascinated the Victorians; and

wealthy collectors in the seventeenth and eighteenth centuries spared no effort to acquire rare and exotic sea-shells. Rather common shells, however, are crowded on the twelve hand-coloured plates in Franz M. Regenfuss's *Choix de coquillages et de crustacés* (1758). The publisher, Thomas Martyn, brought out several natural history books from his art academy in Great Marlborough Street in London. In *The Universal conchologist* (1784–87), his team of young artists unerringly recreated in stipple engraving the distinctive convolutions and variegated markings of shells, amply fulfilling Martyn's ambition to make these four folio volumes 'worthy of himself, of his country, and of the learned world'. Jean-Charles Chenu used steel engraving for a work Peter Dance considers to be the best of all illustrated shell books, *Illustrations conchyliologiques* (1843–53).

As Keeper of the Jardin du Roi in Paris, Comte de Buffon (1707–88) had every facility at hand to embark on a survey of the whole of the natural world from man to minerals. Every day, in full court dress, he researched and wrote for eight hours on the history of the Earth and the animal kingdom. The thirty-six volumes of *Histoire naturelle* which came out in his lifetime were a bestseller, a fashionable updating of Aristotle written with an elegance which found a corresponding echo in its charming coloured engravings. Each successive volume was eagerly awaited and the work concluded with the forty-fourth volume in 1804. Oliver Goldsmith leant heavily upon it when he was writing his *History of the Earth and animated nature* (1774), which Samuel Johnson rightly predicted would be as 'entertaining as a Persian tale'.

If there were any doubts about the pre-eminence of George Stubbs (1724–1806) as an animal painter, then the exhibition of his work at the Tate Gallery in London in 1984 finally dispelled them. He was one of the first English artists to look at animals with scientific honesty. From childhood he had always wanted to know what was beneath the skin, to examine the form and mechanism of muscles, tendons, veins and bones. Oblivious to the smell of putrefying flesh, he dissected and drew horse after horse. Unable to find any craftsman to engrave his drawings, he himself engraved the eighteen plates in the *Anatomy of the horse* (1766), a perfect illustration of the marriage of science and art. Stubbs was a man of obsessions; for thirty years he painted variations on the theme of a lion attacking a frightened horse. He never missed a chance to sketch exotic animals – Lord Shelburne's lion, the Duke of Richmond's bull moose, the Indian cheetah sent to George III. They all made memorable canvases, especially the powerful rhinoceros, monumental against a louring sky. With only Sydney Parkinson's light pencil sketches to guide him, and a skin and skull to examine, he executed the first oil painting of a kangaroo (which was subsequently engraved for the official account of Cook's *Endeavour* voyage). He had a love of animals, free of the sentimentality that pervades the paintings of Herring and Landseer. No maudlin affection mars his dogs, who are pert, alert and inquisitive, never coy. His race-horses and scenes of the hunt were the beginnings of a popular era in British sporting art.

The success of *Birds of America* encouraged Audubon to attempt the same for mammals. His friend, John Bachman, wrote the text and his two sons, John Woodhouse and Victor, supplied about half of the 150 plates. The *Viviparous*

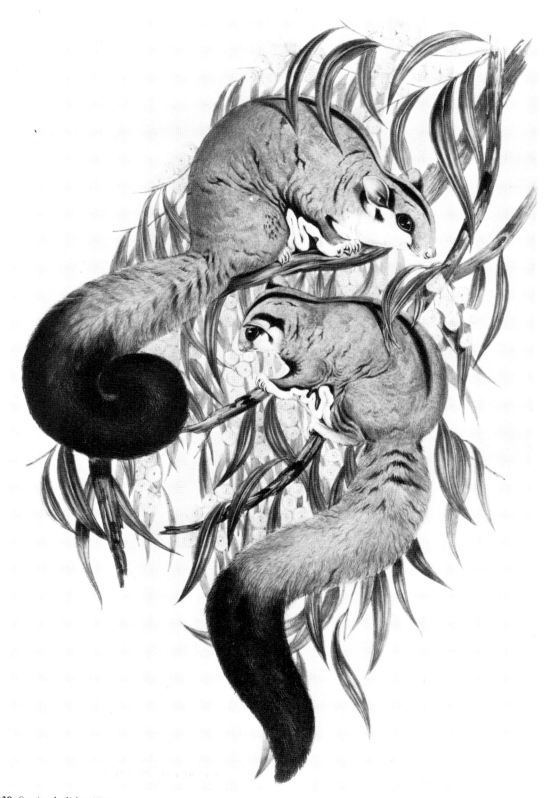

39 Squirrel glider *(Petaurus norfolcensis)*. Lithograph. John Gould *Mammals of Australia*, London, 1863, vol 1, plate 24. X849. *(IOLR)*

40 Thomas Bewick. Wild bull at Chillingham Castle, Northumberland. Wood engraving. 1878. 1822 d.1 (74★★). (*DPB*)

quadrupeds of North America (1845−48) has never been received by mammalogists with the same enthusiasm that ornithologists give to the *Birds*. The plates are not so spectacular; shaggy fur cannot compete with flamboyant feathers and the lithographs look insipid after the aquatints of the earlier work. Gould also departed from birds with his *Mammals of Australia* (1863) (figure 39).

Bewick's *General history of quadrupeds* (1790) falls slightly below the standard he achieved in his *British birds*. Familiar animals Bewick could draw from memory, others he copied from books such as Smollie's abridgement of Buffon. While the *Quadrupeds* was under way, he was asked to engrave the Chillingham Bull. He later recalled that he was unable to get near the nervous herd and 'was therefore obliged to endeavour to see one which had been conquered by his rival and driven to seek shelter alone in the quarry holes and in the woods – and in order to get a good look at one of this description, I was under the necessity of creeping on my hands and knees, leward and out of his sight – and I thus got my sketch or memorandum, from which I made my drawing on the wood'.[25] (figure 40.)

25. T. Bewick *My Life* Folio Society 1981, p 128.

8. Voyages and exploration

WHO CAN RESIST the engraved plates in old travel books which often convey more of the excitement of discovery and the wonder of new lands than the text itself? And yet so often the artist who drew these pictures had never left the shores of his own country. Dependent on reports, sometimes on sketches done on the spot and on his own imagination, he created scenes that often had the authenticity of an eye-witness. Even in those drawings where his interpretation is full of errors, a residual resemblance sometimes comes through. The artist of figure 42 did his best to conform to Kircher's description of a hippopotamus: 'it is a very deformed creature and terrible to behold . . . on the lower jaw it had two high bended teeth, unto which in the upper jaws the great teeth were consentaneous, and the tongue lolling out'.

It was highly desirable to have an artist or draughtsman on any expedition, a precaution Breydenbach, a dean at Mainz, took when he led a party of pilgrims to Jerusalem in the 1480s. Breydenbach's account of his journey, *Peregrinatio in terram Sanctam* (1486) was illustrated by his 'skillful painter', Erhard Reuwich, whose woodcut of a giraffe was copied by Conrad Gesner in the absence of anything better.

According to a Portuguese pilot, when Francis Drake sailed round the world in 1577–80 'he kept a book in which he entered his navigation and in which he delineated birds, trees and sea lions. He is adept in painting and has with him a boy, a relative of his, who is a great painter. When they both shut themselves up in his cabin, they were always painting'. Drake's chaplain on the *Golden Hind*, Francis Fletcher, also indulged in the same pastime (figure 43). During his West Indian campaign, Drake employed a certain Baptista Boazio to make plans of the Spanish bases and to sketch the local fauna.

The age of exploration was an extremely busy time for the cartographer who, having plotted directions and distances, embellished his maps with features of the land and sea, perhaps adding an elaborate cartouche. Medieval maps such as the Ebstorf map of about 1235 and the Hereford map of about 1290 are decorated with a mixed population of animals, real and mythological. Gradually this fauna was made symbolic of the continents: the camel, elephant and ostrich would be placed in Africa and the armadillo frequently represented South America (figure 44). Their accuracy was not a prime requisite. Pierre Desceliers's map of about 1550 has a shaggy rhinoceros, whereas most cartographers were content to use Dürer's famous woodcut.

Some sixty years after Christopher Columbus reached Cuba in 1492, Francisco López de Gómara confidently announced the discovery of the West Indies to be 'the greatest event since the creation of the world, excepting the Incarnation and

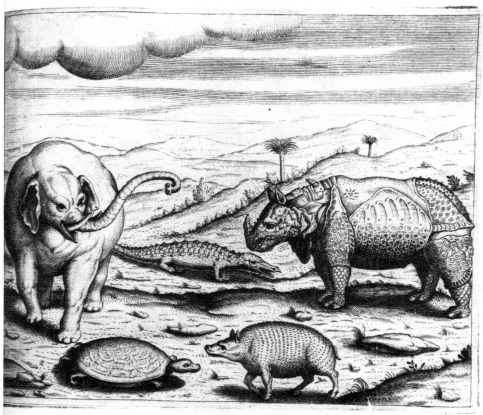

VII.
Abbildung etlicher Thiere / so in
Indien gefunden werden.

Lephanten seyn gar gemein in Indien / allermeist aber in Æ-thiopia, bey der Nation Caffres genant / da sie getödtet werden der Zeen halber / die sie den Portugallesern verkauffen / man findet sie auch in Bengalen, vnd vornemlich in Pegu, in so grosser Menge / daß sie offtmals ein oder zwey tausent auff einmal vmbbringen / vnd alßdann deren so viel darauß nehmen / als ihnen gelüstet / die andern lassen sie wieder hinziehen / das Thier Rhinoceros, wird auch in Indien / aber nur in Bengalen vnnd Patane gefunden / da es in grosser Menge sich helt / an dem Fluß Ganges. In gemeldtem Fluß halten sich auch viel Crocodillen / welche den Fischern offtmahls grossen Schaden thun / wie in der Historien weitleuff-
tig zu lesen.

41 Theodore de Bry *Collectiones peregrinationum in Indiam orientalem et occidentalem* Part 4 *Indiae orientalis*, Frankfurt, 1601. G 6609(4). (*DPB*) With the encouragement of Hakluyt in London, de Bry launched his collections of illustrated voyages and travels in 1590. This engraving (plate 7) includes a copy of Dürer's rhinoceros.

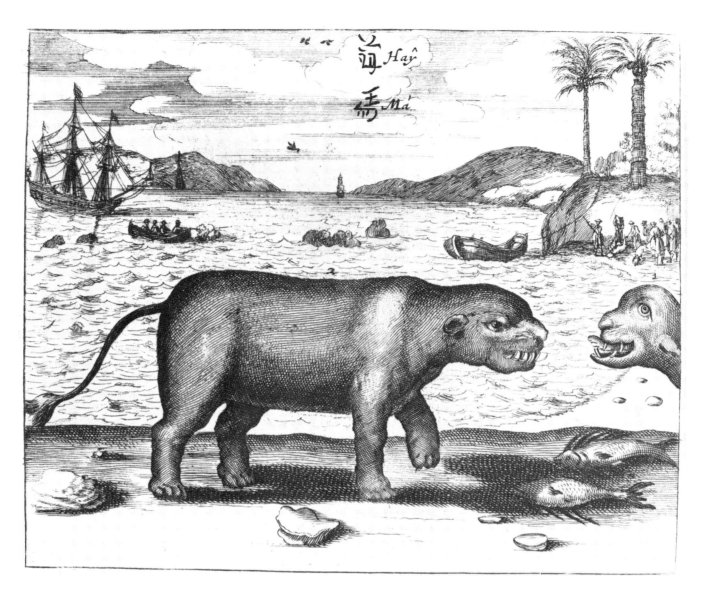

42 Hippopotamus. Engraving. Athanasius Kircher *China monumentis*, Amsterdam, 1667, p. 192. 457 e 3. (*DPB*)

Death of Him who created it'.[1] Pope Alexander VI magnanimously divided this unknown territory in the West between Catholic Spain and Portugal.

When Cortes and his men invaded Mexico one of the many sights that astonished them was Montezuma's vast zoo which had 300 attendants to look after its inmates. Montezuma also had gardens where, according to the chronicler, Cervantes de Salazar, he 'did not allow any vegetables or fruit to be grown, saying it was not kingly to cultivate plants for utility or profit in his pleasance'. Having ruthlessly destroyed the Aztec civilisation, the Spanish systematically set about imposing their own culture. Schools were established. At the College of Santa Cruz an Indian doctor, Martinas de la Cruz, had his notes on native medicine translated into Latin by a fellow Indian, Badianus in 1552. The manuscript, the earliest account of the Mexican flora, is decorated with coloured figures of plants by a native artist clearly influenced by what he had seen in European herbals.

1. C López de Gomara *Historia de las Indias* 1552, dedication to Charles V.

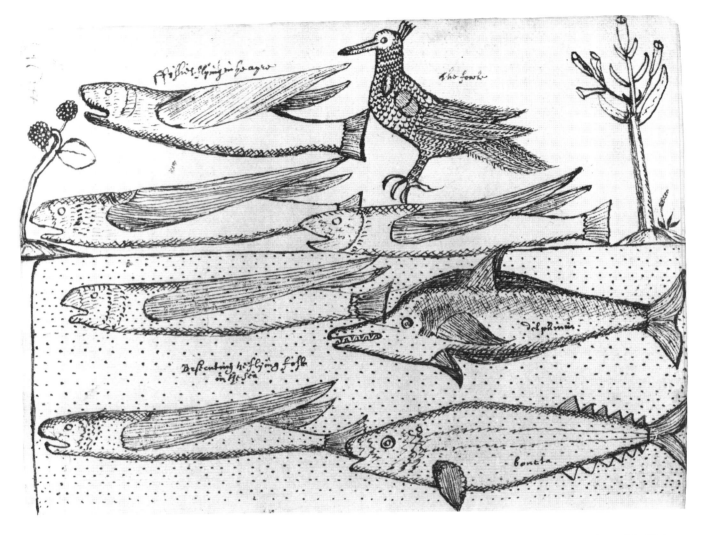

Nicholas Monardes's *Joyfull newes out of the newe founde world*, was one of the first European books to describe the North American flora. Its publication in Seville in 1569 coincided with a decision by Philip II of Spain to despatch his physician, Francisco Hernandez (*c*.1514–87) to Mexico to report on its geography, history, flora and fauna. Reaching Mexico in 1570, Hernandez spent much of his seven years there at the botanic garden at Huaxtepec, which Montezuma had earlier restored. With the assistance of local collectors and artists, he accumulated ten folio volumes of illustrations with another six volumes of explanatory text. He took the precaution of leaving three or four copies of this precious manuscript in Mexico but, unfortunately, none has survived. The original manuscript remained unpublished, except for a short extract in 1615, in the library of the Escorial in Spain where it was destroyed in a disastrous fire in 1671.

The Spanish, Portuguese and French were well established in the New World when the English, made confident by their growing mastery of the sea, appeared on the scene. Under the auspices of Sir Walter Raleigh, the first British colonists landed on Roanoke Island off the coast of North Carolina in 1585. Amongst the

43 Left: Flying fish. Right: Dolphin, Tuna. Francis Fletcher *Account of part of Francis Drake's voyage, 1577–1580*. 1577. Sloane MS 61, folio 13. (*Dept of MSS*)

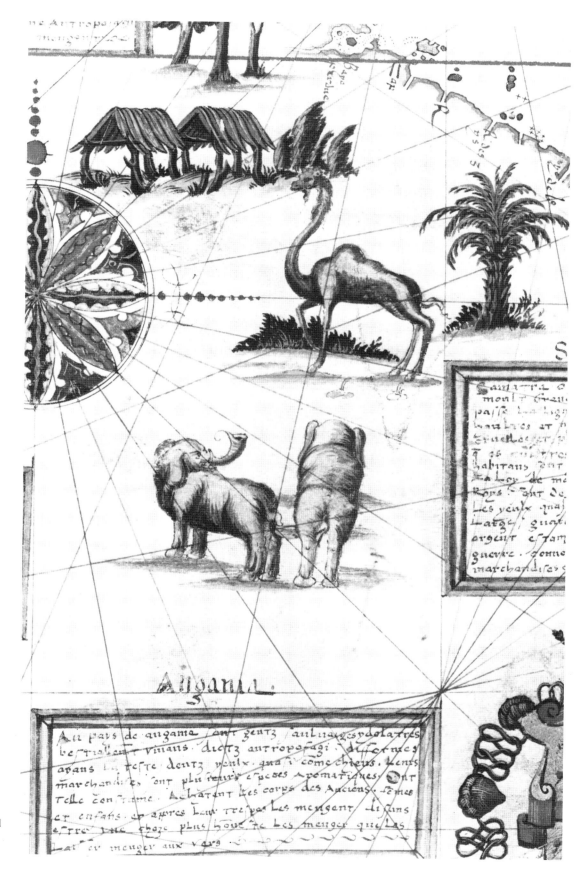

44 Pierre Desceliers *Map of the World.* c.1545–50. Detail showing elephants and a camel. Add. MS 24065. (*Dept of MSS*)

settlers were Thomas Harriot (who had taught science to Raleigh's family), 'to make discription of the lands discouered', and John White, 'an exilent paynter'. White's instructions would presumably have been similar to those issued to Thomas Bavin, Sir Humphrey Gilbert's artist, a few years earlier. Bavin's brief was to 'drawe to lief one of each kinde of thing that is strange to us in England ... all strange birdes, beastes, fishes, plantes, hearbes, Trees and fruites ... also the figure & shapes of men and woemen in their apparell ...'.[2] The colony was evacuated in 1586; when it was re-established the following year White was appointed Governor. Nothing is known about his background but his lively watercolour drawings of Indians and the local fauna bespeak some sort of artistic training. His fish studies are particularly fine. Four of his insect drawings were copied in Mouffet's *Insectorum sive minorum animalium theatrum* (figure 27). Mark Catesby incorporated his Swallowtail Butterfly and some bird drawings in his *Natural history of Carolina*. In White's work can be seen the influence of Jacques Le Moyne (1533–88), the cartographer and artist on the ill-fated colonising expedition of René de Laudonnière to Florida in 1564–65. Le Moyne, a French Huguenot, subsequently settled in England where he published his *La chef des champs* in 1586. A number of its woodcuts were copied from the charming original watercolour studies of flowers and fruit, now in the Victoria and Albert Museum in London.

While newly-independent Holland was at war with Spain, the Dutch West India Company occupied north-eastern Brazil in 1624. Twelve years later, Count Johann Moritz of Nassau-Siegen (1604–79) was appointed Governor-General and Commander-in-Chief. This able administrator, who cherished a vision of an enlightened Dutch colonial empire, established the first European botanical garden and zoo in South America. His entourage included naturalists and six painters of whom only two, Frans Post and Albert Eckhout, are known by name. Post painted landscapes and Eckhout the inhabitants and still-lifes of nuts and fruit which reveal, as no paintings before had done, the astonishing variety and abundance of tropical vegetation. Brazil as observed by Eckhout has a baroque luxuriance. He painted the eighty large canvases of birds of Brazil for the Hoflössnitz Lodge at Radabeul outside Dresden. When Johann Moritz returned to Europe in 1644, he sold four volumes of watercolours and oil sketches of nearly 1,500 figures of animals, birds, insects, plants and natives of Brazil to the Elector of Brandenburg. Moritz commissioned eight Gobelin tapestries woven from Brazilian designs by Eckhout and Post, and financed the publication of *Historia naturalia Braziliae* (1648) by W. Piso and G. Margrave, the first full account of the natural history of any part of the Americas and not superseded for the next 150 years.

Maria Sibylla Merian (1647–1717) was the daughter of a German engraver and publisher and although her interests lay primarily in entomology she became the first of a distinguished line of women flower-painters. With the publication of *Der Raupen wunderbare Verwandelang* (1679–1717), she was the first artist to show insects in association with their host plants. In 1699 she sailed to Dutch Surinam

2. British Library, Department of Manuscripts Add. MS 38823, folios 1–8.

where for two years she and her two daughters drew insects and flowers. The unadventurous entomologist, René Réamur, was much impressed: 'C'a été une espèce de phenomène, de voir une dame traverser les mers pour aller peindre [les insectes] de l'Amerique'. The *Metamorphosis insectorum Surinamensium* (1705) was the splendid outcome. It may be said that the flowers are less well drawn than the insects, but the latter were, after all, the main reason for the book.

The ambition of any naturalist with any spark of adventure used to be an exploration of the Americas. The French monk Louis Feuillée (1660–1732) reached Chile and Peru via Martinique, Venezuela and the Antilles in 1709. He presented Louis XIV with a volume of drawings of the natural products of those two countries. His well-illustrated *Journal* (1714–25) includes his 'Histoire des plantes médicinales de Pérou et Chile'. Charles Plumier (1646–1704) who belonged to the same Minorite order as Feuillée, joined an expedition to the Caribbean in 1689, returning in 1693 and again in 1696. Most of his attention was given to the rich flora of Haiti. His output was prodigious: some 6,000 pen and ink drawings of plants, of which only about 500 were published during his lifetime.

Sir Hans Sloane (1660–1735), who professed that from his early youth he had 'been very much pleas'd with the study of plants, and other parts of nature', had the good fortune to be appointed physician to the Governor of Jamaica from 1687–89. During that very brief stay in the island, he reaped a rich harvest of plants, animals, insects and shells which are described and illustrated in his *Voyage to the islands Madera, Barbados . . . and Jamaica* (1707–25).

Nikolaus Joseph Jacquin (1727–1817) was a Dutch physician whom the Emperor Francis I appointed to take charge of the Royal gardens at Schönbrunn outside Vienna. From 1755 to 1759 he travelled in Martinique, Haiti, Jamaica and South America collecting plants and animals for the gardens and menagerie at Schönbrunn. Jacquin's sketches formed the basis of the plates in his *Selectarum stirpium Americanum historia* (1763). About 1780 a special edition of about eighteen copies, enlarged by about another eighty plates, was issued. The plates in this rare work (there is a copy at the Royal Botanic Gardens, Kew) are *original* drawings, not engravings.

José Celestino Mutis (1732–1808) went to America in 1760 as physician to the Viceroy of New Granada, who encouraged him to study the flora of Colombia. During this survey, up to thirty artists participated in producing 6,000 drawings of plants in natural size and great detail.

The Spanish authorities gave permission to the French botanist, Joseph Dombey, to investigate the flora of South America provided he was accompanied by two young Spanish botanists, Hipolito Ruiz and José Pavon, and two Spanish artists. For ten years (1778–88) this uneasy partnership worked together, but only four of the projected nine volumes of the *Flora Peruvianae et Chilensis* (1798–1802) were ever published.

It seemed to be the fate of many of these projects for drawings to have been neglected and published works not to have been completed. For example, José Mariano Veloso, a Franciscan friar, studied the flora of the neighbourhood of Rio de Janeiro with his artist companion Francisco Solano, from 1782–90. Drawings of over 1,000 plants were deposited in the Imperial Library at Rio until Brazil

became independent in 1825. Pedro I sent the eleven volumes of drawings to Paris for reproduction. All the copies of the books despatched to Brazil were destroyed during the disturbances in that country; the hundred copies providentially retained in Europe are all that survived.

It was a meeting with J. G. A. Forster, the naturalist on Cook's second circumnavigation, that made Alexander von Humboldt (1769–1859) determined to travel. This ambition was realised when he and the French botanist, A. J. A. Bonpland, surveyed and collected botanical, zoological and geological specimens in Central and South America during 1799 to 1804. The thirty volumes of his *Voyages aux régions équinoxiales du nouveau continent* (1805–32) surveyed an enormous range of subjects and was one of the most influential publications of the nineteenth century. Darwin claimed that his future career was resolved after reading Humboldt.

Linnaeus's brightest pupils, or 'apostles', as he somewhat pretentiously called them, were inspired by his teaching to extend the boundaries of knowledge by discovering and collecting new specimens in distant countries. Few parts of the known world were overlooked: Thunberg went to Japan, Osbeck to China, König to India, Sparrman to South Africa, Hasselqvist to the Middle East, Kalm to North America, Löfling to South America – the roll-call includes some of the most assiduous collectors of the mid-eighteenth century. They all endured great hardships and some of them died during their travels. Linnaeus was momentarily distraught. 'The deaths of many whom I have induced to travel have made my hair grey, and what have I gained? A few dried plants, with great anxiety, unrest and care'. Daniel Solander became one of the most widely-travelled pupils of Linnaeus, as one of the company who made the voyage around the world in Cook's *Endeavour*.

In 1768 the Admiralty re-equipped a Whitby-built coal boat, re-named it the *Endeavour*, and selected James Cook as its captain with instructions to sail to the Pacific to make observations of the transit of the planet Venus. That the natural history importance of the voyage overshadowed the astronomical was due to a young Lincolnshire squire whose life, the Reverend Sydney Smith wrote, might so easily have been devoted to 'double-barrelled guns and the prosecution of poachers'. That young man, Joseph Banks (1743–1820), had his appetite for travel whetted and his interest in natural history confirmed during a voyage in 1766 on HMS *Niger* to Labrador, Newfoundland and Portugal. Already a Fellow of the Royal Society at the age of twenty-five, he used the Society's influence to enable him to join the *Endeavour* with selected companions 'for the advancement of useful knowledge'. On 19 August 1768, a week before the *Endeavour* left Plymouth, John Ellis wrote to Linnaeus about Banks's preparations for the voyage. 'No people ever went to sea, better fitted out for the purpose of Natural History, nor more elegantly. They have got a fine library of Natural History; they have all sorts of machines for catching and preserving insects; all kinds of nets, trawls, drags and hooks for coral fishing; they have even a curious contrivance of a telescope by which, put into the water, you can see the bottom to a great depth, where it is clear. They have many cases of bottles ... to preserve animals in spirits. . . . They have two painters and draughtsmen, several volunteers

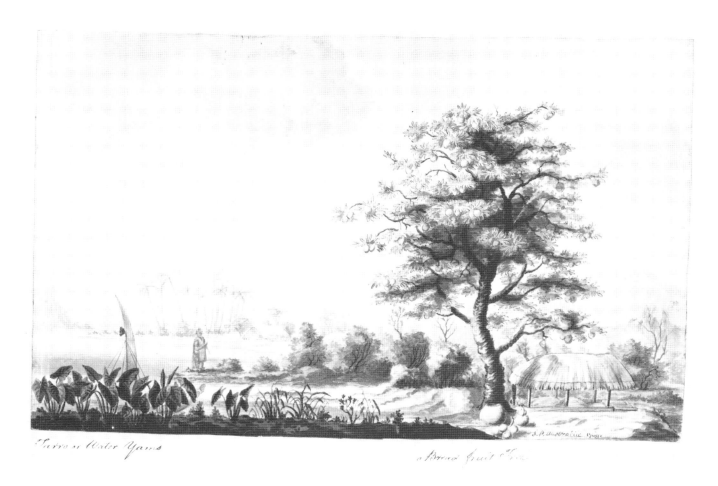

Taro & Water Yams

a Bread Fruit Tree

45 Sydney Parkinson. A view in Tahiti with yams and a breadfruit tree. 1769. *A collection of drawings made in the countries visited by Captain Cook in his first voyage.* Add. MS 23921, folio 9(b). (*Dept of MSS*)

who have a tolerable notion of Natural History ...'. And, concluded Ellis obsequiously, 'all this is owing to you and your writings'.[3] Banks's party included Linnaeus's pupil, Daniel Carl Solander, now domiciled in England, as naturalist, H. Spöring as assistant naturalist and two artists – Alexander Buchan, a figure and landscape painter, and Sydney Parkinson, a botanical artist. Banks's decision to engage artists may have been prompted by Richard Walter's expression of regret in his 1748 edition of Anson's *Voyage*: 'I cannot ... but lament how very imperfect many of our accounts of distant countries are rendered by the relators being unskilled in drawing'. There was nothing new in this remark. As long ago as 1585, Richard Hakluyt the Elder had tried to persuade the organisers of an expedition to North America that 'a skilful painter is also to be carried with you, which the Spaniards used commonly in all their discoveries to bring the descriptions of all beasts, birds, fishes, trees, townes etc'. William Dampier, buccaneer, circumnavigator and (incongruously) naturalist, made a voyage of exploration in the Pacific for the Admiralty. Dampier's account of his mission, *A voyage to New-Holland in the Year 1699*, disclosed that he had on board for the first time in any of his voyages 'a Person skill'd in Drawing'. When the frigate *Boudeuse* and the supply ship *l'Etoile* left Nantes in 1766 under the command of L. A. de Bourgainville to sail round the world, the crew included a naturalist,

3. J. E. Smith *A selection of the correspondence of Linnaeus* vol 1, 1821, pp 230–32.

Philibert Commerson, and a draughtsman, Jossigny. So, there were already precedents for Banks's complement of naturalists and artists; but it was the *Endeavour* voyage which established the pattern for all future scientific voyages.

Sydney Parkinson sketched the plants collected by Banks and Solander, who also made rapid descriptions before the plants lost their freshness. Often Parkinson provided no more than pencilled outlines of leaves and flowers, done at great speed, adding colour notes; only 269 of his 943 plant portraits are finished drawings. When Buchan died in Tahiti, Parkinson became the expedition's only professional draughtsman, with some able assistance from Herman Spöring, whose artistic talents helped to swell the visual records of ethnographical, zoological and topographical subjects. Within two days of each other, while the *Endeavour* was off Java Head in January 1771, Spöring and Parkinson died of fever. Banks had every intention of publishing the scientific results of the voyage and on his return to England in 1772, engaged a team of artists to work up Parkinson's sketches aided by herbarium specimens. Just over 750 of these finished drawings of plants were engraved, but Banks's ambition probably outstripped his pocket and their publication was abandoned. Fortunately, the copper plates have remained intact, and now 200 years after they were made, they are being printed in one of the most ambitious publishing ventures of this century.

After a disagreement with the Navy Board, Banks refused to participate in Cook's second voyage and went off in a pique to Iceland with his new 'articled draughtsman', John Frederick Miller. Johann Reinhold Forster joined Cook's *Resolution* as naturalist, taking with him his son, Georg, as natural history draughtsman. The Forsters proved cantankerous companions, and Cook, no doubt now apprehensive of all professional naturalists, appointed his surgeon's mate, William Anderson, as naturalist and his assistant, William Ellis, as draughtsman on his third and last voyage in 1776.

Sir Joseph Banks, now the influential President of the Royal Society, had suggested Botany Bay in Australia as a suitable site for the new penal colony, and it was ready for occupation in January 1788. Mindful of Banks's botanical interests and his desire to enrich the royal gardens at Kew, the early governors sent him plants, seeds, and drawings. The artists available to them were either talented naval personnel such as George Raper and the unidentified 'Port Jackson Painter', or convicts (PLATE 36). For example Thomas Watling, transported for forgery, was assigned as hospital clerk to the Surgeon General, John White, who swiftly seized the opportunity to employ a professional painter to record the landscape and natural history of the colony. It is believed that some of the drawings of the 'Port Jackson Painter' were engraved in White's *Journal of a voyage to New South Wales with 65 plates of non-descript animals, birds, lizards, serpents, curious cones of trees and other natural productions* (1790). White's collection of drawings were also used in J. E. Smith's *Specimens of the botany of New Holland* (1793–95), the first account of the flora to be published in England.

Under the patronage of Sir Joseph Banks, who now wielded such influence that his wishes were seldom opposed, Matthew Flinders sailed from Spithead in July 1801 in the *Investigator* to survey the Australian coastline. The 'scientific gentlemen' appointed by Banks to accompany Flinders were Robert Brown,

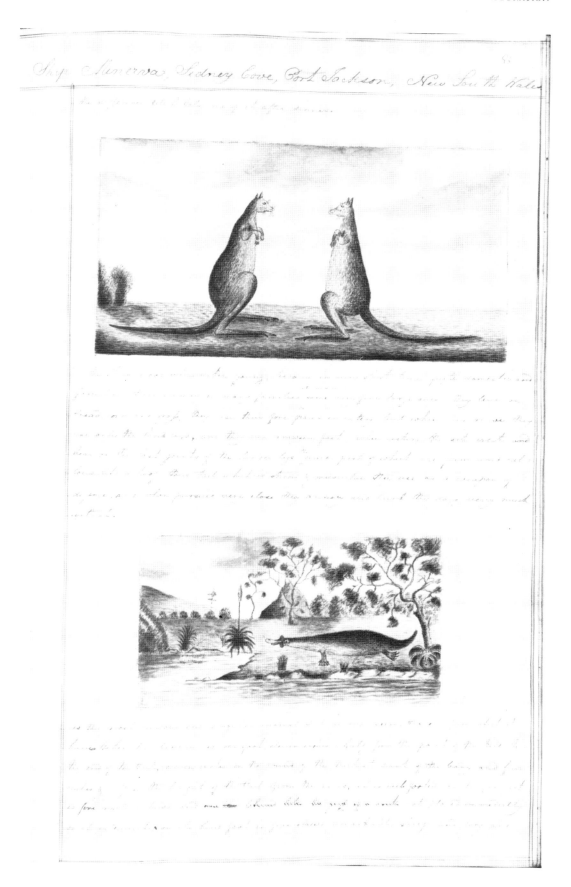

46 Kangaroo (*Macropus sp.*) and Duck-billed Platypus (*Ornithorhynchus anatinus*). *A journal kept on board the Minerva transport from Ireland to New South Wales by I. W. Prince, Surgeon.* 1798–1800. Add. MS 13880, folio 86. (*Dept of MSS*)

botanist, and Ferdinand Bauer, natural history draughtsman. Bauer was an incomparably better artist than Sydney Parkinson. His method of working was different too; where Parkinson relied on outline sketches with colour notes, Bauer's sketches were much more informative, and he had also devised a sophisticated colour chart. Robert Brown, a man of exacting standards, proclaimed Bauer's drawings 'for beauty, accuracy and completion of detail unequalled in this or any other country in Europe'. As Bernard Smith so aptly put it, Bauer 'never lost sight of a plant as a unified whole, so that he avoided both the dryness of science and the sweetness of sentiment'.[4] It was a grave loss to botanical literature when Bauer discontinued his *Illustrationes florae Novae Hollandiae* (1813) after only fifteen plates had been superbly drawn, engraved and coloured by him.

Great Britain was not the only country to sponsor scientific voyages. Five zoologists, three botanists, four astronomers and hydrographers, two mineralogists, and four artists were recruited by the French Institut National for the voyage in 1800–04 of the *Géographie* and the *Naturaliste*, commanded by Nicolas Baudin. Subsequent French voyages yielded generously illustrated scientific reports: *Uranie* and *Physicienne* under Freycinet, 1817–20; *La Coquille* under Duperry, 1822–25; *Astrolabe* under d'Urville, 1826–29 and 1837–40; *La Bonite* under Vaillant, 1836–37 and *La Vénus* under Du Petit Thouars, 1836–39.

In 1831, HMS *Beagle* was equipped by the British Admiralty to explore the coasts of Patagonia, Chile and the islands in the Pacific. Surprisingly, no provision was made for the employment of scientific personnel. Darwin was taken on as an unpaid naturalist; Captain Fitzroy himself paid the salaries of the artist, Augustus Earle and his successor Conrad Martens. Many of the officers on the *Beagle* were, however, competent artists – the result, no doubt, of the instruction in draughtmanship that most naval officers received during their training. But it was Mrs Gould, with some assistance from Edward Lear, who illustrated Darwin's *Zoology of the voyage of HMS Beagle* (1841). Lear also drew some of the illustrations in the *Zoology of Captain Beechy's voyage* (1839), which recorded the specimens collected during a voyage by HMS *Blossom* in the Pacific and Behring's Straits, 1825–28. Gould provided the bird plates for *Zoology of the voyage of HMS Sulphur* (1843–44) and Miss Drake (she was one of the artists for Bateman's *The Orchidaceae of Mexico and Guatemala*) the figures for the *Botany of the voyage of HMS Sulphur* (1844–46). W. H. Fitch, the official artist at Kew Gardens, lithographed the plates in Berthold Seemann's *Botany of HMS Herald* (1852–57) and most of the plates in J. D. Hooker's *Botany of the Antarctic voyage* (1844–59). The most scientifically sophisticated voyage of the century was that of HMS *Challenger*, a three-masted corvette with auxiliary steam, which carried out experiments in deep sea soundings and investigated marine life in the Atlantic, Pacific and Antarctic Oceans from 1872 to 1876. This global voyage of over 68,000 nautical miles generated fifty illustrated volumes of reports.

4. B. Smith *European vision and the South Pacific* 2nd Edition, 1985, p 190.

9. The Islamic world and Asia

BY THE NINTH CENTURY the Islamic Empire stretched from Spain, along the coast of North Africa, through the Middle East to the banks of the Indus River in the Indian sub-continent. It became the inheritor and disseminator of the culture of its subject peoples. A Greek-speaking educated class introduced the Arabs to the philosophy and science of late antiquity through the works of Aristotle, Dioscorides, Euclid, Galen, Hippocrates and Theophrastus. Long after its recapture from the Arabs in 1085, Toledo remained a scholastic centre where Arabic as well as Greek and Latin texts were studied.

For Islamic scholars natural history embraced cosmogony (a theory of the origin of the universe) and sacred history in addition to botany, zoology and geology. The physical and spiritual worlds were inseparable; animals, plants and rocks were evidence of God's omnipotence. Thus the study of Nature had theological and moral as well as scientific connotations. Though religious tenets forbidding the representation of living things were not always observed, there was a tendency in Islamic art towards a decorative rather than a scientific interpretation of animals and plants.

The ninth-century Arabic scholar and man of letters, al-Jahiz, treated zoology from both a scientific and theological point of view in his *Book of animals* (*Kitab al-Hayawan*), an encyclopedic compilation of facts and anecdotes gleaned from the Quran, Aristotle, folklore and personal observation. Written by one of the most accomplished Arabic prose stylists, the book was assured of popular acclaim; however, only one illustrated copy of the manuscript is known to have survived, a fourteenth-century copy from Mamluk in Egypt, now in the Ambrosiana Library in Milan.

Islamic works of natural history range from the literary writings of al-Jahiz and the book of fables, *Kalila wa-Dimna* of Ibn al-Mukaffa, to the cosmological compendium of al-Qazwini. Born in Persia, al-Qazwini (1203–83), like al-Jahiz lived most of his life in Baghdad. His *Wonders of creation* (*Ajaib al-Makhluqat*) became one of the most popular texts in the Islamic world and was still being copied in Persia and India in the nineteenth century. Heavenly and earthly existence was reviewed and the natural world discussed under three categories – mineral, vegetable and animal. The earliest known copy of this manuscript, now in the Staatsbibliothek in Munich, was written three years before its author's death. A few years ago the Department of Oriental Manuscripts and Printed Books in the British Library purchased a copy which has been dated to about AD 1300 (figure 48). The illustrations in both copies show signs of Chinese influence, but in the main conform to traditional idioms of Islamic art.

Distracted, like European scholars, by the medicinal and agricultural uses of plants, Muslims gave less attention to the study of animals. Arab physicians were

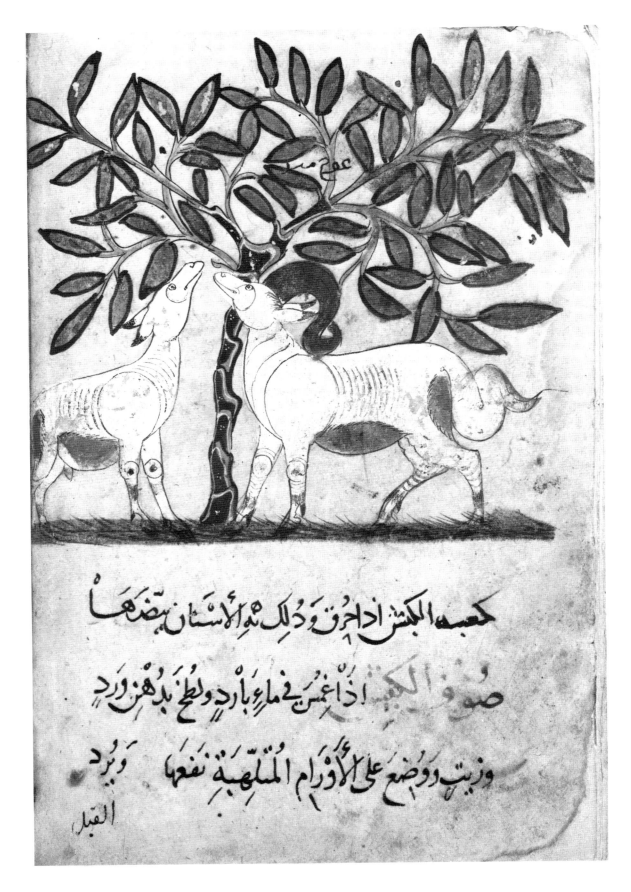

كعسه الكبش اذا احرق و ذلك مو الأسنان يضها

و صوف الكبر اذا اغمس في ماء بارد و لطخ بدهن ورد

و زيت و وضع على الأورام الملتهبة نفعها و يبرد

القبل

47 *(Left)* Persian fat-tailed sheep *(Ovis aries)*. *Na't al-Hayawan*. Arabic. 13th century. Or. 2784, folio III v. *(OMPB)*
Compiled from a description of animals in Aristotle's writings incorporating statements on their medicinal properties from an 11th century work by Ibn Bakhtishu.

48 *(Right)* Date palm *(Phoenix dactylifera)*. al-Qazwini *The wonders of creation* (Ajaib al-makhluqat). Arabic. c.1380. Or. 14140. *(OMPB)*

expected to have an expertise with drug plants and their *vade mecum* was the *Materia medica* of Dioscorides. Stephanos, son of Basilios, a Christian of Baghdad, translated Dioscorides into Arabic in the ninth century. It was revised and expanded by later Arabic writers. The earliest surviving version of Dioscorides, written in AD 1083, has over 600 drawings with human figures demonstrating diseases for which the accompanying plants promised a cure. The Byzantine illustrations of the Greek texts of Dioscorides accessible to Muslim writers interpreted plants in a simplified form; in Arab hands this simplification was transmuted into stylisation (figure 49).

People picking fruit, reaping corn, hunting, fishing, making love and all the other familiar aspects of human activity were painted with a Chaucerian appetite by the illustrators of the medieval health handbook *Tacuinum sanitatis*. Arabic medicine, possibly the Arab physician Ibn Botlan himself, inspired the prescriptions in these handbooks. The word *Tacuinum* comes from the Arabic *taqwin*

49 Top: *Aeonium arboreum*. Dioscorides *De simplicibus libri III, IV*. Arabic. 1334. Or. 3366, folio 142. (*OMPB*)
By the 14th century, figures in Arabic medical works were as stylised as those in European herbals. The bottom
figure cannot be identified.

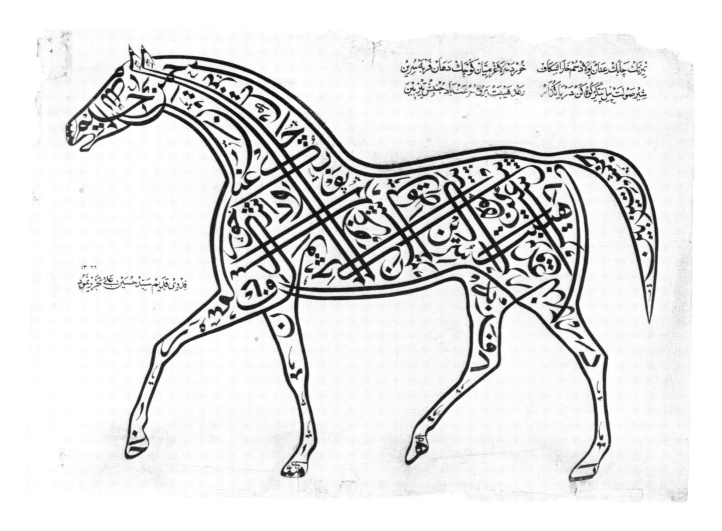

50 Tughra calligraphy by Sayyid Husain Ali. 1849. *(IOLR)*
The opening verses of the Quran start at the mouth of the horse; the remainder of the text, repeating the two verses in Persian in the top right-hand corner, praises the physical qualities of the animal.

meaning a table; in this instance a table of health based upon a consideration of animal and vegetable foods, drink, clothing and state of mind. With the aid of homely illustrations they offered practical advice for well living, and found a receptive and appreciative audience in the West.

Calligraphy, which for Muslims is the vehicle for the word of God, became a medium of exquisite sensibility in Islamic culture, a decorative feature of infinite subtlety on stone, metal, pottery and paper. It was a sixteenth-century Persian calligrapher endowed with an elegant hand and good taste who devised a mode of writing which fashioned the cursive Arabic script into images of men and beasts, thus circumventing the religious prohibition on the pictorial representation of living beings. This ingenious and imaginative manipulation of the supple strokes of the calligrapher's pen is known as *Tughra*. The parrot and the lion – symbolic of Ali – were favourite motifs for amulets and decoration in Muslim homes. The outline of the animal encompassed a sentence from the Quran or a suitable prayer (figure 50).

In the Islamic world the calligrapher and illuminator depended upon princely patronage. Nowhere was this more evident than in Persia, with each new dynasty supporting large workshops of artists and craftsmen. Persia was a dynamic centre

of Islamic culture, its chief contribution from the fourteenth century being the art of the book. A page of a Persian manuscript is a harmonious integration of graceful calligraphy and delicate miniature, the outcome of a perfect partnership of scribe and illuminator (PLATE 23). Just about the time that European painters were experimenting with landscape, the Persian illuminator made landscape an essential component of his vision of the unity of man and Nature. His figures share a landscape of contorted pink-grey rocks, sinuous trees, a floral display of indeterminate plants with a community of animals and birds. Plants provided colour: only a few, such as the iris or the rose, the cypress or the plane tree, are recognisable with any certainty. However the flowers of Mir Sayyid 'Ali, one of the great illuminators of the Safavid school at Tabriz, were painted with a devoted accuracy. Impressed by his work, the exiled Mughal Emperor, Humayan, invited him to return to India with him.

Soldier, statesman and scholar, Babur (1483–1530), the first Mughal Emperor, was not only the founder of a distinguished dynasty but also a keen and observant naturalist. In the midst of his campaigns and conquests he could always find time to examine an unfamiliar flower or to note an unusual bird. A Mongol whose ancestors included Genghiz Khan and Timur, he was 'an attractive person, a typical Renaissance prince, bold and adventurous, fond of art and literature and good living'.[1] His memoirs, the *Baburnama*, record his constant wonder and pleasure on seeing new animals, birds and plants (PLATES 25–27). On his death, after a brief five years' reign in India, he was succeeded by his son, Humayan (1508–56). Indecisive, and without his father's military genius, Humayan was forced to flee from India in 1540, seeking refuge in the court of the Persian ruler, Shah Tahmasp (PLATE 29). With Shah Tahmasp's help he regained his throne, bringing back with him two notable Persian painters, Mir Sayyid 'Ali and Abd al-Samad, who were to become the founders of a new school of Mughal painting. A cynic might be tempted to observe that being the founder of Mughal painting and the father of Akbar were Humayan's only two positive achievements.

Akbar the Great (1542–1605) enlarged and consolidated the Mughal Empire, and though illiterate, showed a remarkable tolerance and understanding of other religions and philosophies and a sincere love of architecture, literature and art. Taught the rudiments of drawing as a boy, he had an abiding interest in painting and extended the *atelier* founded by his father. Since his enquiring mind resented the restrictions placed upon artists by Islam, he encouraged them to draw living creatures. The decorative conventions of Persian art were slowly yielding to a new realism which evolved from Akbar's preference for naturalism and the lessons of perspective, foreshortening and portraiture learnt from European pictures. The partnership of Hindu and Persian artists in Akbar's studios introduced a new vitality into the traditional Persian miniature whose sensuous beauty became imbued with a more robust Indian sensibility. Akbar had his grandfather's memoirs translated from the original Chaghatai Turkish into Persian and early illustrated copies of the *Baburnama* depict animals and plants with vigour, honesty and evident enjoyment (PLATES 25–27).

1. Jawaharlal Nehru *The discovery of India* 4th edition, 1956, p 255.

Many of the painters employed by Akbar continued to enjoy royal patronage under his son, Jahangir (1569–1627). They completed a version of the *Anvar-i Suhaili* undertaken during the last year of Akbar's reign (PLATE 30), maintaining a conscious verisimilitude, now the hallmark of all their natural history drawing. These miniatures, however, were cast in the standard mould – a crowded composition closely linked to the narrative. The fashion for portraiture and nature studies gradually relaxed this symbiotic relationship; people and animals were taken out of this context and appreciated for their own sake. Animals were drawn as zoological specimens. Both Jahangir and Babur were dedicated naturalists and Jahangir emulated his great-grandfather by also keeping a journal, the *Tuzuk-i-Jahangiri*. Babur viewed Nature with an untrained curiosity and childish wonder; whereas Jahangir made observations and carried out experiments with scientific thoroughness. He firmly believed in keeping visual records. 'Although King Babur has described in his Memoirs the appearance and shapes of several animals, he had never ordered the painters to make pictures of them. As these animals appeared to me to be very strange, I both described them and ordered that painters should draw them in the *Jahangir-nama*, so that the amazement that arose from hearing of them might be increased'.[2] Artists were always at hand to draw whatever intrigued him: the first zebra to be seen in India, a turkey cock from the New World, an African elephant. He admired a falcon: 'There were many beautiful black markings on each wing, both back and sides. As it was something out of the common, I ordered Ustad Mansur, who has the title of *Nadir-ul-'asr* (Wonder of the age), to paint and preserve its likeness'.[3] Jahangir also mentions that Mansur painted over a hundred flowers on a visit to Kashmir; unfortunately, only three flower studies now exist by the master of animal and bird painting who started his career under Akbar. Mansur painted directly from Nature, filling outlines with colour washes and fixing detail with body colour. His birds stand out boldly and motionless against an austere background of a few boulders or plants; there is no incidental decoration to distract the eye.

A painting of a western Asiatic tulip, *Tulipa montana*, by Mansur, adopts the formal pose of a European flower study. Mughal artists copied the engraved plates of European flower books and herbals with the same facility that enabled them to adapt Western portraiture and incorporate Western landscape into their miniatures. One positive identification has been made; a seventeenth-century Mughal painting of a Martagon Lily in the Victoria and Albert Museum was copied from Pierre Vallet's florilegium, *Le jardin du très Chrestien Henry IV*.[4] Not disciplined by any botanical knowledge, Mughal artists felt free to modify plant forms and colours to create hybrids impossible in Nature. By Shah Jahan's reign flowers had become an ubiquitous motif in the *pietra dura* enrichment of marble and in carpet and textile design.

By the seventeenth century Mughal artists had at their disposal a rich legacy of technical skills. They knew how to make pigments from minerals, earths, insects

2. *The Tuzuk-i-Jahangiri, or Memoirs of Jahangir*. Edited by H. Beveridge, vol 1, 1909, p 215.
3. *Ibid* vol 2, 1914, p 108.
4. R. Skelton, 'A decorative motif in Mughal art'. In P. Pal *Aspects of Indian art* 1972, pp 147–52.

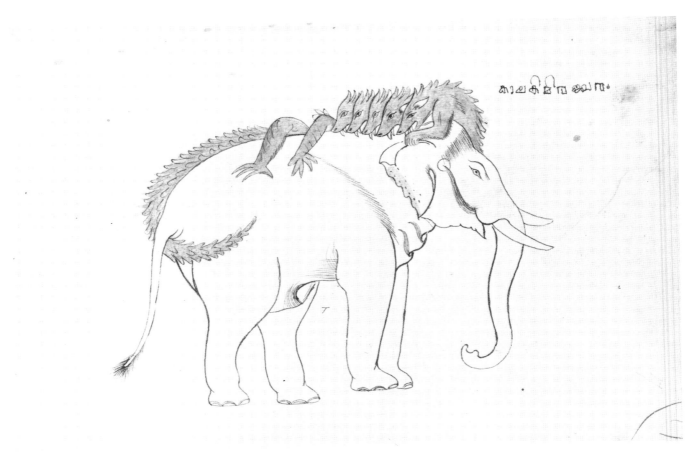

51 *Diseases of an elephant emblematically expressed by the King of Travancore's brother.* Late 18th century. Add. MS 19249, folio 17. (*Dept of MSS*)
The health of elephants was a matter of considerable concern to Indian princes. Manuals illlustrated diseases caused by devils or demons in this graphic way. This particular drawing refers to a neck complaint.

and animal substances; how to select hairs for their brushes with just the right amount of stiffness or flexibility from the tails of cats or squirrels, the ears of calves or donkeys and the barks and fibres of particular trees; how to manipulate these brushes of varying amplitude, some with only a single hair; and how to apply the watercolours, burnishing the back of the paper with a smooth crystal or agate after the application of each layer of colour. Such accomplishments meant nothing to Aurangzeb, a religious bigot, who seized the throne by murdering his elder brother, Dara Shikoh, and imprisoning his father, Shah Jahan. As an orthodox Muslim, he was no friend of the arts; denied his patronage, the royal studios closed and artists sought employment in the courts of the Mughal governors in Bengal, Oudh and Hyderabad. In Rajasthan, former artists of the Mughal court enjoyed the support of Raj Singh and his son, Sawant Singh, and helped to forge a new regional school of painting that combined Mughal naturalism with the Hindu innate feeling for all living things.

The rapport that Hindus have with the animal world has its origins in Vedic times when all life was seen as an integral part of a great cosmic design. The faith enshrined in ancient Vedic hymns endured in the Paranas and the Epics. All creatures are variant forms of Brahma. A belief in reincarnation confirms the existence of a harmony which regulates the natural world. Thus it is reasonable that animals should personify gods. Those unknown sculptors who carved with such animation the elephants, horses, snakes and monkeys at Amaravati, Bharhut

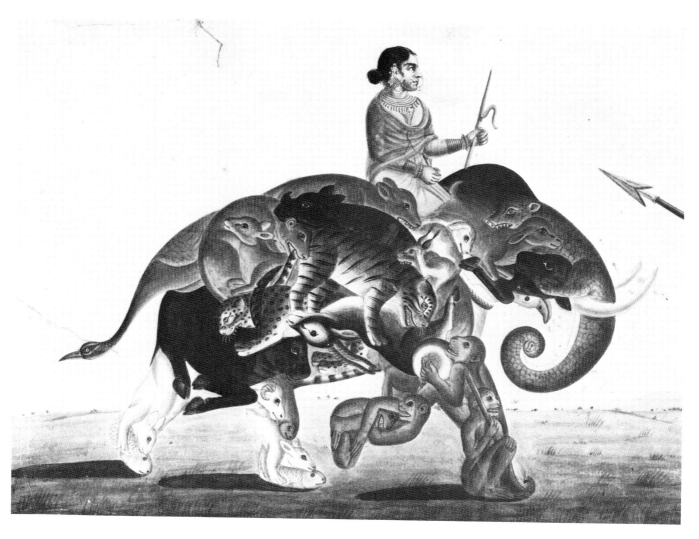

52 Composite elephant. Indian. 19th century? (*IOLR*) Pictures of animals made up of a mosaic of other creatures have an ancestry extending back to Akbar's reign and probably earlier.

and Sanchi, were inspired by a sympathetic – an intuitive – understanding of their fellow creatures. Hindu painting was less contrived, seemingly more spontaneous than Mughal art; colours were usually flat, not carefully blended. An exuberance in design, an intoxicating delight in primary colours characteristic of Hindu art have survived to the present century in the fresh, direct, untutored folk art, conveniently labelled 'popular paintings' (PLATE 48).

There is ample literary evidence to show that Indians of Vedic times knew enough about plants to devise a rudimentary classification of vegetation into trees, herbs, creepers, flowering and non-flowering, fruit-bearing and fruitless plants. This broad classification became more precise in the post-Vedic era, but India had to wait until the seventeenth century for the first systematisation of its flora. Hendrik Adriaan van Rheede tot Draakenstein (1637–92), appointed Governor of the Dutch possessions in Malabar in South India in 1669, believed it would be more convenient and economical to make use of native plant medicines than to rely upon uncertain supplies from Europe. The compilation of a list of such plants was a prerequisite. Knowledgeable Indians collected the plants and a small team of artists (two came from families of painters in the Low Countries) painted them.

Finally 725 different species were illustrated on nearly 800 copper plates, excellently engraved in Holland where the book was published in twelve volumes from 1678 to 1703. The *Hortus Indicus Malabaricus*, which remained the most authoritative work on the Indian flora until the late eighteenth century, established rigorous standards in botanical illustration. The lines of each illustration are crisp and wiry, thrusting confidently across the double-spread of pages. There are inaccuracies which might be forgiven in the intoxication of these sweeping rhythms (figure 53).

Although the *Herbarium Amboinense* (1741–50) is strictly a flora of the small island of Amboina, west of New Guinea, the plants it describes have a much wider geographical distribution, and botanists in India found it useful. It is possibly the most ill-fated book in the annals of botanical literature. When it was almost ready to be submitted for publication after seventeen years of devoted labour, the author, Georg Rumpf (1627–1702) went blind. Then his wife, his amanuensis, died in an earthquake. In 1687 all the illustrations prepared for the book were lost in a fire that destroyed Rumpf's house. Friends and his son Paul replaced the lost

53 Bamboo *(Bambusa* sp.) Engraving. Hendrik Adriaan van Rheede tot Drakenstein *Hortus Indicus Malabaricus,* Amsterdam, 1678–1703, vol 1, figure 16. X976. *(IOLR)*

Canarium odoriferum hirsutum:
Camacoan.
Libr. 3. Cap. 9

Pieter de Ruyter Fecit

die 29 9b 1692

54 *Canarium hirsutum*. Pieter de Ruyter *Plants of Amboina*. 1692. Add. MS 11027, folio 9. (*Dept of MSS*)
Pieter de Ruyter, a soldier, was one of Georg Rumpf's assistants. He was trained by Philips van Eyck, a draughtsman
sent to Amboina in 1688 to redraw the plants after Rumpf's original drawings were lost in a fire in 1687.

drawings but misfortune continued to impede the work (figure 54). The ship carrying the first half of the manuscript to Holland was captured and destroyed by the French. When a replacement copy finally did reach Holland it remained neglected in the archives of the Dutch East India Company until 1736 when Jan Burman edited it for publication. Thirty-nine years after Rumpf's death, the first of the six volumes was published. But the bad luck which haunted this book lingered on. In 1913 a Canadian botanist, Charles Robinson, went to Amboina to collect plants for a re-assessment of the *Herbarium Amboinense*. Before his collecting was finished he was murdered by superstitious natives who had identified him with a local evil spirit.

It was the Dutch monopoly of the pepper market that persuaded a group of London merchants to form a British East India Company in 1599. The small fleet of ships that this infant Company sent to South East Asia in 1601 came back with a fortune in cloves, cinnamon and nutmeg. Cloth bought in Surat on the western coast of India for £5,000 could be bartered at Bantam in Java for pepper which would then fetch £20,000 back in Europe. It was partly the need for Indian cotton fabrics and opium with which to barter in this lucrative spice trade that made it imperative that the British had a base on the Indian coast. It was trade and not territory that guided the decisions of the Court of Directors of the Company in London; but conquest came as an inevitable consequence of that goal and, before the eighteenth century was out, the East India Company found itself unwillingly in control of vast areas of India.

When wives joined their husbands in India it was not just the heat, dust and all the tribulations of tropical life that taxed them. An abundance of servants gave them a surfeit of leisure and for some of them an interest in natural history became a refuge from boredom. The nineteenth-century writer Emma Roberts, who busied herself with many aspects of Indian life, wrote that 'there are so very few methods for the employment of the time for the softer sex in India, that a love of natural history opens up endless fields of pleasurable research to those who have enjoyed the taste for it'. Lady Impey, wife of Sir Elijah Impey, Chief Justice of the Supreme Court in Calcutta, studied the Indian fauna with commendable diligence. She had a large menagerie in Calcutta and employed three artists – two Hindus and a Muslim – to paint birds and animals. By the time her husband was recalled to England in 1783, nearly 200 bird paintings had been executed in decorative postures on detached branches or standing with minimal or no background. The artists applied their colours in the painstaking Mughal manner of burnished layers. John Latham consulted the Impey drawings for his *General synopsis of birds* and George Edwards copied at least one animal for his *Gleanings in Natural history*.

While he was in India from 1765 to 1784, James Forbes filled 150 note-books with sketches and comments on its fauna, flora, archaeology and customs. In the introduction to his *Oriental memoirs* (1813–15), he disclosed that this record 'formed the principal recreation of my life. The pursuit beguiled the monotony of four Indian voyages, cheered a solitary residence at Anjengo and Dhuboy, and softened the long period of absence from my native country'. A few of his

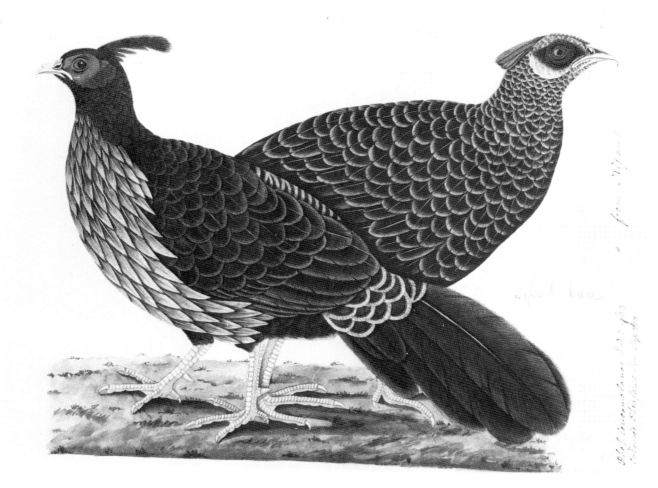

55 Nepal Kalij Pheasant *(Lophura leucomelana).* One of the 2,660 drawings of animals, plants, insects and fishes from India and elsewhere in the East in the Marquess Wellesley collection. Late 18th and early 19th centuries. NHD 29 no 73. *(IOLR)*

competent drawings of birds and flowers were lithographed in *Oriental memoirs.*

The museum of the Asiatic Society in Calcutta and the India Museum, Linnean Society and Zoological Society in London were beneficiaries of General Thomas Hardwicke's collecting zeal. An enthusiastic naturalist, the many volumes of the drawings he commissioned are now in the British Museum (Natural History) and the British Library (PLATES 34 and 35). He and Lady Impey and James Forbes are outstanding examples of amateur interest and participation which contributed in no small degree to the progress of natural history studies in Britain as well as in its overseas territories. They made valuable observations and collections for the professional biologist to evaluate.

One of the first professionally-trained botanists to reach India was Johann Gerhard König (*c.*1728–85), a pupil of Linnaeus. He joined the Royal Danish Mission at Tranquebar in the Madras Presidency as a physician in 1768. There he met other Europeans with botanical proclivities: J. and J. G. Klein, J. P. Rottler, C. S. John and B. Heyne. After a few years as naturalist to the Nawab of Arcot, König went to Siam and the Straits of Malacca on behalf of the East India Company to study plants yielding gamboge, cardamoms and other commercial products. König was the first botanist to apply Linnaeus's plant classification in

South Asia. His competence and industry led eventually to his appointment as the Company's official botanist in Madras in 1782. When König died in 1785, Sir Joseph Banks, who acquired his plant collections and notes, said that he had repaid the East India Company 'a thousand fold over in matters of investment, by the discovery of drugs and dying materials fit for the European market'.[5]

The Company, ever mindful of the potential economic uses of plant and animal products, usually gave every encouragement and facility to suitably qualified officials, such as doctors, to engage in some research. So when König died he was promptly replaced as naturalist in the Madras Presidency by Patrick Russell, also a physician. Russell urged that König's researches on the useful plants of Coromandel (*i.e.* the east coast of the Madras Presidency) should be published, under the supervision of Sir Joseph Banks. Banks concurred and also proposed that it should be illustrated with plates that took William Curtis's *Flora Londinensis*, then currently appearing in part numbers, as their model. It was, however, left to William Roxburgh (1751–1815), Russell's successor in 1790, to implement this project. By July 1794 he had sent some 500 drawings to Sir Joseph Banks, who was confident that European botanists would find them more satisfactory than the illustrations in the *Hortus Indicus Malabaricus* and *Herbarium Amboinense*. Roxburgh, who trained his Indian artists, admitted to Sir Joseph that 'there is a degree of stiffness [that] runs through the whole of my drawings, particularly, the first, which now begins to wear off, so that I think you will be better pleased with those I am about to send than with any of the former, the same men have drawn the whole, but they daily improve, tho very slowly'.[6] William Tennant, a Company chaplain, said of such Indian artists that 'the laborious exactness with which they imitate every feather of a bird, or the smallest fibre on the leaf of a plant, renders them valuable assistants in this department'. They had to learn to paint flowers in a completely alien naturalistic idiom, to add diagnostic details and to handle watercolours in the European manner (PLATE 38). A lack of suppleness and organic movement in these Roxburgh drawings reflect their disquiet in working in this unfamiliar style. Some artists had difficulty in portraying large leaves and intricate blossoms. A drawing of *Musa nepalensis*, a species of banana, incurred the displeasure of the English botanist for whom it was done. In the top right-hand corner of the sheet is the indignant comment: 'Most abominable leaves for which Master painter shall be duly cut with reference to his month's wages'. Altogether Roxburgh sent over 2,500 drawings to London, from which Banks selected 300 for the *Plants of the coast of Coromandel*, published in twelve parts, 1795–1820. The European line engravers resisted the temptation to modify or adapt these drawings, which have a compelling decorative appeal. It is regrettable that the transparent washes of watercolour were so indifferently applied to the engravings.

In 1793 Roxburgh moved to Calcutta to take charge of the Botanical Garden, established some six years earlier, primarily for the purpose of growing teak for the building of ships. Roxburgh was instructed to give preference to the study of

5. Letter from Sir Joseph Banks to East India Company, 22 February 1787. IOLR: E/1/80 folio 169.
6. Letter from Roxburgh to Sir Joseph Banks, 17 August 1792. Department of Manuscripts: Add. MS 33979 folios 171–73.

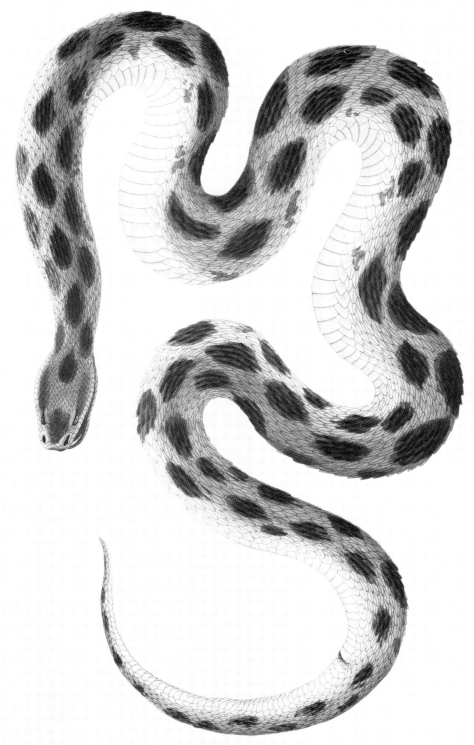

56 *Viper russelli*. Engraving. Patrick Russell *An account of Indian snakes collected on the coast of Coromandel*, London, 1796, plate 32. X360. (*IOLR*)
Russell was the East India Company's naturalist in the Carnatic and the first person in India to distinguish harmless from poisonous snakes.

plants 'connected either with medicine, the arts or manufactures' but the Company also allowed 'the admission of new plants, or of such as hitherto have been imperfectly described'.

Three years before the creation of this garden, that is in 1784, the Asiatic Society of Bengal was founded with 'MAN and NATURE, whatever is performed by one, or produced by the other' as its objective. The first President, Sir William Jones (botany was among his many interests) issued in 1790 a paper on *The design for a treatise on plants in India*; his early death, unfortunately, prevented its realisation.

Lord Wellesley (1760–1842), who was appointed Governor-General in 1798, as an ardent naturalist, must surely have been sympathetic towards the aims of the Asiatic Society of Bengal. After the defeat and death of Tipu Sultan in 1799, he chose Francis Buchanan (later Buchanan-Hamilton) (1762–1829) to conduct a survey of Mysore, the former kingdom of the late Tipu, and also the neighbouring territories of Canara and Malabar. Wellesley had chosen his man in the full knowledge of his reputation as a naturalist, and Buchanan was instructed to send any 'rare or curious plants and seeds' to the Botanical Garden in Calcutta. The survey gave Buchanan the opportunity to investigate the flora described in Draakenstein's *Hortus Indicus Malabaricus* a century earlier. Wellesley, delighted with the report of the survey, made Buchanan his personal physician. Wellesley's concept of Britain's imperial role in India incurred the displeasure of the Company's commercially-motivated Directors. They were hostile to his College of Fort William where new entrants to the Company's service were taught Indian languages, history and law. But Wellesley was not easily discouraged. He was convinced that the study of natural history in the sub-continent deserved official recognition and support. 'The illustration and improvement of that important branch of the natural history of India which embraces an object so extensive as the description of the principal part of the animal kingdom is worthy of the magnificence and liberality of the English East India Company, and must necessarily prove an acceptable service to the world'.[7] He established an Institution for Promoting the Natural History of India in 1804 and selected his friend, Francis Buchanan, to collect quadrupeds and birds for the new menagerie at the Governor-General's country residence at Barrackpore (PLATES 36 and 37). Funds were allocated for the employment of an artist and for his materials. Wellesley's extravagance in the rebuilding of Government House was the last straw for the Company. He was recalled to England in 1805 and his successor, the aged Lord Cornwallis, under orders to reduce expenditure, selected the Institution for Promoting the Natural History of India as his first victim. Buchanan found himself undertaking yet another regional survey, this time Bengal (PLATE 39). Having failed to get the post of Superintendent of the Botanical Garden, and having quarrelled with the Governor-General about the ownership of a collection of natural history drawings, he retired to England, an embittered and frustrated man. Members of the Linnean Society of London stoically endured Buchanan's erudite discourses on the *Hortus Indicus Malabaricus* through thirty-one of its meetings.

7. Bengal Public Council. Minute of 26 July 1804. IOLR: Range 6, vol 1, item 4337.

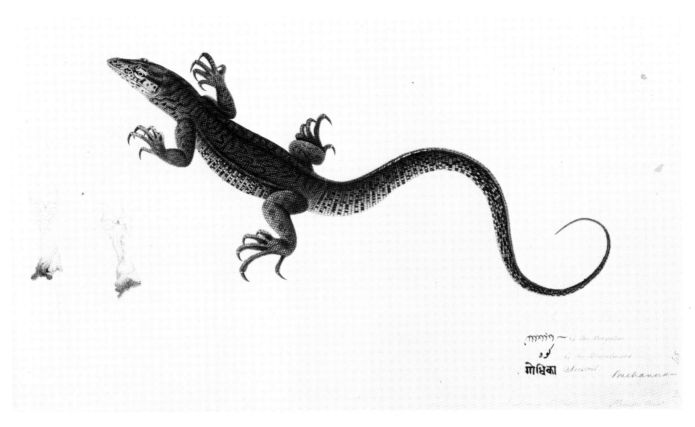

57 *Varanus bengalensis.*
Francis Buchanan collection.
1819. NHD 3 no 519. *(IOLR)*
Pen-and-ink and colour wash
by the Indian artist, Haludar.

It was Nathaniel Wallich (1786–1854), who had originally been a surgeon at the Danish settlement at Serampore, who was appointed to the post of Superintendent of the Botanical Garden that Buchanan had coveted. He continued the practice of employing Indian artists and published a selection of their drawings in *Plantae Asiaticae rariores* (1829–32). The lithographed plates are vigorously executed, but the colouring lacks restraint.

Robert Wight (1796–1872), a man of superhuman energy and industry, produced four botanical works with little official backing. He had about twenty native artists colouring the lithographs of his *Illustrations of Indian botany* (1840–50). This work he found 'a source of much regret': it was impossible to obtain satisfactory watercolours anywhere in India, and he was compelled to use thick, coarse paper which marred the quality of the lithographs. Almost as soon as he had published the first number of the *Illustrations*, Wight realised that the number of plates planned for the work was patently inadequate. So in the same year he launched *Icones plantarum Indiae Orientalis* which, like the *Illustrations*, was also printed and published in Madras. In this new work he aimed to publish over a hundred figures a year in monthly instalments. Remembering that James Sowerby's *English botany* had taken twenty-four years to complete, he looked to other means for speeding up production; he abandoned any idea of colour plates and selected transfer lithography as being the quickest process available to him in India. The work was completed in fifteen years with 2,115 lithographic line-drawings, many of which were copies of paintings done earlier for Roxburgh and Wallich. Wight was highly appreciative of the talent of native artists, of whom

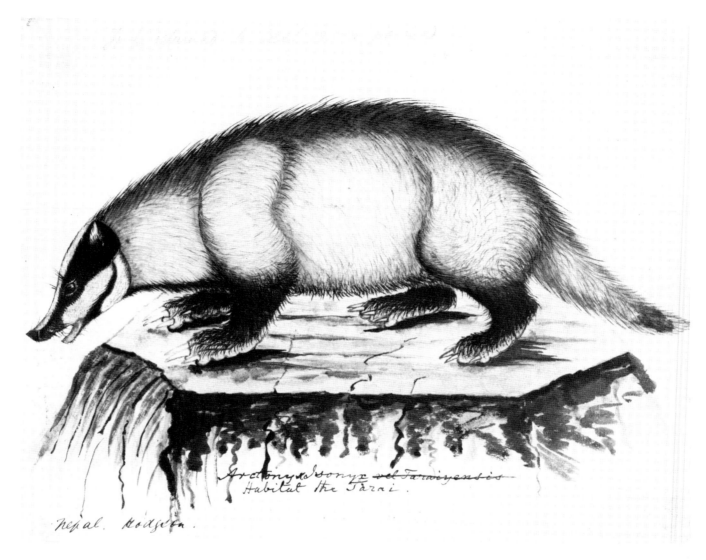

Govindoo was an especial favourite with him. In his honour he named a plant *Govindooia* as a tribute to his 'facile pencil ... and whose skill in analytical delineation is, I believe, as yet quite unrivalled among his countrymen and, but for his imperfect knowledge of perspective, rarely excelled by European artists'.[8]

When Joseph Hooker was plant-collecting in India in the late 1840s he met J. F. Cathcart of the Bengal Civil Service. Cathcart was an amateur botanist who employed natives to collect specimens of the flora of the Darjeeling region, and at one time had five artists producing about three flower paintings a week. He had intended illustrating a work similar to Hooker's *Rhododendrons of Sikkim-Himalaya* but died before he was able to do so. As a tribute to his memory Hooker saw *Illustrations of Himalayan plants* (1855) through the press. Hooker used Kew's resident botanical artist, W. H. Fitch, to lithograph the plates and, as he states in the Introduction, to correct 'the stiffness and want of botanical knowledge displayed by the native artists who executed most of the originals'. They display handsome boldness and ebullience, characteristic of so much of Fitch's work.

8. R. Wight *Icones plantarum Indiae Orientalis* vol 6, p 34.

58 Hog Badger (*Arctonya colleris*). B. H. Hodgson collection. Early 19th century. NHD 5 no 767. (*IOLR*) Brian Houghton Hodgson (1800–94) was Assistant Resident, then Resident, in Nepal 1820–44. He devoted years of solitary study to the languages, religion and natural history of the Himalayas. He employed three native artists to paint his collections.

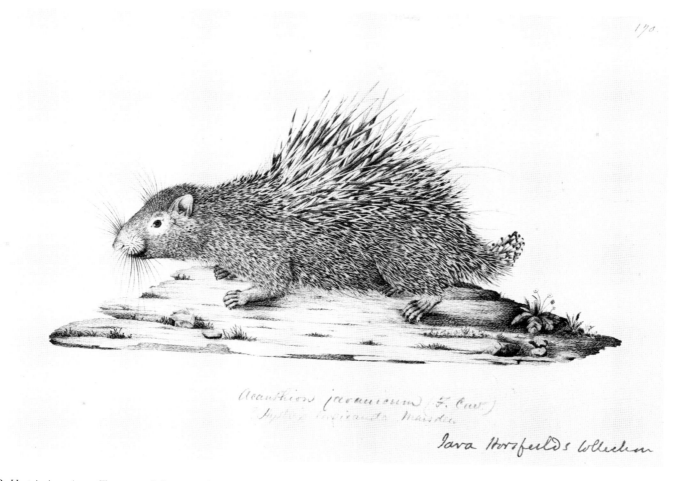

Acanthion (javanicum) (F. Cur.)
Hystrix javanica Marsden

Java Horsfield's Collection

59 *Hystrix javanicum. T. Horsfield collection.* Early 19th century. NHD I no 170. (*IOLR*)
Thomas Horsfield (1773–1859), an American physician in the service of the Dutch East India Company in Java, was encouraged by Sir Stamford Raffles to continue his natural history researches after the island had been occupied by the British. Horsfield engaged local artists, including two Dutchmen, to draw his collections.

Most painters in the West direct their skills towards conveying the tangible presence of a plant or animal through a faithful interpretation of physical structure and surface textures. It is observation based on analysis. In the East the artist in all humility sought to encapsulate the essence of flowers and beasts in an attitude of reverence nurtured by Taoism, Buddhism or Shintoism, faiths which proclaimed the sanctity of all life. The European artist painted what he saw, the Chinese or Japanese artist what he felt after careful scrutiny. Like the calligrapher, he used only brush and ink. Life and movement were suggested by the rhetoric of line. The Yüan painter, Chao Meng-fu, said that 'painting and writing are fundamentally the same'; both were formalised patterns of broad and tapering strokes made with an ink-loaded brush on paper. The bamboo, whose leaves resembled the calligrapher's brush strokes, remained for many centuries the painter's favourite plant. The Chinese artist Li K'an produced in 1299 a treatise on the bamboo, divided into four sections: outline drawings, ink paintings, drawings of bamboo under various conditions, and drawings of different species of bamboo.

A tradition of flower and animal painting had become firmly established by the T'ang Dynasty (AD 618–906), with individual artists renowned in this field. Herbals, illustrated with line-drawings, were also available. A combination of sophisticated technique in ink painting, a sensitive appreciation of Nature and the patronage of the Emperor Hui Tsung, himself an able artist, distinguishes the

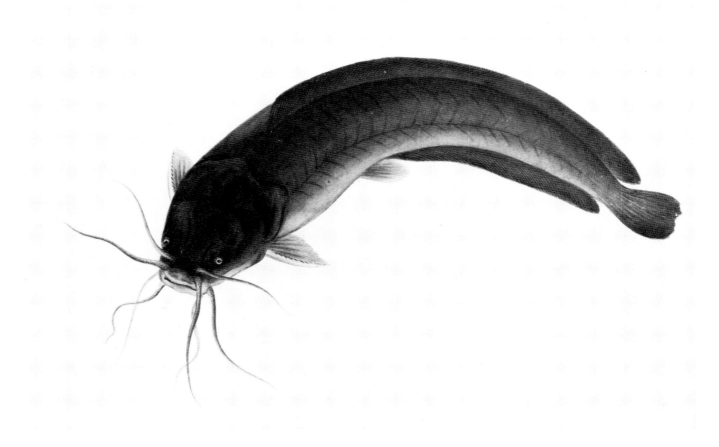

Sung dynasty (960–1279). Vitality and movement permeated flower compositions and the flight of birds was rendered with a credibility that the West was not to achieve until the nineteenth century. In Japan, Zen artists adopted the pure ink painting of the Chinese, and Sung flower-and-bird themes were widely imitated. With the advent of the Yüan Mongol dynasty (1280–1368), nature paintings became more decorative and more richly coloured. The Mongols occupied Persia and by the close of the fourteenth century the Chinese dragon and kilin were familiar motifs in Persian miniatures. After the expulsion of the Mongols, royal patronage was extended once more to scholar-artists under the Ming dynasty (1368–1644). The *Four noble plants* – the bamboo, plum, orchid and chrysanthemum – were the core of the repertoire of conventional plant forms. Rules for depicting plants, animals and the components of landscape – mountains, rocks, waterfalls, trees, etc. – were demonstrated in copybooks, the two most popular being the *Ten Bamboo Hall album* (1622–33) and the *Painting manual of the Mustard Seed Garden* (1677–1701). Both were illustrated by colour woodblock printing and are outstanding examples of Chinese expertise in this medium. But it is to Japan that one has to look for its later development.

Japanese art evolved from Chinese: during the Muromachi period (1334–1573), the many Sung, Yüan and Ming paintings reaching the country

60 Catfish *(Clarius* sp.*)* Chinese. Early 19th century. Add. MS 21179, folio 41. *(OMPB)*
One of a series of watercolour drawings of fish, probably done for sale to foreigners. They could be copies of European work since the style and plain background are not Chinese.

61 Irises. Monochrome woodblock. Yamaguchi Soken. *Soken Gafu* (Soken's picture album). Kyoto. 1806. Or. 16111 c 10★, folios 6v and 7. (*OMPB*) Yamaguchi Soken (1759–1818) was skilled in depicting landscapes and flowers.

provided inspiration and copy for artists. With a deft economy of line, Zen artists painted nature studies of a quiet serenity. Large folding paper screens, made as draught excluders in homes, invited colourful designs, such as those of the Rimpa school, a product of the Momoyama period (1573–1615). Rimpa artists paraded brilliantly coloured flowers of the four seasons in harmonious compositions on a gold or silver ground. The prosperity of Japanese merchants and the emergence of a rich and powerful middle class during the Edo period (1615–1868) provided new patrons for Japanese artists. Many new regional schools reflected their dynamism and inventiveness in their vision of Nature. The Ukiyoe school of popular prints, which had its beginnings back in the sixteenth century, represented the best of colour woodblock printing by the end of the eighteenth century. The theatre, fashionable life, bath-house girls and prostitutes were popular themes, executed in a spirit of confidence and originality. Hokusai did two series of flower prints and Hiroshige fish and bird studies.

It was the rise of the Mongol Empire in the thirteenth century that first brought Europe into direct contact with China. The Portuguese reached China in 1517, and forty years later they were granted a permanent base at Macao. Chinese ships took the Portuguese to Japan in 1543 and in 1570 Nagasaki was opened to foreign trade. The first British ship sailed into the harbour at Macao in 1635. Trading links

between Britain and China were largely maintained through the ships of the East India Company. A 'factory', or trading post, was established in 1676 at Amoy, where in 1698 James Cuninghame, a surgeon in the service of the Company, collected seeds, shells and insects and obtained 'Paintings of near eight hundred plants in their Natural Colours, with their Names to all, and Vertues to many of them'.[9] In 1766 John Blake sailed to Canton, the other principal trading station in China. His mission was to collect plants of economic interest and before he died in 1773 he had sent seeds to Kew Gardens and Chelsea Physic Garden, and under his supervision a Chinese artist had produced accurate drawings of plants which are now in the British Museum (Natural History). Gilbert Slater, the manager of several East Indiamen, also engaged Chinese artists to make drawings of their flora. 'These drawings are in general not only elegant and accurate; but severally distinguished by their names in Chinese characters: the characters are copied on Chinese paper, which being thin and almost transparent, may be accurately traced, and such as refer to rare productions, are distributed to captains of ships, and other persons undertaking voyages, with directions to purchase such living plants as correspond with the character. Sometimes these are accompanied with the drawings themselves'.[10] Pierre Joseph Buc'hoz copied some of these Chinese botanical drawings now reaching Europe, in his *Herbier, ou collection des plantes médicinales de la Chine* (1781).

The restrictions put on free trade by the xenophobic Chinese induced the British Government to send an Embassy to Peking in 1792 under Lord Macartney, former Governor of Madras, to establish better relations between the two countries. Macartney's second-in-command was Sir George Staunton, a Fellow of both the Linnean and Royal Societies, who botanised whenever the opportunity presented itself during the two years the Mission was in China. The official draughtsman to the Mission, William Alexander, concentrated on Chinese topography and social life; a couple of his bird drawings are reproduced in Staunton's *Authentic account of an Embassy . . . to the Emperor of China* (1797–98) (figure 62). Macartney's overtures were rejected by the Emperor who contemptuously referred to 'the lonely remoteness of your island, cut off from the world by intervening wastes of sea'.

Foreigners were confined to the island of Macao and only allowed in Canton when their ships were in port. When David Lance, the East India Company's Superintendent at Canton, was returning from England in 1803 he took with him a Kew gardener, William Kerr, selected by Sir Joseph Banks to be the first professional plant collector in China. The newly formed library and museum of the Company in London, then seeking Chinese drawings and objects for its collection, requested Canton's help. Canton complied with the request.

The Honble Committee's Instructions respecting the Desiderata for their library has been attended to. A botanical painter has been constantly employed in copying the plants, fruits and flowers of this Country, as they come successively in Season and we shall continue him till all that is curious in vegetable nature shall be designed. Mr Ker, His

9. J. Petiver *Museum Petiverianum* 1699.
10. J. C. Lettsom *Naturalist's and traveller's companion* 3rd edition, 1799.

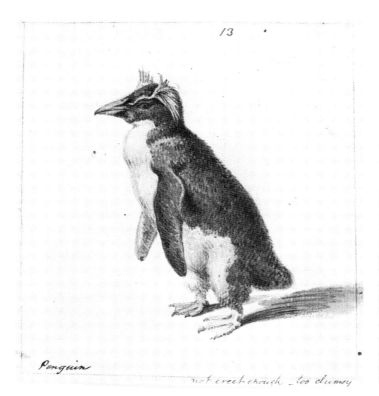
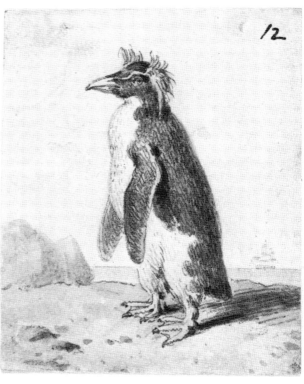

Penguin

not erect enough _ too clumsy

62 Rockhopper Penguin *(Eudyptes chrysocome)*. W. Alexander *Album of drawings executed during Lord Macartney's embassy to China, 1792–94.* WD 961, folio 4. *(IOLR)* William Alexander (1767–1816) was a competent topographical and figure artist but had difficulties with birds as can be seen in these two attempts at drawing a penguin.

Majesty's Botanical Gardener, directs his employment and sends a description of those already painted which go in the Earl Camden's Packet together with Drawings of the Malacca Fruits by the same Artist.[11]

The trading activities of the Portuguese and the British and the Dutch East India Companies were to some extent a reflection of chinoiserie, that fashionable cult for all things Chinese in seventeenth- and eighteenth-century Europe. Chinese paintings of scenes, flowers and birds, mounted on linen or canvas, hung on the walls of Georgian houses; Chinese blue and white porcelain was tastefully shelved in cabinets; and screens and lacquered furniture were proudly displayed. Lined up on the banks of Canton's Pearl River were the factories of the Americans, British, Danish, Dutch, French and Swedes, all competing for Chinese goods. And enterprising Chinese workmen set up workshops in Canton to produce the wares that Europe craved. Pretty paintings of flowers, birds and insects could always find a buyer. 'The Chinese having found that the representation of natural objects are in more request among foreigners they pay a strict attention to the subject that may be required'.[12] There gradually evolved a genre of painting done specifically for the European market, in which decoration took precedence over accuracy. No flower composition was complete without a brightly coloured bird or a hovering insect (FRONTISPIECE). The poise of a petal or the contrived curve of a leaf mattered more than honest observation.[13] The insects were painted with exquisite delicacy, especially the texture of wings, but

11. Letter of 29 January 1804 from East India factory at Canton.
12. J. Barrow *Travels in China* 1804, p 327.
13. The butterfly and grasshopper in the Frontispiece, for instance, cannot be identified, and there is uncertainty about the flower.

far too often these export paintings were mechanical and lifeless with little of the technical virtuosity of which Chinese artists were capable (PLATE 49).

On the other hand, drawings executed under European supervision were generally correct and factual records that satisfied the scientific standards of most professional botanists in Europe. John Reeves (1774–1856), whom the Company employed as their Inspector of Tea in Canton from 1812, devoted his leisure to collecting plants for the British Museum and the Horticultural Society of London. The drawings he commissioned from local artists in Canton and Macao were invaluable in the taxonomic researches of John Lindley and other botanists. Sir John Richardson identified seventy-seven new species of fishes on the evidence of Reeves's drawings. 'These drawings are executed with a correctness and finish which will be sought in vain in the older works of ichthyology, and which are not surpassed in the plates of any large European work of the present day'. The competence of Chinese artists also pleased other naturalists such as Sir Stamford Raffles, who employed an artist from Macao to draw the flowers of Malacca, and T. E. Cantor, who recruited a local artist on the island of Zhoushan for his zoological studies (figure 63).

The restrictions on the movement of the Dutch in Japan – the only foreigners permitted in the country – were, if anything, more rigorous than those endured by Europeans in China. The Dutch were still confined to the small artificial island of Deshima (about 66 metres long by 27 metres across) off Nagasaki, when the German, Engelbert Kaempfer, joined them as physician. Kaempfer (1651–1716) was driven by an urge to travel. In 1683–85 he had accompanied the Swedish Mission to Isfahan; then sailed as physician in ships of the Dutch East India Company before reaching Japan in 1690. Although fraternisation was prohibited, Kaempfer, by discreet instruction in medicine, astronomy and mathematics and a supply of western liquor, learnt a good deal about the country from the Japanese. He was able to observe the flora on his mandatory expeditions to pay tribute to the Court at Edo, and he never missed a single chance to fill his box with 'plants, flowers and branches of trees, which I figured and described'. His general account of his travels, *Amoenitates exoticae* (1712) includes the first European study of the Japanese flora with engravings of some of his flower drawings. After his death, Sir Hans Sloane purchased all his manuscripts and drawings and organised the publication of an English translation of his *History of Japan* (1728) (figure 64). In 1791 Sir Joseph Banks chose fifty-nine of Kaempfer's drawings in the Sloane collection for engraving in *Icones selectae plantarum*, to complement the text of Carl Thunberg's *Flora Japonica* (1784).

The British Library possesses two seminal collections on Japanese history, culture and science: the Kaempfer manuscripts and drawings acquired by Sir Hans Sloane, and Siebold's library of over 3,000 printed books, manuscripts and maps, purchased in 1868 (figure 65). Philipp Franz von Siebold (1791–1866) was the last of the great triumvirate (the others being Kaempfer and Thunberg) who pioneered the study of Japan's natural history. He arrived in Deshima in 1823 and his skills as an eye specialist gained him exemption from the official restrictions still imposed on the Dutch community there. He was allowed to visit patients in Nagasaki and to open a school to teach clinical surgery. This freedom of

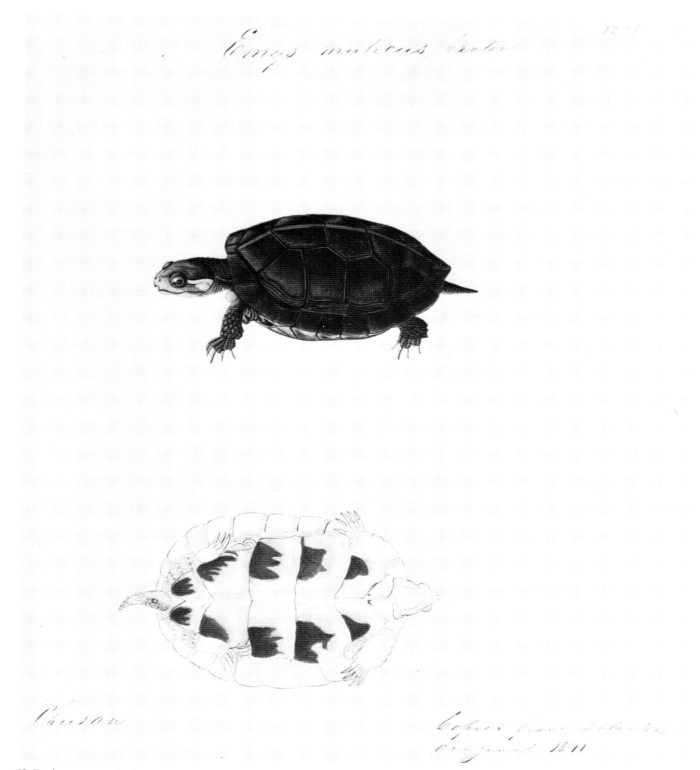

63 Freshwater terrapin *(Mauremys nigricans)*. T. E. Cantor *Drawings made in Chusan*. 1841. NHD 8, folio 1205. *(IOLR)*
Theodore Edward Cantor (1809–54) collected specimens for the East India Company's museum in London while on duty in China.
Chinese artists copied his drawings. This drawing was reproduced in his *Zoology of Chusan*, 1842.

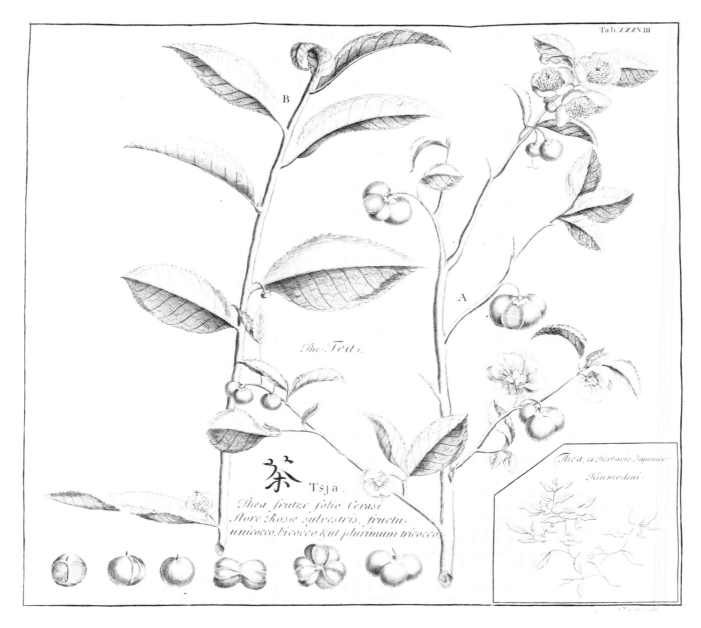

64 Tea *(Camellia sinensis)*. Engelbert Kaempfer *History of Japan* London, 1727, vol 2, plate 38. 370/53. *(DPB)* The inset in this copper engraving is copied from a printed Japanese herbal.

movement enabled him to collect specimens, and, during the course of a visit to Edo in 1826, he conducted, with the assistance of Dutch and Japanese colleagues, what might be viewed as the first scientific survey in Japan. Some of the drawings of Keiga Kawahara, whom he taught to paint in the European manner, appear in Siebold's *Fauna Japonica* (1833–50) and *Flora Japonica* (1835–70). He was expelled from the country in 1830 when prohibited items were discovered in his luggage, but returned in 1859, five years after Commodore Matthew Perry had compelled Japan to abjure its traditional isolationist policy. His stay was brief. The reasons are not altogether clear, but his behaviour alarmed the Dutch and his presence was resented by some Japanese officials. He retired to his native Bavaria in 1862 to work on his extensive collections.

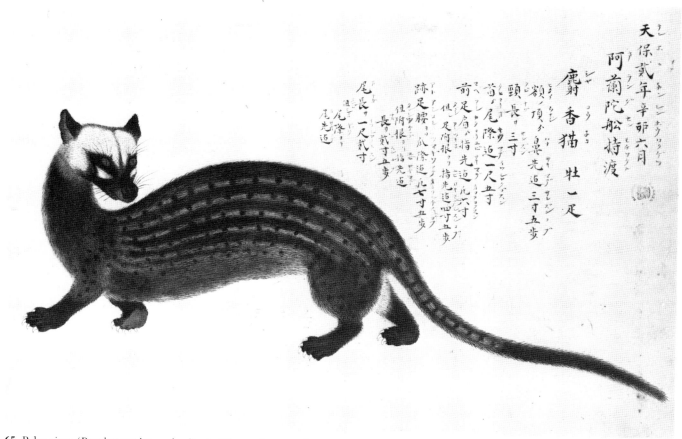

天保貳年辛卯六月
阿蘭陀船持渡

麝香猫 牡一足

65 Palm civet *(Paradoxurus hermaphroditus)*. Album of watercolours entitled *Jurui shinzu* (True pictures of animals). Japan. 1830s. Or. 913, folio 17. *(OMPB)*
From Alexander von Siebold's collection. The caption states that the animal was 'brought to Japan in a Dutch ship in the second year of the Tempo period (1831), 6th month' and gives its measurements.

10. From Victorian times to the present day

THERE WAS NO diminution in the output of natural history illustrations in Victorian England, whereas there was a perceptible decline in the art on the Continent. Gifted animal painters such as Wolf, Keulemans, Smit and Grönvold migrated to England. Botany and horticulture in particular flourished. The important single event was the establishment in 1841 of the Royal Botanic Gardens at Kew, out of the remnants of the former royal gardens. This new national institution, under its energetic director, Sir William Hooker, had links with the new botanic gardens in the colonies and also advised on the introduction and planting of economic crops in the Empire. The invention of a hermetically sealed plant case by Nathaniel Ward in the 1830s offered protection to plants from variable climates and indifferent attention on long sea voyages. For the first time it was possible to guarantee the safe transportation of tender plants. The London nurseryman, Conrad Loddiges, informed Sir William Hooker that 'whereas I used formerly to lose nineteen out of the twenty of the plants I imported during the voyage, nineteen out of twenty is now the average of those that survive'.

By the beginning of Queen Victoria's reign, British nurserymen were firmly entrenched as arbiters of horticultural taste and fashion. With a confidence born of their prosperity, they boldy entered the world of publishing. The Devon nurseryman, Henry Curtis, issued an illustrated *Beauties of the rose* in quarterly parts from 1850 to 1853. From a small catalogue prepared for the nursery firm of Peter Lawson emerged the last of the great conifer books, *Pinetum Britannicum* (1863–84), with hand-coloured lithographs of trees in park settings. Lawson's catalogues were extravagantly illustrated to tempt as well as to inform the gardening public. A sumptuous list added distinction to a nurseryman's reputation. E. G. Henderson & Sons of St John's Wood, London, were rightly proud of their three-volume catalogue which they presented as *The illustrated bouquet* (1857–64), with 85 hand-coloured lithographs. Nurserymen even ventured into the financially unstable market of periodical publishing. Conrad Loddiges launched the *Botanical cabinet* 'consisting of coloured delineations of plants from all countries' in 1817. For sixteen years it appeared monthly in two simultaneous issues: a large paper copy, fully coloured at five shillings, and an octavo version, at half the price, in which the plates were only partly coloured.

Horticultural periodicals proliferated during the nineteenth century, but fierce competition made their existence insecure and often brief. The *Botanical magazine*, founded in 1787, survived this rivalry and, though now called the *Kew magazine*, still commissions drawings of plants. The *Transactions of the Horticultural Society of London* (1807–48) which set itself printing standards it could not sustain, published some of the best fruit engravings of the century. The *Botanical register* set up in opposition to the *Botanical magazine* lasted thirty-two years and thirty-three

volumes with Sydenham Edwards as its principal artist. In the days of cheap literature during the 1830s most publishers and editors were obsessed with costs and value for money. Joseph Paxton was concerned that the high price for some horticultural magazines 'places them beyond the reach of most flower culti-vators'. On the other hand, he conceded that 'cheap periodicals, although unobjectionable in respect of price, are manifestly defective in other points of greater importance; the plates they contain bearing but little resemblance to the plants they are intended to represent'. This was where *Paxton's magazine of botany* (1834–49), published monthly with 'four engravings of plants, of the natural size, beautifully coloured from original drawings' was to redress the balance. All editors boasted that their periodicals were superior. *The Botanist* (1836–41) claimed that its 'plates are finished pictures by the best artists'. The editors of the *Floral cabinet and magazine of exotic botany* (1837–40) deplored the failure of many botanical illustrations as works of art. Their periodical, however, would 'give accurate, and at the same time, highly finished representations'.

Walter Hood Fitch (1817–92), the first botanical artist at the newly established Royal Botanic Gardens at Kew, was one of the most prolific of Victorian flower painters. He worked with remarkable speed, often straight on to the lithographic stone. The *Rhododendrons of Sikkim-Himalaya* (1851) needed his bravura con-fidence, incisive line and botanical knowledge to recreate these exotic blooms from the dried specimens and meagre field sketches supplied by Joseph Hooker. That fastidious gardener, E. A. Bowles, had reservations about Fitch's fluent line when he assessed his contribution to H. J. Elwes's *Monograph of the genus Lilium* (1877–80). 'The artist has a way of making a flower look artificial, as though made of painted calico and not of living sap-filled cells.'[1] More to Bowles's taste would have been the delicate watercolours by George Maw in his *Monograph of the genus Crocus* (1886), which John Ruskin praised as 'most exquisite . . . and quite beyond criticism'.

By the mid-nineteenth century, lithography – cheaper, speedier and capable of longer runs than copper-engraving – had become the leading graphic process. The cheapness of chromolithography, a development of lithography, recommended it to horticultural periodicals. Some really impressive chromo-lithographs were made for R. Hogg and H. G. Bull's *Hereford pomona* (1876–85) and *Reichenbachia* (1888–94), the last of all the ambitiously conceived orchid books.

Just about the time that chromolithography was patented by a French lithographer in 1837, George Baxter in England started to use commercially multiple colour blocks. By the second half of the nineteenth century, colour woodblocks had joined chromolithography as the main colour printing process. Until fairly recently, the colour woodblocks of Benjamin Fawcett were often wrongly identified as chromolithographs. Incredibly high standards were maintained by Fawcett at his engraving and printing firm in Driffield, Yorkshire, manned by locally recruited and trained staff. Some of his best natural history work is to be found in Shirley Hibberd's *New and rare beautiful-leaved plants* (1870),

1. *Journal of Royal Horticultural Society*, vol 43, 1918–19, p 363.

all the fifty-four plates in perfect register, or in W. Houghton's *British freshwater fishes* (1879), where the plates are subtle in their tonal values and sensitive in their details (figure 66).

66 W. Houghton *British freshwater fishes*, London, 1879. 1893 a 5. (*DPB*) Golden carp by A. F. Lydon. Multiple-colour woodblocks by Benjamin Fawcett.

Among the many processes competing for attention in the nineteenth century, nature printing was the most novel (figure 67). Its basic concept is absurdly simple; to use the object itself – plant, insect, textile, etc – to obtain a facsimile copy. The application of ink or paint to a plant which is then pressed down on paper, thus transferring a silhouette image, is so beguiling a technique that it has been experimented with for centuries. Of course Leonardo da Vinci investigated it. Alexis Pedemontanus in his *Liber de secretis naturae* (1557) was the first to publish a description of it. The first book in which nature prints were mass-produced was *Botanica in originali seu herbarium vivum* (1734–47) by J. H. Kniphof of the University of Erfurt. As only about twenty satisfactory impressions could be made from each plant, the number of copies prepared was small. In the early 1850s the Imperial Printing Office in Vienna devised a process which involved sandwiching a plant between a smooth sheet of copper and one of lead, and putting it into a press. The impression of the plant was taken up by the soft lead from which an electrotype was made for printing. L. Heufler's *Specimen florae Cryptogamicae* (1853) was the first German botanical work to adopt nature printing. Henry Bradbury patented the process in England and used it in T. Moore and J. Lindley's *Ferns of Great Britain and Ireland* (1855–56) and W. G. Johnstone and A. Croall's *Nature-printed British seaweeds* (1854–60). The

67 *Nature's selfprinting. A series of useful and ornamental plants of the South Indian flora. Taken from fresh specimens in facsimile colours*, Mangalore, 1862. X459. (*IOLR*)
Nature printing by the Basel Mission Press in India.

fragility of many plants eliminate them as candidates for nature printing; the most suitable are the non-fleshy ones, such as ferns and algae. But the great strides made in photo-mechanical processes killed any possibility of a survival of nature printing.

Painting flowers for pleasure rather than for science has never waned. Marianne North resolutely travelled around the world painting plants in their natural habitat (the result is a tight mosaic of over 800 paintings in the gallery she built in Kew Gardens); William Henry Hunt's pictures of primroses in hedges were in great demand; Edward Ladell found inspiration in Dutch seventeenth-century painters for his repetitive groupings of flowers, fruit, bird-nests and insects. The flamboyance and variety of floral colours were irresistable to the Impressionists. Renoir loved painting flowers as much as he did ripe young women. Monet made a pond in his garden in order to paint waterlilies. Van Gogh's sunflowers communicate his intense excitement: 'I am working every morning from sunrise, for flowers fade so soon and the thing is to do the whole at a flash'. How remote is his feverish vitality from the serene reserve of Fantin Latour's elegant bouquets. The Pre-Raphaelite painters followed Ruskin's dictum of 'truth to nature' by taking their easels into the open air to observe very precisely the physical world about them. In order to be absolutely correct in every detail, Holman Hunt felt compelled to go to the Dead Sea where, perched on a stool beneath a broad sunshade, he painted a tethered goat for his symbolic picture, *The scapegoat*. Complete honesty and delicate precision, two of the qualities they sought to attain in their own art, were the attributes that Dante Gabriel Rossetti and Thomas Woolner, two members of the Pre-Raphaelite Brotherhood, especially admired in the work of Josef Wolf.

Josef Wolf (1820–99), born in Germany,[2] was working in England for John Gould in 1849. He became one of the most productive animal artists of his day. Much of his output was lithographed in the *Proceedings* and *Transactions* of the Zoological Society of London. His enthusiasms as a naturalist were refined by his instincts as an artist. He told his biographer, A. H. Palmer: 'Among the naturalists there are some who are very keen about scientific correctness, but who have no artistic feeling. If a thing is artistic they mistrust it'.[3] He would have agreed with Delacroix who wrote in his diary: 'Art does not consist in copying nature, but in recreating it, and this applies particularly to the representation of animals'. All his work communicates a sympathetic awareness of the energy and movement of animals.

Wolf helped the Dutch artist, Joseph Smit (1836–1929) to settle in England in the 1860s, and introduced him to clients. After Wolf's death, he was considered to be the best living animal painter. Another Dutchman, John Gerrard Keulemans (1842–1912), who also arrived in England in the 1860s, lighographed some of Wolf's drawings. Museum specimens provided many of the models for his drawings, which lack the imaginative display of Wolf's compositions.

Wolf, a fanatic for work, never had time for the social contacts that Edwin

2. Natural history illustration in Great Britain owes a great deal to German and Austrian immigrants and artists: for example Dillenius, Ehret, John Miller (Müller), the Bauer brothers.

3. A. H. Palmer *The life of Josef Wolf, animal painter* 1895.

Landseer so successfully cultivated. Landseer received the accolade of royal approval, when the Queen engaged him to paint her favourite dogs.

The seven volumes of Lord Lilford's *Coloured figures of birds of the British Isles* (1885–98) sounded an eloquent fanfare for the departing years of Victoria's reign. The chromolithographs of Thorburn's watercolours constitute some of the finest published drawings of birds. Archibald Thorburn (1860–1935) is the despair of most bird painters who try to emulate his mastery in conveying the soft, springy feel of feathers. His equal was Charles Tunnicliffe (1901–79) whom that other outstanding bird artist, Sir Peter Scott, considers to be 'one of the very greatest bird draughtsmen who ever lived'.[4]

The modest revival of wood engraving during this century reminds us that this medium is capable of successfully tackling the tints of fur, feather and flower, when in the hands of accomplished engravers like Eric Fitch Daglish, John Farleigh and Agnes Miller Parker.

The top rank of today's natural history artists compare favourably with yesterday's giants. Audubon's dramatic tableaux find a reflection in the meticulously rendered bird and animal studies of the Argentinian, Axel Amuchástegui; the Canadian, Robert Bateman, can miraculously recreate the ambience of forests and lakes; Paul Jones, in Australia, has revived the spirit of Thornton's *Temple of Flora* with the scenic backdrops he has introduced into his flower portraits.

But photographic equipment has now attained such a degree of sophistication that one wonders whether there is still a legitimate function for the traditional natural history illustrator. Doubts arise as one admires the bird prints of Eric Hoskins or Heather Angel's photographs of flowers. High-speed photography can record the mechanics of motion with an exactness that is beyond the power of the artist's hand. Photography, however, cannot give the diagnostic details that botanists demand, nor perhaps convey the personality of an animal with quite the same sympathetic rapport of a painter.

What ever the merits of photography, people will continue to paint for the pleasure that it gives them and others. The Reverend William Keble Martin began painting the flowers of the countryside as a young Oxford undergraduate; seventy years later he had the satisfaction of seeing a selection of a lifetime's paintings in the *Concise British flora* (1965) becoming a bestseller. In this age of specialisation, natural history is one of the few disciplines left which offers a role for the amateur, be it in methodical recording or in conservation; and who can doubt that there will always be an audience ready to appreciate the works of nature, the wonders of creation?

4. *Archives of natural history* vol 12, 1985, p 173.

Select bibliography

ANDERSON, Frank J. *An illustrated history of the herbals*, New York, 1977.

ANKER, J. *Bird books and bird art: an outline of the literary history and iconography of descriptive ornithology*, Copenhagen, 1938.

ARANO, Luisa Cogliati *The medical health handbook, Tacuinum sanitatis*, New York, 1976.

ARBER, Agnes *Herbals, their origin and evolution: a chapter in the history of botany, 1470–1670*, 2nd Edition. London, 1938.

ARCHER, Mildred *Natural history drawings in the India Office Library*, London, 1962.

BAIN, Iain *The watercolours and drawings of Thomas Bewick and his workshop apprentices*, London, 1981, 2 volumes.

BAZIN, Germain *A gallery of flowers*, London, 1960.

BLUNT, Wilfrid *The art of botanical illustration*, 3rd Edition. London, 1955.

BLUNT, Wilfrid and RAPHAEL, Sandra *The illustrated herbal*, London, 1980.

BRION, Marcel *Animals in art*, London, 1959.

BUCHANAN, Handasyde *Nature into art: a treasury of great natural history books*, London, 1979.

BURBIDGE, R.B.A. *A dictionary of British flower, fruit and still life painters*, Leigh-on-Sea, 1974, 2 volumes.

CALMAN, Gerta *Ehret, flower painter extraordinary: an illustrated biography*, London, 1977.

CARR, D.J., editor *Sydney Parkinson, artist of Cook's Endeavour voyage*, London, 1983.

CAVE, Roderick and WAKEMAN, Geoffrey *Typographia naturalis*, Wymondham, 1967.

CLARK, Kenneth *Animals and men: their relationship as reflected in Western art from pre-history to the present day*, New York, 1977.

CLARKE, T.H. The iconography of the Rhinoceros from Dürer to Stubbs, *Connoisseur*, September 1973, pp.2–13; February 1974, pp.113–22.

COATS, Alice M. *The book of flowers: four centuries of flower illustration*, London, 1973.

COATS, Alice M. *The treasury of flowers*, London, 1975.

DANCE, Peter *The art of natural history: animal illustrators and their work*, London 1978.

D'ANCONA, M.L. *The garden of the Renaissance: botanical symbolism in Italian painting*, Florence, 1977.

DRUCE, George C. 'The Elephant in medieval legend and art', *Archaeological Journal*, vol 76, 1919, pp.1–73.

DRUCE, George C. 'The medieval bestiaries and their influence on ecclesiastical decorative art', *Journal of the British Archaeological Association*, vol 25, 1919, pp.41–79.

DUNTHORNE, G. *Flower and fruit prints of the 18th and early 19th centuries: their history, makers and uses, with a catalogue raisonné of the works in which they are found*, London, 1938.

EWAN, Joseph *William Bartram: botanical and zoological drawings 1756–1788. Reproduced from the Fothergill album in the British Museum (Natural History)*, Philadelphia, 1968.

FRIEDMANN, Herbert *A bestiary for St Jerome: animal symbolism in European religious art*, Washington, 1980.

FRIES, W.H. *The double elephant folio: the story of Audubon's Birds of America*, Chicago, 1973.

GEORGE, Wilma *Animals and maps*, London, 1969.

HARTHAN, John *Books of Hours and their owners*, London, 1982.

HATTON, Richard G. *The craftsman's plantbook, or figures of plants selected from the herbals of the 16th century*, London, 1909.

HENREY, Blanche *British botanical and horticultural literature before 1800*, London, 1975, 3 volumes.

HOLME, Bryan *Creatures of Paradise: animals in art*, London, 1980.

HULTON, Paul *America 1585: the complete drawings of John White*, London, 1984.

HULTON, Paul *The work of Jacques Le Moyne de Morgues: a Huguenot artist in France, Florida and England*, London, 1977, 2 volumes.

HULTON, Paul and QUINN, David B. *American drawings of John White 1577–1590*, London, 1964, 2 volumes.

HULTON, Paul and SMITH, Lawrence *Flowers in art from East and West*, London, 1979.

HUNT INSTITUTE FOR BOTANICAL DOCUMENTATION *A selection of late 18th and early 19th century Indian botanical paintings*, Pittsburgh, 1980.

HYMAN, Susan *Edward Lear's birds*, London, 1980.

JACKSON, Christine E. *Bird illustrators; some artists in early lithography*, London, 1975.

JACKSON, Christine E. *Wood engraving of birds*, London, 1978.

JAMES, M.R. *The bestiary: being a reproduction in full of the manuscript Ii.4.26 in the University Library, Cambridge, with supplementary plates from other manuscripts of English origin, and a preliminary study of the Latin bestiary as current in England*, Oxford, 1928.

JONES, Peter Murray *Medieval medical miniatures*, London, 1984.

KADEN, Vera *The illustration of plants and gardens, 1500–1850*, London, 1982.

KLINGENDER, Francis *Animals in art and thought to the end of the Middle Ages*, London, 1971.

KNIGHT, David *Zoological illustration: an essay towards a history of printed zoological pictures*, London, 1977.

KORENY, Fritz *Albrecht Dürer und die Tier- und Pflanzenstudien der Renaissance*, Munchen, 1985.

LEWIS, F. *A dictionary of British bird painters*, Leigh-on-Sea, 1974.

LEWIS, F. *A dictionary of Dutch and Flemish flower, fruit and still life painters: 15th to 19th century*, Leigh-on-Sea, 1973.

LLOYD, Joan Barclay *African animals in Renaissance literature and art*, Oxford, 1971.

LYSAGHT, A.M. *The books of birds: five centuries of bird illustration*, London, 1975.

McCULLOCH, Florence *Mediaeval Latin and French bestiaries*, Chapel Hill, 1960.

MITCHELL, Peter *European flower painters*, London, 1973.

NIALL, Ian *Portrait of a country artist: C.F. Tunnicliffe* S C *1901–1979*, London, 1985.

NISSEN, Claus *Die botanische Buchillustration: ihre Geschichte und Bibliographie*, Stuttgart, 1951, 2 volumes; Supplement, 1966.

NISSEN, Claus *Die zoologische Buchillustration: ihre Bibliographie und Geschichte*, Stuttgart, 1966–78, 2 volumes.

NOAKES, Vivien *Edward Lear 1812–1888*, London, 1985.

PÄCHT, Otto 'Early Italian nature studies and the early calendar landscape', *Journal of Warburg and Courtauld Institutes*, vol 13, 1950, pp.13–47.

PAVIE, S.H. *A dictionary of flower, fruit and still life painters*, London, 1962–64, 4 volumes.

PEDRETTI, Carlo and CLARK, Kenneth *Leonardo da Vinci: nature studies from the Royal Library at Windsor Castle*, London, 1981.

RAWSON, Jessica *Animals in art*, London, 1977.

RIX, Martin *The art of the botanist*, London, 1981.

ROGERS-PRICE, Vivian *John Abbot in Georgia: the vision of a naturalist artist (1751–ca 1840)*, Madison, 1983.

SAUER, G.C. *John Gould the bird man: a chronology and bibliography*, London, 1982.

SCRASE, David *Flowers of three centuries: one hundred drawings & watercolours from the Broughton collection [Cambridge]*, Washington, 1983/4.

SINGER, Charles 'Greek biology and its relation to the rise of modern biology'. *In* C. Singer, Editor, *Studies in the history and method of science*, Oxford, 1921, vol 2, pp.1–101.

SINGER, Charles 'The herbal in antiquity and its transmission to later ages', *Journal of Hellenic Studies*, vol 46, 1926, pp.1–52.

SITWELL, Sacheverell and BLUNT, Wilfrid *Great flower books, 1700–1900: a bibliographical record of two centuries of finely illustrated flower books*, London, 1956.

SITWELL, Sacheverell, BUCHANAN, Handasyde and FISHER, James *Fine bird books, 1700–1900*, London, 1953.

SKIPWORTH, Peyton *The great bird illustrators and their art, 1730–1930*, London, 1979.

STERN, Harold P. *Birds, beasts, blossoms and bugs: the nature of Japan*, New York, 1976.

TATE GALLERY *George Stubbs 1724–1806*, London, 1984.

TAYLOR, Basil *Animal painting in England from Barlow to Landseer*, London, 1955.

TITLEY, Norah M. *Dragons in Persian, Mughal and Turkish art*, London, 1981.

TITLEY, Norah M. *Plants and gardens in Persian, Mughal and Turkish art*, London, 1979.

VANDERVELL, Anthony and COLES, Charles *Game & the English landscape: the influence of the chase on sporting art and scenery*, London, 1980.

WELKER, Robert Henry *Birds and men: American birds in science, art, literature and conservation, 1800–1900*, Harvard, 1955.

WHITE, T.H. *The book of beasts, being a translation from a Latin bestiary of the twelfth century*, London, 1984.

WOOD, J.C. *A dictionary of British animal painters*, Leigh-on-Sea, 1973.

YAPP, Brunsdon *Birds in medieval manuscripts*, London, 1981.

THE PLATES

Plate 1

Yarrow (*Achillea millefolium*)

Anglo-Saxon Herbal. Mid-11th century.
Cotton MS Vitellius C III, folio 46. (*Dept of MSS*)

This manuscript is one of four surviving Old English translations of Apuleius, three of which are now in the British Library. Nothing is known about the author of the *Herbarium Apulei*, now usually referred to as Apuleius Barbarus or Pseudo-Apuleius Platonicus, to distinguish him from Lucius Apuleius who wrote *The golden ass*. Some scholars believe he lived in North Africa, not far from ancient Carthage. The *Herbarium* was compiled about AD 400 from the works of Dioscorides and Pliny. This copy has 184 coloured drawings of plants and twenty-eight of animals; some of them reveal their Mediterranean origin. The English artist slavishly copied them, unaware that they were not all to be found in his country. The manuscript also includes a treatise on the medicinal uses of the badger and thirteen chapters from the *Liber mediciniae ex animalibus* (Book of medicines derived from animals). Unfortunately, the manuscript was severely damaged in a disastrous fire in 1731, which destroyed many of the precious items in the Cotton collection in Ashburnham House, Westminster.

This drawing of yarrow is one of the few that escaped the artist's impulse to transform it into a decorative pattern. The plant was recommended for toothache, 'ache of the bowels', headache, swellings of all sorts, 'wounds made with iron', and dog and snake bites.

ac þan totypeð.

Pið mpe punda genim hyrre
ylcan pyrce blofc man lege
todum punou butan telcpie
ylomege ŋ ypecenyrre hyþu punou
gehiæluð.

Pið liþa sare genim hyrre ylcun
pyrce sumne diæl rpoð onpine
to þyrddan diæle ŋ ofþum pine
syn þon þulyþu gebeðeðe ealle
þepa liðu uncpum nysse hyt
gelidignþ.

Pið næddpun rlite genim hyrre
ilcan pyrce leap þepe cpurci
nemdun spa mpe gecnucuðe
lege todum syne.

gappe

Dur pyrce hemun millepoliu
onupe gehroðe ŋ euppe nrmneþ

ŋ rceð þ uchu ler rp culðop
man hy pinrou rceolðe þe
miðþyrre sylpan pyrce gehælde
baþe miðirepine geꞇlegene ŋ
gepunðuðe þæpan enr heo
ofsumu munnu rorþygenem
neð yr uchylleor miðþe-ire
pyrce yr sæð þ he ene sunne
man gehælan rceolðe þum
þer thelephon nama

id toð ece genu hyrre pyrce
pyrc pulan þepe mille roluu
nemðun ryle ecun prercenou

Pið punou þermið irepine ꞇyn
gepoþhte genim þur ylcun
pyrce mið pyrle gecnucuðe
lege toþum punou heoþu punou
urroumaþ ŋ gehæled.

Pið gerpell gꞇhu þur ylcun pyrce
mylle poluu mro buꞇepan gecnu
cuðe lege toþu gerpelle.

id þæt hpyrte man eur roðlicer
gemigun mæge genim hyrre
ylcun pyrce þos mið ecede pyle
djuncan pirrouplicr heo hæleþ.

ir puno onmen arolod sy ge
nim þonne ðu sylpan pyrce
mille folium ꞇgniðspyþe punle
ŋ menge pið buꞇepan lꞇge ðon
onða punou heo epreaþ rona
ŋ ypeupmaþ.

Plate 2

(LEFT) Chicory (*Cichorium intybus*)
(RIGHT) Dropwort (*Filipendula vulgaris*)

Liber de simplici medicina. Italy. Early 14th century.
Egerton MS 747, folio 91. (*Dept of MSS*)

The Normans, in taking Sicily from the Arabs at the end of the eleventh century, exposed Europe to the culture of Islam and — through Arabic translation — to the Greek texts of Dioscorides. It was this rediscovery of Dioscorides's *Materia medica* with its description of plants that fostered a new interest in their medicinal properties. The first medical school in Europe was established in Salerno near Naples, and in the thirteenth century one of its leading figures, Platearius, compiled a plant manual known variously as *Liber de simplici medicina*, *Secreta Salernita* or, from its opening words, 'Circa instans'. It incorporated information from Latin and Arabic sources. Illustrated versions were not available until about the fourteenth century, and the earliest surviving copy is Egerton MS 747.

It signals the first indications of a return to realism in plant drawing after centuries of routine copying of earlier illustrations by illuminators who often knew nothing about the structure of plants (and consequently, whose stylised plant portraits were useless for plant identification). The illuminator of *Liber de simplici medicina* still reduces his plants to a decorative formula but they do show some awareness of living plants.

Early herbals often included remedies obtained from animals, and the animals themselves were illustrated, as here. The ground-up tusk of the elephant was recommended for spots on the face and its blood for the relief of haemorrhages.

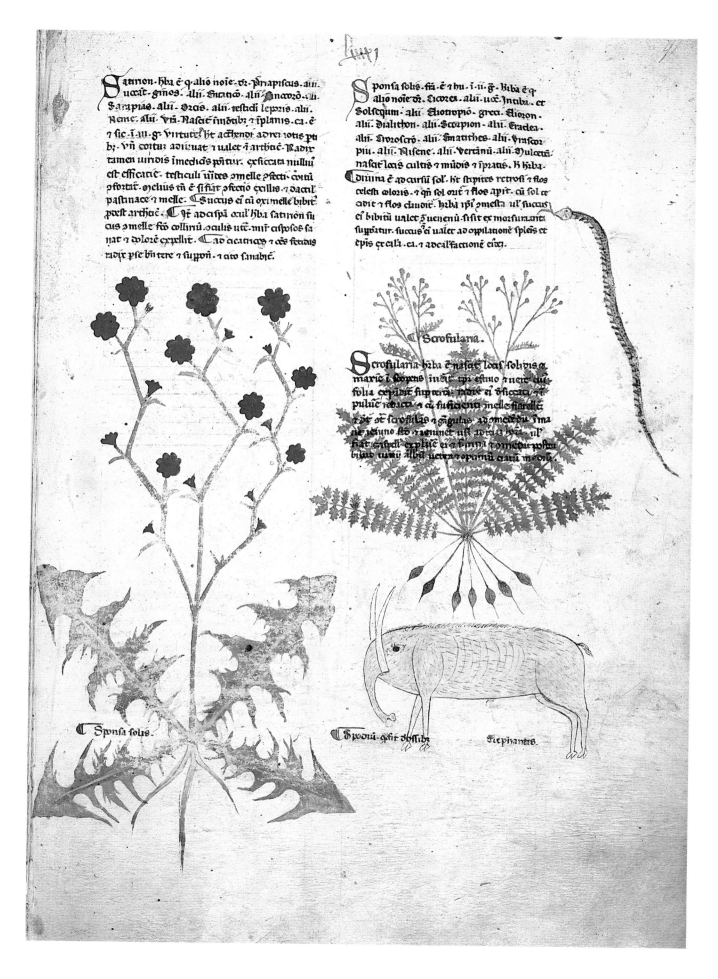

Satirion herba est que alio noie dr. Priapiſcus. alii
ſuccat. ginos. alii Satiriō. alii Incordio. alii
Sarapias. alii oras. alii teſticuli leporis. alii
Renec. alii vñ Naſcit in oatib; ſplanis. ca. é
ז ſic in. in. g. virtutē hr. achendi adrenotis pa
b; vñ coitū adiuuat ז ualet iñ arthae. Radix
tamen uiridis in medicis pōitur. exſiccata nulliū
eſt efficaie. teſticuli uires ꝯmelle ꝯfecti contū
pfortat. melius tñ é ſi fiat ꝑfectio exillis. ז dacril
paſtinace ז melle. Succus eī cū oximelle bibit
pʒeſt arthae. Et ad aſpʒa ocul herba ſatiriō ſu
cus ꝯ melle fʒo collirio oculis ute. mir aſpoſos ſa
nat ז doloʒē expellit. Et ad cicatrices ז oēs ſcuas
radix ipſe bñ tere ז ſuppon. ז cito ſanabit.

Sponſa ſolis. fra. é ז hu. in. in. g. Riba é que
alio noie dr. Cicoʒea. alii uoc. Intiba. et
Solſequim. alii ſhonuopio. greca. Eioʒon
alii. Dialithon. alii Scorpion. alii Eraclea
alii. Dioioſcʒo. alii Smatithes. alii Fraſcor
piū. alii Diſene. alii Vertanū. alii Dulceta
naſcit loeis cultis ז mūdis ז ſpatiis. K herba
diuina é ad curſū ſol. hr ſtiptes retroſi ז flos
celeſti coloʒis. ז qn ſol oʒit ז flos apit. cū ſol ca
adit ז flos claudit. herba ipʒ ꝯmeſta ul ſucus
eī bibitū ualet ꝗ uenenū. fiſit ex morſu ráta
ſuppoʒatur. ſuccus eī ualet ad opilationē ſpleis et
epis ꝯ calt. ca. ז ad cal factionē cūit.

Scrofularia.

Scrofularia herba é ז naſcit loeis ſolhvis ez
marie in ſoʒenis inat ipʒ eſtuo ז uere eius
folia ꝯpebit ſuʒperiū. næte ei oſiccata ז
puluē redacta. ז cū ſufficieria melle ſtirallē.
ז fiat oʒ ſcrofillas ז ſigulas. ad meʒidū. in ma
ne ieiuno ſto ꝯeuniet uſt auiaʒ hūa. ul
fiat eiſdel expltē ei ז bᴵuitat ז ꝯmedat poſtea
biſtū uini albū. uetaʒ ꝯpanū eiuʒ media.

Sponſa ſolis.

Sponu geſit abſſibi Elephanras.

Plate 3

Lion, cheetah, rabbit or hare and elephant

Compendium of medicinal plants. Northern Italy. Second half of
14th century.
Sloane MS 4016, folio 50. (*Dept of MSS*)

This herbal, like Egerton MS 747 (PLATE 2), includes drawings of
animals.

In medieval Europe there were few opportunities for seeing live
animals from tropical lands. An exception was the hunting cheetah,
which was a prized possession of many Italian princely families.

It is, nevertheless, surprising that the elephant was caricatured for
so long. The citizens of Rome were familiar with it and Pliny's
Natural history has much to say about its habits. The Caliph of
Baghdad presented an elephant to Charlemagne's court at Aix-la-
Chapelle, and the elephant that the Emperor Frederick II brought
back from the Holy Land was used in his siege of Cremona in 1229.
Yet the depiction of elephants by medieval artists reveals a
lamentable ignorance of the creature's anatomy. Tusks invariably
protruded from the lower jaw, trunks looked like elongated
trumpets, ears were either minimal or huge pendant flaps and bodies
inclined towards the equine (PLATE 2 and figures 5 and 6). The well-
known misericord of an elephant in Exeter Cathedral is similarly
grotesque. Most artists were content to create the animal from
written records or to copy inaccurate drawings. Occasionally they
did take the trouble to draw from the living model. In 1255 the
monk Matthew Paris drew the first realistic elephant in post-classical
western art (figure 9). Andrea Mantegna's tempera paintings of 'The
triumph of Caesar', painted about 1486 to 1494, now at Hampton
Court Palace, incorporate a procession of elephants that must surely
have been drawn from life.

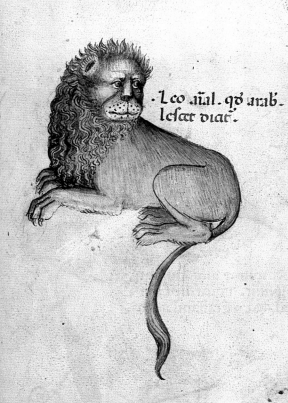

Leo aïal. qd arab.
lesec viat.

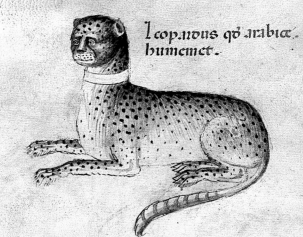

Leop. nous qd arabice
humemet.

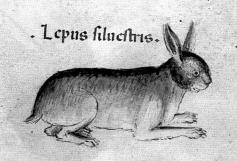

Lepus siluestris.

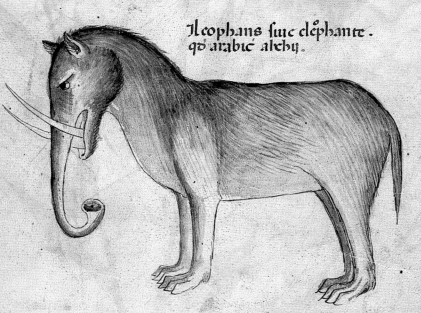

Ileophans sine elephante.
qd arabic alchy.

Plate 4

De septem vitiis. North Italy. Late 14th century.
Add. MS 28841, folio 3. (*Dept of MSS*)

Outstanding among early examples of the revival in naturalistic art are the zoological drawings in the three manuscript fragments executed in or near Genoa during the late fourteenth century (Additional MSS 27695 and 28841 and Egerton MS 3127, all in the British Library). The text by a member of the Genoese merchant family, Cocharelli, is a prose treatise, *On the vices*, and a verse narrative of the history of Sicily in the time of the Emperor Frederick II (1194–1250).

The significance of these fragments lies not in the text, but in the abundant drawings of insects, shells and animals that crowd not only the margins but also the narrow space between the two columns of script. Nearly all the insects are readily identifiable. The exotic beasts seen in this plate may have been housed in one of the private menageries owned by Italian nobles. The birds, almost certainly drawn from Nature, were the most popular group with the anonymous artist whom some scholars have tried to link with the shadowy Cybo d'Hyeres. Whoever he was, he clearly had some acquaintance with oriental miniatures. His close observation anticipates Leonardo da Vinci and Albrecht Dürer, whose scientific curiosity contributed so much to the development of modern biology.

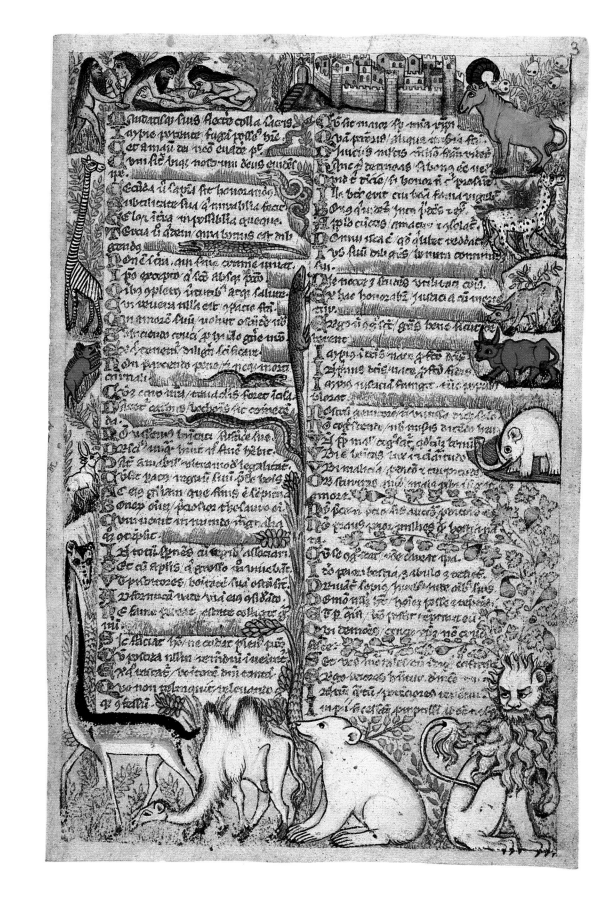

Plate 5

(TOP LEFT) *Polypodium vulgare*
(BELOW) Plantain (*Plantago major*)

Codex Bellunensis. Belluno. Early 15th century.
Add. MS 41623, folio 39. (*Dept of MSS*)

Produced about a century after *Liber de simplici medicina* (PLATE 2), the illustrations in this anonymous herbal mark a further stage in the slow progression towards naturalism in plant portraiture. There is still a preference for formal symmetry, as can be seen in this drawing of a plantain. The herbal was made at Belluno in the Venetian Alps, and some of the local flora, including alpines, were featured. but most of the plants were taken from Dioscorides.

Dioscorides recommended the plantain for healing wounds, sores and ulcers. Other writers and herbalists added eye disorders, mad dog bites and lung complaints to its impressive list of cures. The antiquary, John Aubrey, strolling in London on St John's Day in 1694, saw a score of young women in a field 'most of them well habited, on their knees very busy, as if they had been weeding'. On enquiry, he learnt that 'they were looking for a coal under the root of a plantain, to put under their head that night, and they would dream who would be their husbands: it was to be sought for that day and hour'.[1]

1. J Aubrey *Miscellances* 1890.

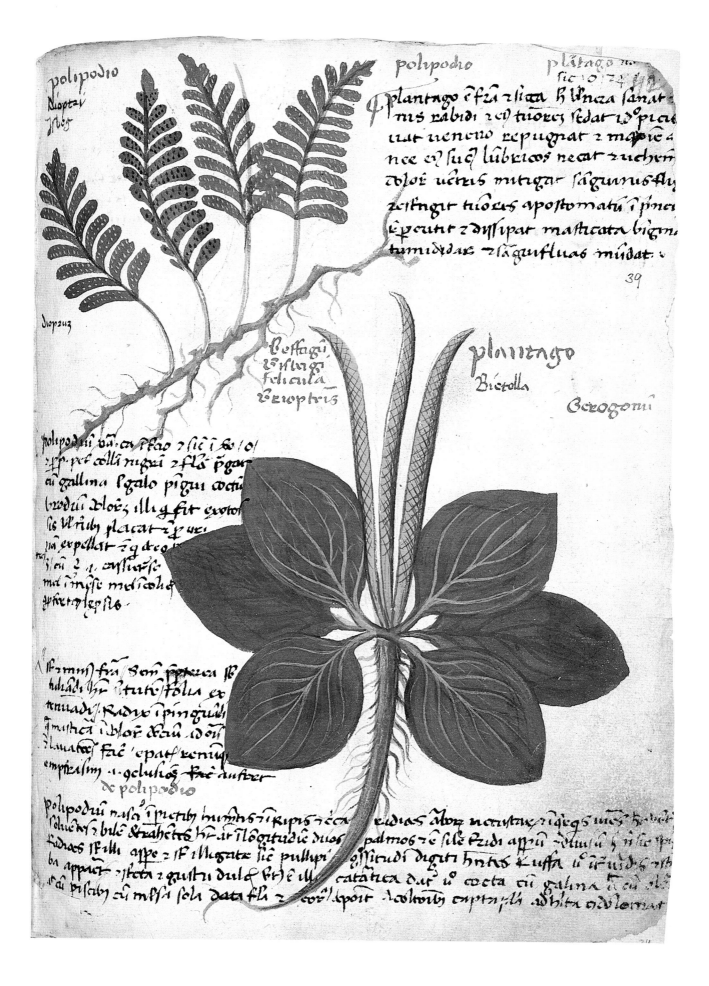

polipodio

Diopter
Jolcof

polipodio

plātago m
sic 10 24 9

plantago ē fri zsicca h vnca sanat
mus rabidi zcr tuores sedat 1ōprcc
uat ueneno repugnat z mavie a
nce cȝ suci lubricos necat zuchen
dloe uetris mitigat saguinus fly
zstingit tuores apostomatu i pnei
epeunt z dissipat masticata bigni
tumiddas zsāguifluas mūdat

39

Diopzuz

Uestagi
zdistago
feliculã
zeioptris

plantago

Bictolla

Ceeogonu

polipodiu vā cattao zsic i cō 10
app pet colli nigri zflo ȝgant
ai gallina segalo pigui coeti
brodui dloes illi ȝ fit exotof
sis uetuby placati z ȝ uel
pia expellat ȝ deco
ffon ȝ q asturso
mai ingse mesicobs
gesterplepfsile

firmus fra son pepeca s
bibади hic ctuts folis ex
muadi Radis spingui
ȝmstica i dloe stau ado
lauates fac epat reniȝ
empicalsm z gelusos fre anfcer
depolipodio

polipodiu nasa i spieтiby mimbis ȝ ripis zca eidias alog neustax ziȝegs mes habu
soluetz bile straherts hr at ilogitudie duos palmos ze sile txidi appu dliuid h i te spi
fidias steili appe zst illegata sic pullipi gssitudis digiti hntes zuffa u iz uid ib
ba appuet zsteta zgusti dulc brī e ill catatica dat iȝ coeta cu galina ī cu ob
ib cu pistby cu messa soli data fli zcorlepott ацoluthy ceptifsti adhba oislomat

Plate 6

Hounds, hare, fox and stoat(?)

Sherborne Missal. England. *c.*1400.
Loan 82, folio 47 (detail). (*Dept of MSS*)

This manuscript, on loan to the British Library from the Trustees of the Will of the Ninth Duke of Northumberland, is the most important English illuminated manuscript still in private ownership.

The huge volume, measuring 21 by 15 inches, was written for the celebration of the mass or eucharist at the Benedictine abbey of Sherborne by John Whas, a Benedictine monk, about 1400. The use of such a splendid manuscript would have been restricted to the high altar on high days or holy days.

It was illuminated with a generosity of decorative detail, mainly by John Siferwas, one of the leading English artists of the International Gothic period (*c.*1380–1430). The two columns of text on most pages are contained within a frame of flourishing foliage, among which are positioned medallions depicting portrait heads, figures and biblical scenes. About 170 birds appear on these pages and, according to Dr Brunsdon Yapp, about sixty per cent of them can be recognised. Their identification is often confirmed by the English names which have been added.

This delightful episode of hounds pursuing a hare and a fox at the bottom of one of the pages is typical of the numerous naturalistic drawings that distinguish this masterpiece of the illuminator's art.

PLATE 6

Plate 7

The Hastings Hours. Flemish. Late 1470s.
Add. MS 54782, folio 49. (*Dept of MSS*)

All families of any standing during the later Middle Ages and the Renaissance possessed a special lay prayerbook or Book of Hours. They owe their name to the ritual of prayers and psalms delivered at the canonical hours of the day.

This precious volume of miniatures once belonged to William, Lord Hastings, who was beheaded in 1483. As a diplomat, Hastings knew the Duke and Duchess of Burgundy, notable patrons of manuscript illuminators, who may have introduced him to Flemish artists. The Hastings Hours is a masterpiece of late Flemish illumination, with its harmonious proportions of facing pages and the vitality of the miniatures within unifying gold borders filled with swirling acanthus leaves, flower heads, insects and birds.

The miniatures are considered to be the work of one artist, but his identity is in dispute. The Master of the Older Prayerbook of Maximilian I is the most likely candidate. Whoever he was, he developed the device of placing shadows behind the objects on the gold borders so that they appear to stand off the page. This technique of creating depth was characteristic of Flemish illuminators.

The flowers are all familiar garden plants: columbine, iris, pansy, pink, daisy, violet, speedwell, lesser periwinkle, primrose, ground ivy and yellow-horned poppy.

Memoria de sco xpoforo. ant

sancte xpoforo
re martir
ihesu xpusti
qui pro eius
nomine pe
na pertulisti oprem confer in
seris atqz mundo tristi. qui
celestis glorie regna manusti
xpofori sancti speciem quicui
qz tuetur illo nempe die nul
lo sanguoze grauetur. confer
solamen et mentis tolle gra
uamen. Judicis examen fac
mite sic omnibus. Ve Ora
pro nobis beate martir xpo

Plate 8

Carnation (*Dianthus caryophyllus*) and daisy (*Bellis perennis*)

Huth Book of Hours. Probably Valenciennes. Late 1480s.
Add. MS 38126, folio 110. (*Dept of MSS*)

This manuscript once belonged to the banker, scholar and bibliophile, Henry Huth (1815–78). It came from the workshop of Simon Marmion (*d*.1489), an illuminator of Valenciennes, who specialised in devotional books. The manuscript uses the technique of giving shadow backgrounds to border motifs, made fashionable by the Master of Mary of Burgundy and the Master of the Older Prayerbook of Maximilian I (PLATE 7).

Symbolising divine love, the carnation was a favourite flower with illuminators. It is one of the oldest and best-loved of garden flowers. Thirty-nine varieties of carnations and pinks were listed by John Parkinson in his *Paradisi in sole Paradisus terrestris* (1629). For William Lawson, author of *New orchard and garden* (1618), it was the 'King of flowers except the rose'.

John Harvey, in *Mediaeval gardens* (1981), states that the first mention of a wheelbarrow in England in garden literature was about 1170, and this illustration in the Huth Hours must surely be one of the earliest pictorial records.

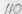
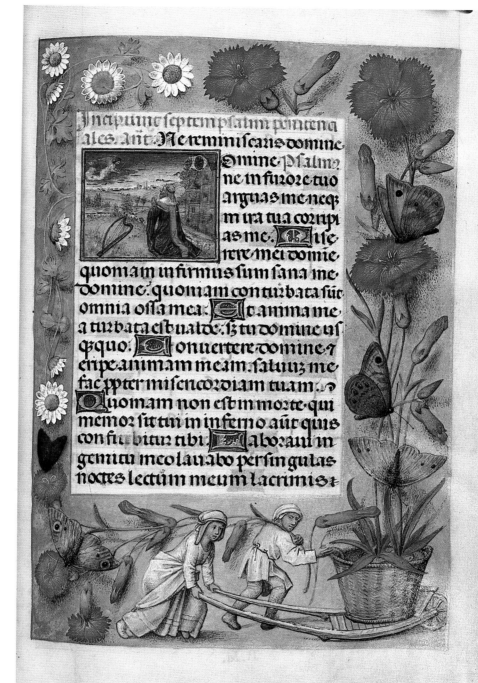

Incipium septem psalm penitenti
ales. Ant. Ne reminiscaris domine
Omine psalm
ne in furore tuo
arguas me neqp
in ira tua corripi
as me. Mise
rere mei domie
quoniam infirmus sum sana me
domine. quoniam conturbata sut
omnia ossa mea. Et anima me
a turbata est valde. sz tu domine us
qp quo. Convertere domine 7
eripe animam meam. saluum me
fac ppter misericordiam tuam. 7
Quomam non est in morte qui
memor sit tui in inferno aut quis
confitebitur tibi. Laboraui in
gemitu meo lauabo per singulas
noctes lectum meum lacrimis 7

Plate 9

Iris germanica

Breviary of Queen Isabella of Castile. Bruges. Before 1497.
Add. MS 18851, folio 111v. (*Dept of MSS*)

Breviaries, which are a compilation of the prayers, psalms, etc. said by the clergy at the canonical hours, came into existence probably in the eleventh century. They offered artists a wider range of themes than the Books of Hours, and the Grimani Breviary (Venice, *c.*1500) and the Breviary of Queen Isabella of Castile (illustrated here) are outstanding among the ones which survive.

The Flemish miniatures in this breviary, over 150 in number, were the work of two *ateliers* and the Master of the Dresden Prayerbook and the Master of James IV of Scotland were its principal illuminators.

The birds at first glance look like immature peafowl; and then there is a resemblance to the American Blue Jay, which is extremely unlikely in a manuscript of this early date. The iris, in the margin, is one of the oldest flowers in cultivation. A *bas relief* of two irises, incised in the wall of the temple at Karnak dates back to the time of Thutmososis III (1501−1447 B C). For the ancient Egyptians, it was a symbol of eloquence and for the French, much later, of royalty. Since it also symbolised the Madonna as Queen of Heaven it is frequently encountered in religious paintings. It stands proudly in a vase of flowers in the Portinari Altarpiece by Hugo van der Goes, and it is a focal point in Albrecht Dürer's 'Madonna with the Iris'.

Plate 10

Saffron crocus (*Crocus sativus*)

Horae Beatae Mariae Virginis et Officia Varia. Germany. Beginning of 16th century.
Egerton MS 1146, folio 293. (*Dept of MSS*)

The margins of this small quarto manuscript are graced with very accomplished watercolours of animals and plants. While the identification of plants in contemporary printed herbals is frequently impossible, their accurate and confident rendering in this manuscript poses little difficulty.

The Saffron crocus has been cultivated since ancient times for the sake of its scented stigma, which, when dried, could be used for medicine, perfume, flavour and as a dye. It was probably introduced into Britain by the Romans and, after some centuries of neglect, reappeared in Anglo-Saxon leech-books. It gave its name to the small Essex town of Saffron Walden, where it was extensively grown. In the Middle Ages, harsh laws were enacted to prevent its adulteration with substances such as candle-grease and butter. Now it is only used as a condiment but Gerard's *Herball* (1597) recommended it for heart, lungs and liver complaints, yellow jaundice, and assured its effectiveness 'to procure bodilie lust'.

Saffron was sometimes substituted for gold leaf in the illumination of medieval manuscripts.

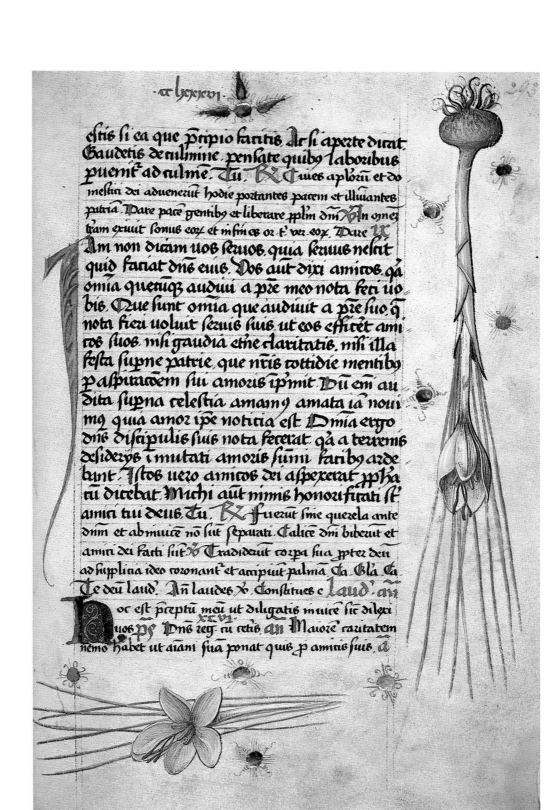

estis si ea que ppio facitis At si aperte dicat.
Gaudetis de culmine pensate quibz laboribus
puenit ad culme. Tu R Ciues aplou et do
mestici dei aduenerut hodie portantes pacem et illuiantes
patria. Dare pace gentibz et liberare ppl'm dm V In omne̅
tram exiuit sonus eor et in fin es or t' uer eor. Dare R
Am non dicam uos seruos. quia seruus nescit
quid faciat dns eius. Vos aut dixi amicos. qa
omia queuiq3 audiui a pre meo nota feci uo
bis. Que sunt omia que audiuit a pre suo q̅
nota fieri uoluit seruis suis. ut eos efficeret ami
cos suos. nisi gaudia etne claritatis. nisi illa
festa supne patrie. que nris cottidie mentibz
paspirandem sui amoris ipmit Dii em au
dita supna celestia amams amata ia noui
ms quia amor ipe noticia est Omia ergo
dns discipulis suis nota fecerat qa a terrems
desidery̅s imutati amoris su̅i faribz arde
bunt. Istos uero amicos dei asspexerat ppha
tu dicebat Michi aut nimis honorificati st̅
amici tui deus. Tu R fuerut sine querela ante
dnm et ab inuice no su̅t separati. Calice dni bibeant et
amici dei facti su̅t V Tradideru̅t corpa sua ppter deu
ad supplicia ideo coronant et accipiu̅t palma. Gla Gla
Te deu laud'. An laudes V Constitues e laud' an
Oc est preptu meu ut diligatis inuice sic dilexi
uos ps Dns reg tu cetis an Maiore caritatem
nemo habet ut a̅i̅a̅i sua ponat quis p amicis suis q̅

Plate 11

European catfish (*Silurus glanis*)

Leonhardt Baldner *Coloured drawings of waterfowl, fish, & 4 footed beasts, insects, etc at Strasburg.* 1653.
Add. MS 6485, folio 39. (*Dept of MSS*)

Baldner, who called himself a 'Fisher and Citizen at Strasburg', explains in the preface to this manuscript that 'At the first I had no design to write a Book of Fishes or Fowls, much less of insects, but because I shot in the year 1646 some wonderful water-fowls, & made them to be drawn to Life, and as soon as I got the same, my Delight and Meditations I had of them prevailed with me to go on'.[1]

John Ray and Francis Willughby met Baldner in 1663 as they were passing through Strasburg and Willughby purchased this manuscript. The drawings of birds, fish, amphibia, reptiles and insects are exquisitely executed in black ink, watercolours and gold leaf. Baldner paid particular attention to fish, whose habits and migrations interested him. On one occasion he painstakingly counted 148,000 eggs in the body cavity of a pike. His researches represent one of the earliest local faunas and John Ray incorporated some of his observations in his *Ornithologiae* and *Historia piscium*.

This specimen of the European catfish, native to the Danube, but now spread to all parts of Europe, was described by Baldner as 'A sea fish about a foot long'. It was bought by a Strasburg fisherman who put it in his pond in 1569 and kept it until 1620 when it died, having grown to five feet. 'I cut him up and sent him to ye market but nobody would dare to buy him'.

1. English translation. Add MS 6486.

N.º 3.

Ein Scheid.

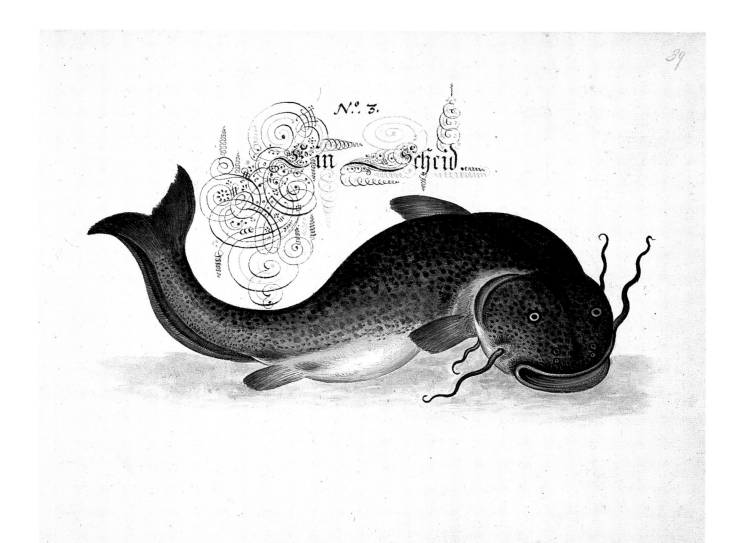

Plate 12

(TOP) Grey mullet (*Chelon labrosus*)
(BOTTOM) Shad (*Alosa*)

A book of Fishes done at Flamburgh with Mr Ray's Notes.
Add. MS 5308c, folio 5. (*Dept of MSS*)

John Ray (1628–1705), who has been hailed as 'The father of Natural History' and the 'Aristotle of England', joined forces with his friend Francis Willughby to compile a systematic description of the plant and animal kingdoms. On Willughby's early death, Ray acquired his friend's notes and, considerably enlarging them, wrote the *Historia piscium* (1686). It was Charles E. Raven's opinion that the work when 'based on first-hand knowledge is astonishingly accurate. When [Ray] has seen and described a fish, it is hardly ever difficult to identify it'.[1]

The artist who did the watercolour drawings of these fishes is not known. Fish are notoriously difficult to draw, their delicate colours rapidly fading when they are taken out of the water. Mark Catesby wrote that 'Fish which do not retain their colours when out of their element, I painted at different times, having a succession of them procur'd while the former lost their colours'[2] (PLATE 18). No matter how skilled the artist, a drawing of a fish always looks flat; there are no characteristic postures such as those that enliven an animal portrait.

1. C. E. Raven *John Ray, naturalist* 1942.
2. M. Catesby *Natural History of Carolina*, vol I, 1730, p xi.

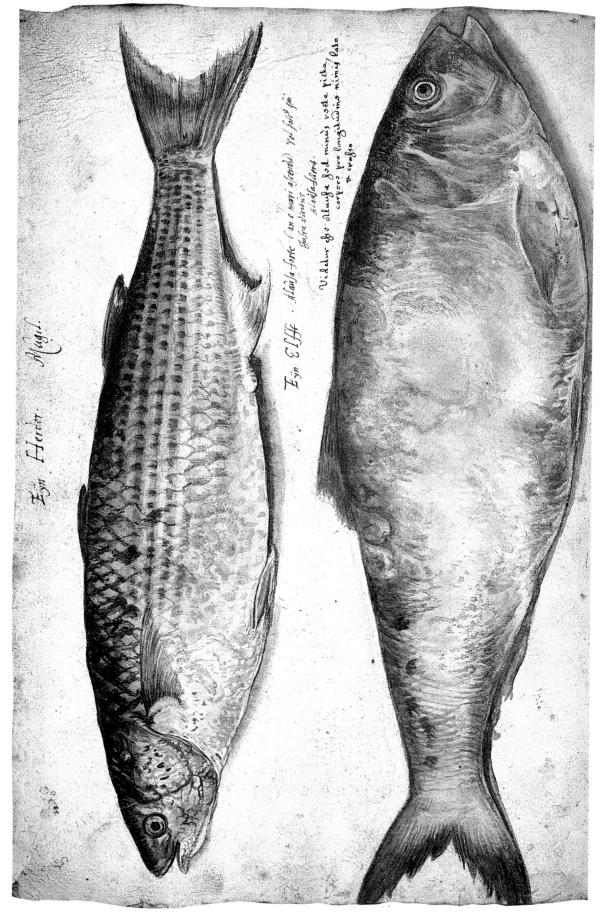

Eyn Herder. Mugil.

Eyn Elffe. Alosa forte. (an e mari ascendit) Yel forte sm̄
Guira viratrix.
Alosa sarvi.

Viddur sio alaufa god minnis voste pitta,
corpore pro longitudine nimis lato
et crasso.

PLATE 12

Plate 13

*A collection of British insects. Anonymous drawings of flowers, trees, wild and cultivated in England. c.*1684.

Add. MS 5282, folio 186. (*Dept of MSS*)

This manuscript is devoted almost entirely to competent water-colours of plants with a few pages of zoological specimens, of which this one. The precision of the artist's eye and brush makes it a relatively easy task to identify these British insects. For instance: *top line* Peacock Butterfly (first from left), Ghost Moth (second from right); *second line* Red Admiral (first from left), Orange-tip (second from left); *fourth line* Magpie Moth (fourth from left), Meadow Brown (fifth from left).

In the eighteenth century butterfly collecting was taken up with as much enthusiasm by women as by men. It was Mary Somerset, Duchess of Beaufort, while breeding insects, who observed that butterflies and moths sought particular plants as sources of food. The Glanville Fritillary commemorates Mrs Eleanor Glanville (died *c.*1707), another amateur entomologist. The names of butterflies and moths, like those of plants, can be most evocative. Many are named after the places where they were first observed: Camberwell Beauty, Essex Skipper, Arran Brown and Bedford Blue. Some names have fallen into disuse, like the Lady of the Woods which is now called, more prosaically, Orange-tip.

No self-respecting entomologist would go on a field excursion without his little boxes and pin cushion for specimens, and, of course, his batfolding net made of mosquito gauze. Moses Harris, a lepidopterist of considerable repute, gave explicit instructions on the choreographic movements required for wielding the batfolder. An approaching insect was to be met on the right side, 'then having the net in your hands, incline it down to your right side, turning yourself a little about to the right, ready for the stroke ... when the fly is within your reach, strike at it forcibly, receiving the fly in the middle of your net ... but should the fly strike against the belly or wider part of the net, the course of air caused by the motion of the net would carry the fly with it out of the net between your hands, which I have often experienced. ... You are likewise to remember never to give the stroke over-handed, unless the situation of the place oblige you to it'.[1]

1. M. Harris *The Aurelian* 1766, introduction.

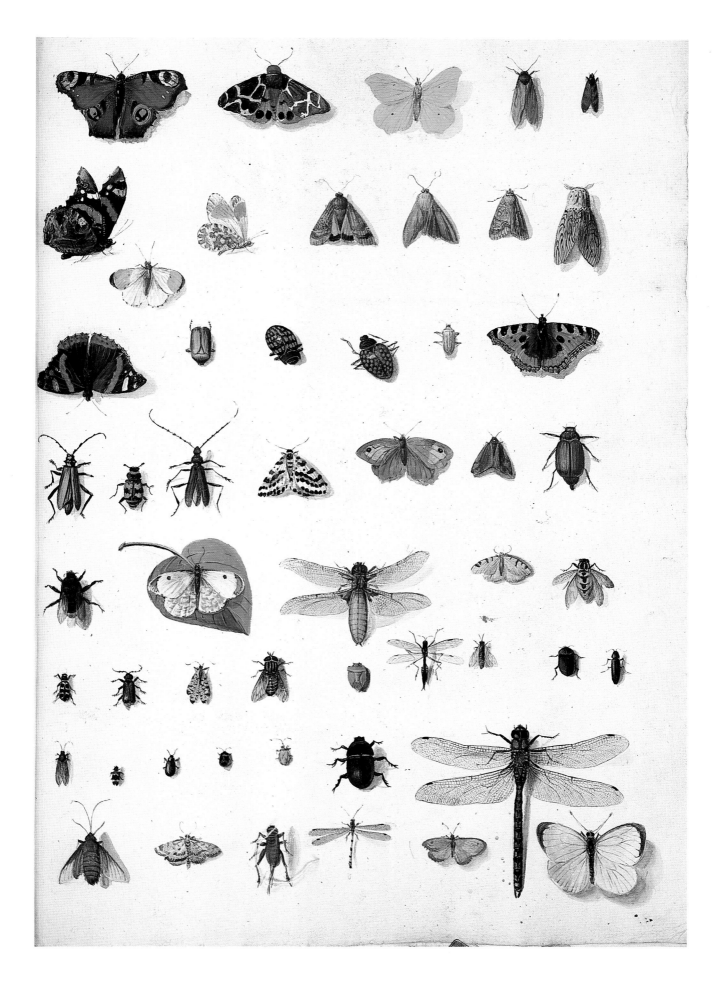

Plate 14

Garden or Diadem Spider
(*Araneus diadematus*)

Joseph Dandridge *A hundred and nineteen different spiders observed in England by Mr Joseph Dandridge described and drawn by himself, bought of him with his collection of insects. c.*1707.
Sloane MS 3999, folio 84 (figure 89). (*Dept of MSS*)

That devoted admirer of arachnids (it is a popular misconception that spiders are insects), W. S. Bristowe, conceded that 'Spiders are a matter of taste'. But, he continued, 'There will be few so fond of them as the "great lady still living" who, as described by Thomas Mouffet in 1607, "will not leave off eating them" '.[1] It is not known whether Joseph Dandridge (*fl.*1660–1744), a silk designer at Moorfields, also indulged in this peculiar culinary custom, but he did amass a large collection of insects and spiders. In this manuscript he describes and illustrates in watercolour the spiders he found mainly in the London area.

One of the risks of being a collector of spiders and insects is that one's behaviour might on occasion be misconstrued by others. A farm labourer who saw Dandridge leaping in the air for no apparent reason, thought him demented, and sought to restrain him by pinning him to the ground. His suspicions were confirmed when his victim simply kept moaning 'the Purple Emperor's gone! the Purple Emperor's gone!'.

The white cross on the body of the Garden Spider made it an object of veneration in medieval times.

1. W. S. Bristowe *A Book of Spiders* 1947, p 5, 34.

Plate 15

Beetles: *Dynastes hercules* and *Dynastes satanus*

Albertus Seba *A book containing severall sorts of insects from Europe, Asia, Africa etc. America: painted from the life in their naturall colours from the collection of Mr Albert Seba of Amsterdam.* 1728.

Add. MS 5273, folio 88. (*Dept of MSS*)

The apothecary Albertus Seba (1665–1736) returned to Holland from his travels in the East and West Indies with a huge collection of curiosities. It was subsequently enriched with many more items from travellers, sailors and merchants. These personal museums, or 'cabinets of curiosities', were very fashionable: Gesner, Cesalpino and Aldrovandi all formed such collections. The great Swedish naturalist, Linnaeus, made a point of inspecting their contents whenever possible. He saw Sir Hans Sloane's collection in London and while he was in Amsterdam paid a visit to Seba's home. In 1717 Seba sold his cabinet to Peter the Great, but, like so many other inveterate collectors, he started all over again. His second collection outstripped the original one. The four volumes of *Locupletissimi rerum naturalium thesauri* (1734–65) are based largely on his collections and the work is best remembered for its superb plates.

Seba probably kept these South American beetles in tightly corked bottles of brandy or rum, a method often used to preserve them on long voyages.

The green Hercules beetle (*Dynastes hercules*) is found in Central America and the Caribbean. It is one of the largest insects in the world, but through the destruction of the rain forests and the indiscriminate use of pesticides, it is now an endangered species. The black beetle (*Dynastes satanas*) is found only in Bolivia.

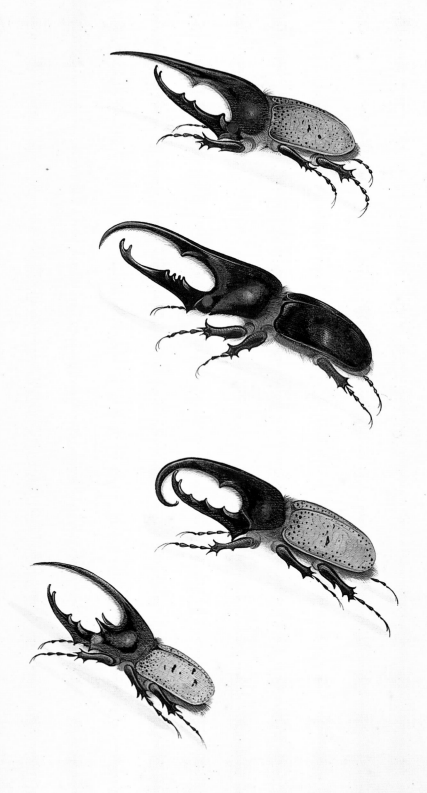

Plate 16

Flying Squirrel (*Glaucomys volans*)

Jacobus Theodorus Klein *Descriptive notes, letters, etc to Sir Hans Sloane with coloured drawings of natural history.* 1726–40.
Add. MS 5310, folio 11. (*Dept of MSS*)

J. T. Klein (1685–1795), in addition to his duties as Secretary of the State of Danzig, found time to write more than twenty books on geology, botany, quadrupeds, birds, fishes, marine worms, molluscs, etc. His study of reptiles, *Tentamen Herpetologiae* (1755), coined the word herpetology. The genus *Kleinia* commemorates him.

The North American flying squirrel does not actually fly but glides, launching out from a high point, extending the large flaps of skin between its arms and legs and using its tail as a sort of rudder. From a height of about 17 metres it can glide about 50 metres in about 30 seconds.

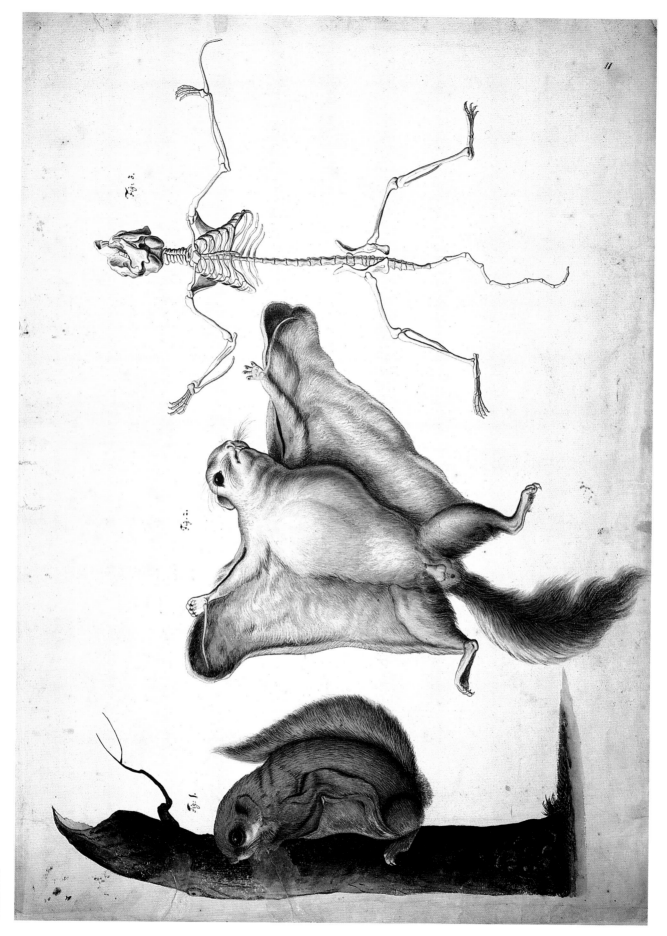

PLATE 16

Plate 17

Eleazar Albin *Descriptions & delineations of English & some foreign spiders.* 1732.
Sloane MS 4001, folio 62. (*Dept of MSS*)

Joseph Dandridge's drawings of spiders (PLATE 14) were copied in an inferior manner and without acknowledgement by Eleazar Albin in his *Natural history of spiders and other curious insects* (1736). This would appear to have been a typically ungenerous act. Dandridge, who probably did much to launch Albin's career as a painter of insects, never protested. Another zoological artist, George Edwards, was not so reticent; he never missed an opportunity to express his contempt for Albin's artistic skills. Albin had a large family to support, so his daughter, Elizabeth, assisted in the colouring of the plates in his books. His sons may have contributed to their father's efforts in an unusual way. According to James Petiver, Albin made his vermilion by washing the dry pigment 'in 4 waters then grind it in boys urine 3 times, yn gum it and grind it in brandy wine'.[1]

The creature in the top-left corner is *Araneus marmoreus pyramidatus* but Albin's drawings of spiders are not always sufficiently accurate to enable certain identification. The pattern of dots in front of each spider is a diagnostic feature indicating the pattern of the eyes.

1. Sloane MS 3338

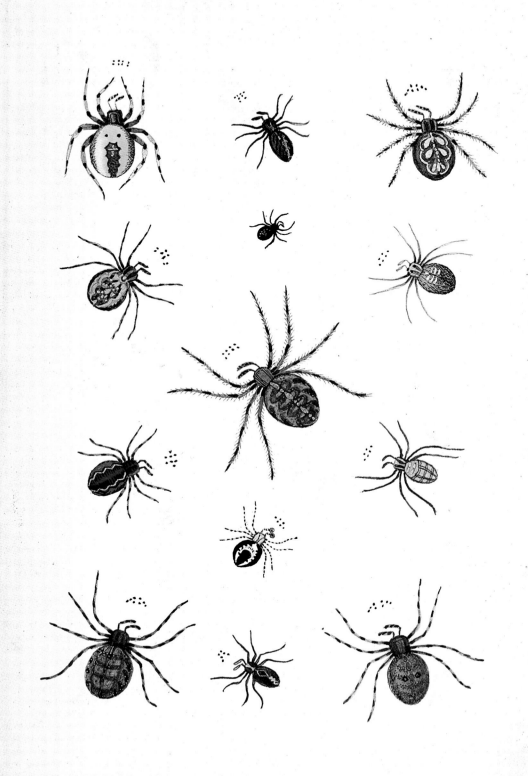

Plate 18

Chauliodus sloanei

Mark Catesby *Album of drawings by Catesby, G. Edwards, G. Jago et al.* 18th century.
Add. MS 5267, folio 67. (*Dept of MSS*)

Mark Catesby (1682–1749) travelled and collected specimens in the North American colonies and the Bahamas between 1712 and 1726. He taught George Edwards how to etch his own copper plates to save expense, having originally acquired that skill himself for the same reason. He engraved 220 plates and supervised their colouring in his *Natural history of Carolina, Georgia, Florida and the Bahama Islands* (1729–47), accompanying the plates with nearly 300 pages of text, a remarkable achievement for a man with no formal education in science or art.

His fishes do not reach the standard of his bird drawings. The American naturalist, Alexander Garden, criticised the accuracy of Catesby's drawing of a Mullet in a letter to Linnaeus in 1760: 'Please to observe the Albula, our Mullet; and you may immediately perceive that he [*i.e.* Catesby] has not only forgotten to count and express the rays of the fins, but that he has, which is hardly credible, left out the pectoral fins entirely, and overlooked one of the ventral ones'.[1] Linnaeus, in fact, declined to name Catesby's drawing of *Chauliodus sloanei* because he had doubts about the reliability of this drawing.

1. J. E. Smith *A selection from the correspondence of Linnaeus and other naturalists*, vol 2, 1821. pp 300–06.

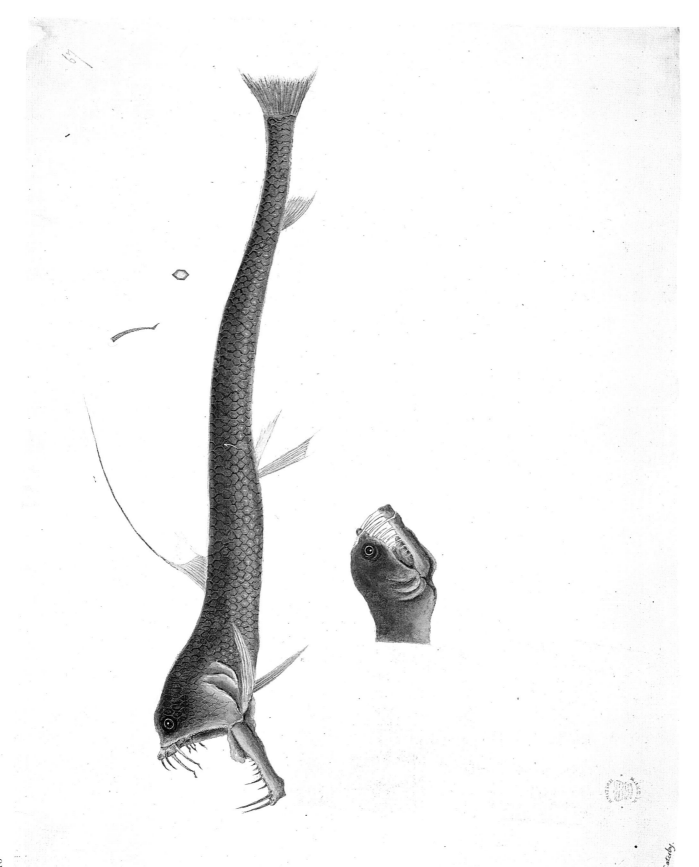

PLATE 18

Catesby.

Plate 19

Lizard (*Lacerta lepida*) and moth (*Abraxas grossulariata*)

George Edwards, E. Kirkius, *et al. Amphibians and reptiles*. First half of 18th century.
Add. MS 5272, folio 20. (*Dept of MSS*)

After two years wandering on the continent, George Edwards (1694–1773) settled down to the career of a zoological artist in 1721. One of his patrons, Sir Hans Sloane, was instrumental in getting him the post of librarian at the Royal College of Physicians in 1733. His *Natural history of uncommon birds* and its continuation, *Gleanings of natural history*, occupied him for twenty years. Many naturalists of his day approached the study of Nature in a spirit of veneration, and so it is not at all surprising that Edwards piously dedicated his *Natural history* to God. He set high standards in the hand-colouring of his prints, and, to guard against the possibility of prints coloured by unskilled people being taken for his work, had a reference set of carefully coloured prints deposited in the library of the Royal College of Physicians.

This watercolour of the lizard is engraved as plate 202 in his *Natural history* (1750). The lizard is common in Southern France, Spain and Portugal, and the moth frequents soft fruit bushes.

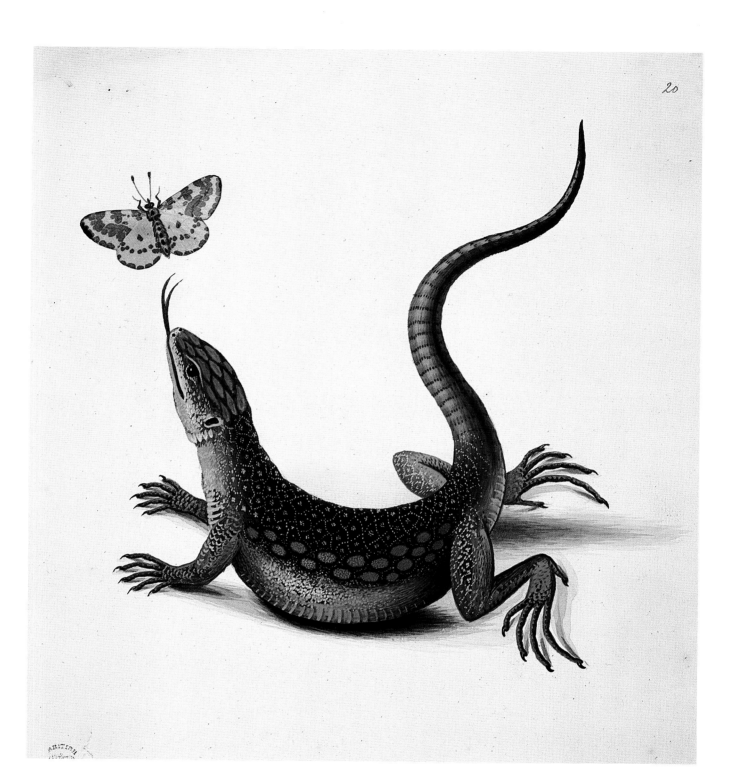

Plate 20

Purple-bellied Lory (*Lorius hypoinochrous*)

George Edwards *Drawings of birds*. First half of 18th century.
Add. MS 5263, folio 40. (*Dept of MSS*)

George Edwards was proud of the fact that he drew directly from
Nature whenever he could, using a stuffed specimen or bird skin
only when a living specimen was not available. It was an eighteenth-
century convention to pose a bird on a branch or stump of a tree, but
Edwards claimed to 'have, for variety's sake, given them as many
different turns and attitudes'[1] as he could devise. He deplored the
work of a contemporary artist (Albin?) who gave 'his birds no
variety of posture . . . they were direct profiles standing in the same
position, which sameness is disagreeable. I observed also in his trees,
stumps, and grounds, a poorness of invention'.[2] To enliven his
composition and 'to fill up the naked spaces in the plates', Edwards
would add an insect or two, drawn with the same care he always
gave to the bird.

1. G. Edwards *Natural history of uncommon birds*, 1743, p xxi.
2. *Ibid* 1751, plate 170.

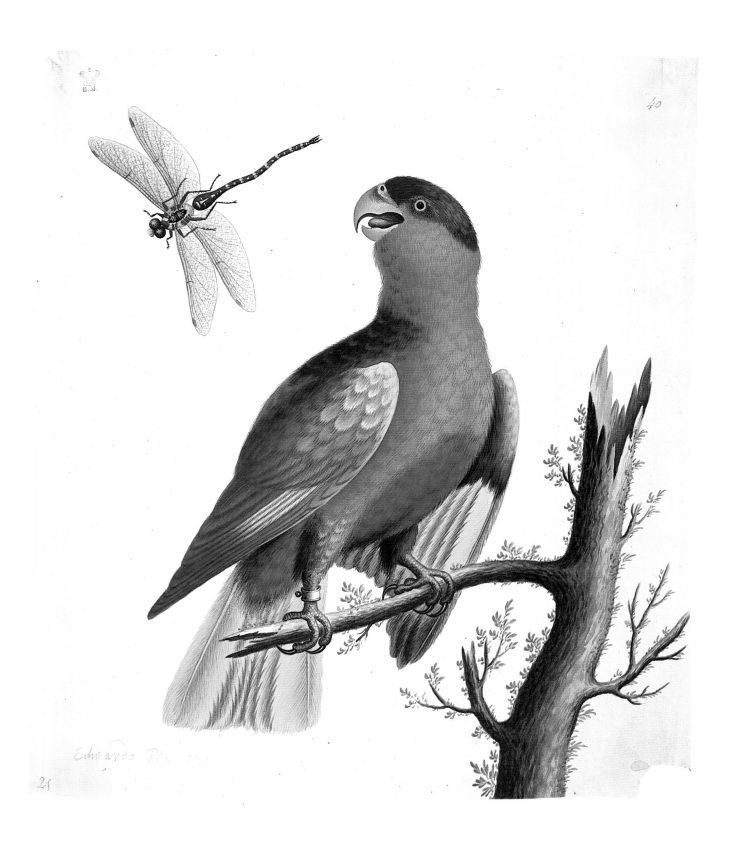

Edwards Pic.

21

Plate 21

Leviathan

Chummash et Machzor Hebraice. Late 13th century.
Add. MS 11639, folio 518v. (*OMPB*)

One of the forty-one full-page paintings which illustrate this celebrated Hebrew manuscript which was probably written between 1278 and 1286 in northern France. Artists from four different workshops were employed and their obvious understanding of Jewish motifs would suggest they were themselves Jews.

The word Leviathan probably derives from the Hebrew *livyah* and *tan*, the latter word being variously translated as whale, dragon, great fish, crocodile or snake according to context. It is mentioned five times in the Old Testament. In *Job* it is a crocodile and in *Isiaih* a sea-dragon. Terrifying sea-serpents are encountered in most ancient mythologies and, presumably, the whale was the source of some of these beliefs. The long-headed whale (*Physeter catodon*), which can reach over twenty-two metres in length, is occasionally found off the coast of Israel. In the Bible, leviathan is a symbol of evil over which God triumphs. God 'brakest the heads of leviathan in pieces, and gavest him to be meat to the people inhabiting the wilderness' (Psalms 74: 13−14).

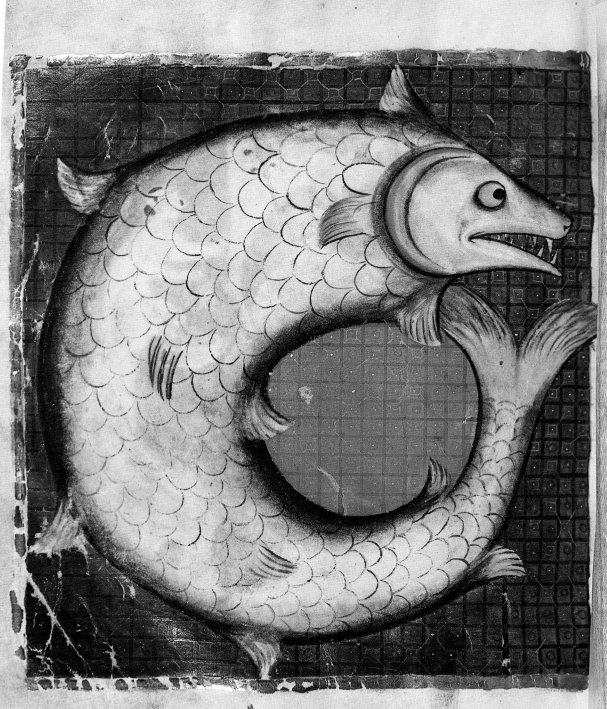

לויתן הוא

Plate 22

A ram leading a flock of goats (*Capra hircus*)

Muhammad ibn Da'ud ibn Muhammad ibn Mahmud. *Miftah al-Fuzala*. Mandu. 15th century.
Or. 3299, folio 278v. (*OMPB*).

The author of this glossary of proper names and rare words culled from Persian poetry lived in Mandu (Shadiabad) in Western India. The 187 small illustrations embrace subjects as diverse as occupations, tools, musical instruments, toys, parts of the body and physical abnormalities. The animal kingdom is represented by beasts of prey – lion, leopard, hyena, wolf, etc – and birds such as the falcon, lark, ostrich, swallow and wagtail. Even the lowly tortoise and inconspicuous moth are not overlooked.

بیاموز او و مردم پارسی ، که در کان که آن را آغاز در دستان

Plate 23

Majnun befriended by the animals in the desert

Nizami *Khamsa*. Tabriz. 1539–43.
Or. 2265, folio 166. (*OMPB*)

The *Khamsa* is one of the most celebrated poetical works in Persian literature and perhaps the most frequently illustrated. It is a collection of five (Khamsa is Arabic for five) metrical romances written over a period of some thirty years by Nizami (1140–1202/3). It relates the tragic love story of Layla and Majnun who, because they came from opposing tribes, were not allowed to marry. The love-torn Majnun retreated to the wilderness and the companionship of the animals there.

The portraying of gatherings of animals has been a popular theme with artists of many cultures. In the West, it was the story of the *Creation* or the *Flood* with animals meekly entering the Ark; in Persia and India, stories of Layla and Majnun, Solomon conversing with animals and birds, and the fables of the *Kalila va Dimna*.

Aqa Mirak, whose signature appears on five of the fourteen miniatures, executed this exquisite painting. He was employed by Shah Tahmasp at his academy in Tabriz, the Persian capital and centre of the school of miniature painters. Artists from the Tabriz academy established the Mughal school of painting in India.

Plate 24

Plato charming the wild animals with his music

Nizami *Khamsa*. Probably Lahore. 1593.
Or. 12208, folio 298a. (*OMPB*)

This version of the *Khamsa*, described as 'without exception the most wonderful Indian manuscript in existence'[1] has, unfortunately, been dismembered. Thirty-seven of the original forty-four full-page miniatures are in the British Library, five are owned by the Walters Art Gallery in Baltimore and the remaining two are lost.

The manuscript was written for the Mughal Emperor Akbar, probably at Lahore, by 'Abd al-Rahim, one of the foremost calligraphers of his day. Several artists drew the miniatures. Madhu, who after Akbar's death was employed by the Emperor Jahangir, painted this scene of Plato entertaining the animals. It comes from the last poem in the *Khamsa*, the *Sikandar-nama*, or the story of Alexander the Great. Alexander, seeking wisdom, meets Greek philosophers including Aristotle, Diogenes, Plato and Socrates. Nizami devotes several dozen lines to Plato's accomplishment on the 'organon' with which he was able to arouse all sleeping creatures and hold them spellbound. The organ in this miniature came to Akbar's court from Italy.

1. F. R. Martin *The miniature paintings and painters of Persia, India and Turkey*, vol 1, 1912, p 81.

چنان نسبت ناقش امید بست	که هر جاکه زد مرد دورا پای بست	همان نسبت او می نمود دو	یکایک بران خم میشد زد
چنانکه و می کشیدی نی کنش	برقص و طرب خیره خیره می کوش	بلع و بهایم بران پنجست	یکی کشت پیدار و دیگر نخست
چو روز نبست ناله در کرسی	بدست مادر این و دست پیمان بسی	زموسقی آورد بار کی پرن	که از ابشد پخ خاور زنون
چنان بساخت نرستی و حروش	کنالنده راول دواره پخش	بجای رسیدا که زنواخت	که وامار و بعب و علت نشست
زقانون آن یافت عقل آکی	زبر علی بافت عقل آکی	چو بار زنون بسته مقام	شدانع و بخت بران و و دخام
برون شد بصحرا و بلاش	بهر نسبت انداره نساخش	خطی جار بسوکرد و خود در کشید	دران خط شد و ازنون برکشید
دد و دام را زبسا به او کرد	روان کرد به خود کرو ما کرو ه	دویدند به سرک به آواو	نهاد مدیر پر خط و پا زاو
همه ملیک از خویش تف پاک			فتاد مدیر چون مرد و بر روی خاک

Plate 25

(TOP) Oleander (*Nerium odorum*)
(BOTTOM) Screwpine (*Pandanus odoratissimus*)

Baburnama. Mughal. *c.*1590.
Or. 3714, folio 407v. (*OMPB*)

Several early versions of the *Baburnama*, the memoirs of Babur, the first Mughal Emperor, still survive, and the British Library has the most complete and best illustrated copy. About half of the 143 miniatures depict India's flora and fauna.

Here are Babur's detailed descriptions of these two plants, which were drawn by Ibrahim Nakkash:

Oleander

'It grows both red and white. Like the peach-flower, it is five-petalled. It is like the peach-bloom (in colour?), but opens fourteen or fifteen flowers from one place, so that seen from a distance, they look like one great flower. The oleander bush is taller than the rose bush. The red oleander has a sort of scent, faint and agreeable. (Like the jasun [*Hibiscus rosa-sinensis*]), it also blooms well and profusely in the rains, and it is had through most of the year.'

(In the gardens he created at Agra, Babur planted some of the 'rosy red' oleanders he so much admired.)

Screwpine

'It has a very agreeable perfume. Musk has the defect of being dry; this may be called moist musk – a very agreeable perfume. The tree's singular appearance notwithstanding, it has flowers perhaps $1\frac{1}{2}$ to 2 qarish ($13\frac{1}{2}$ to 18 inches) long. It has long leaves having the character of the reed gharau and having spines. Of these leaves, while pressed together bud-like, the outer ones are the greener and more spiny; the inner ones are soft and white. In amongst these inner leaves grow things like what belongs to the middle of a flower, and from these things comes the excellent perfume . . .'[1]

1. *Babur-nama.* Translated by A. S. Beveridge, 1922, p 514.

گل دریکجا می شکفد از دو رمثل یک گل کلانکه گل کلانی سیه نماید بوته این

از بوته گلبن کلانتر است کبیر سرخ طور بویکی داره خوش آینده است

این هم در سه چهارماه بیشگال متصل می شکفد و بسیار و خوب می شکفد

این هم در اکثر سال یافت می شود دیگر کبیوره است سیار بوی

Plate 26

(TOP) Red Jungle fowl (*Gallus gallus*)
(BOTTOM) Partridge (?)

Baburnama. Mughal. *c.*1590.
Or. 3714, folio 388. (*OMPB*)

At least eight of the bird paintings in this *Baburnama* are by Ustad Mansur, whom the Emperor Jahangir declared was 'unique in his generation', bestowing upon him the title, 'Wonder of the Age'. These two drawings are modest examples of Mansur's skill.

او تا پسینه خوش رنگ سرخ است پلی نگار در کوهستان میشود دیگر مرغ

مرغ صحرائی است در میان مرغ خاصیکی فرق اینست که این مرغ صحرائیست

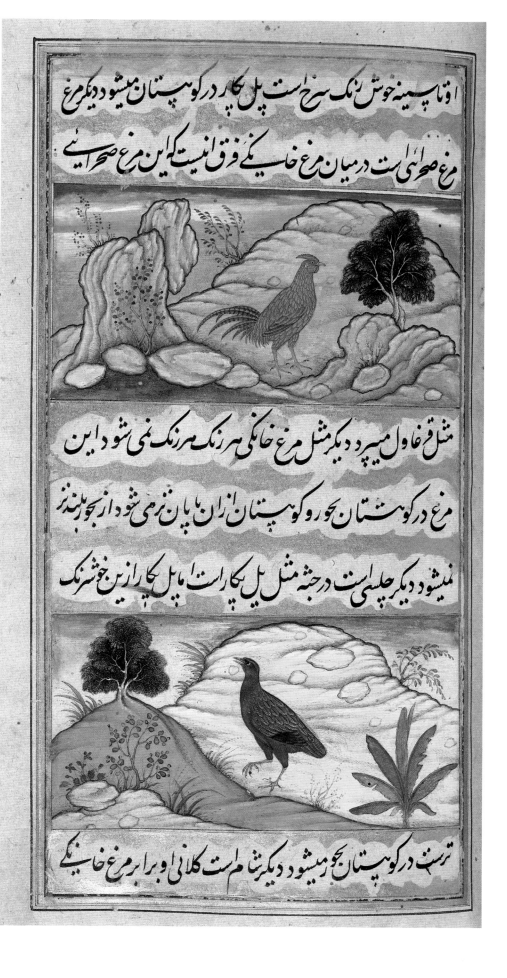

مثل قاول میپرد دیگر مثل مرغ خاکی هر رنگی هر رنگ نمی شود این

مرغ در کوهستان بجو رو کوهپستان ازان بالا بان نزی می شود از بجو بلند نر

نمیشود دیگر چلسی است در حبشه مثل لیلگار است مایل لگار ازین سرخ شتر رنگ

ترش در کوهستان بجو میشود دیگر شنام است کلانی او برابر مرغ خاصیکی

Plate 27

Indian Rhinoceros (*Rhinoceros unicornis*)

Baburnama. Mughal. *c*.1590.
Or. 3714, folio 379. (*OMPB*).

Drawing a rhinoceros was a challenge to the skill and credulity of artists from Dürer onwards (figure 41). This Mughal artist was clearly defeated by the many layers of the creature's skin which Babur graphically described as looking 'like housings thrown over it'. Babur had a great respect for the strength and ferocity of this formidable animal:

'This also is a large animal, equal in bulk to perhaps three buffaloes. The opinion current in those countries that it can lift an elephant on its horn seems mistaken. ... The rhinoceros's hide is very thick; an arrow shot from a stiff bow, drawn with full strength right up to the arm-pit, if it pierce at all, might penetrate 4 inches.'[1]

1. *Babur-nama* Translated by A. S. Beveridge, 1922, pp 489–90.

دانه یک فطار شتر را یک فیل می خورد کرگدن هم این جانور کلانست

صحبت او و برابر سه گاو میش می باشد آن سخن که در آن لاینها مشهورست

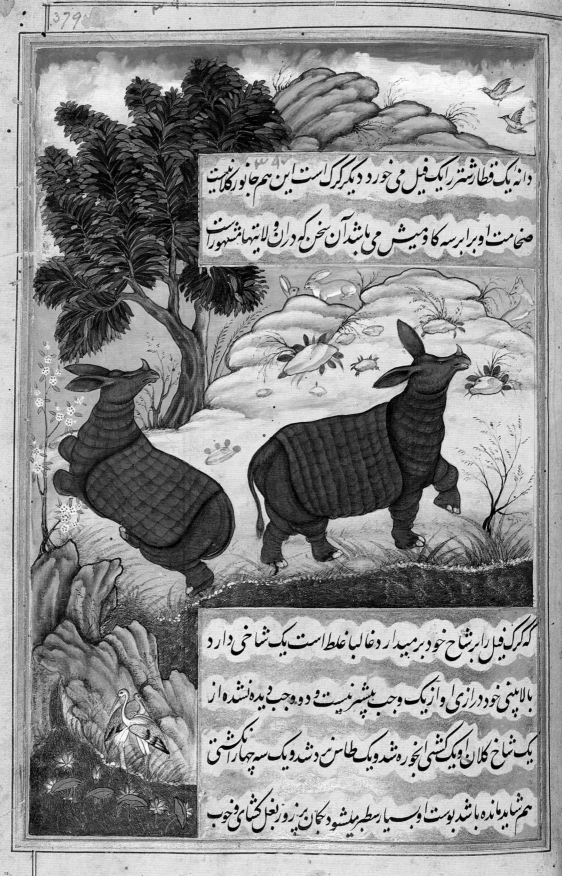

که کرگ فیل را بر شاخ خود بر میدارد و غالبا غلط است یک شاخی دارد

بالای بینی خود درازی او از یک وجب بیشتر نیست و دو وجب دیده نشده از

یک شاخ کلان او و یک کشتی انجوره شد و یک طاس زر شد و یک سه چهار کشتی

هم شاید مانده باشد و بست و بسیار سطبر میشود گان یعنی زور بغل کشای و خوب

Plate 28

Tree locust (*Cyrtacanthacris tatarica*)

Mughal. *c*.1600.
Johnson album 67, no 1. (*IOLR*)

Insect drawings were not common during Akbar's reign. This very accurate drawing of a female tree locust was remounted as a separate sheet during the eighteenth century, and therefore it is not known whether it formed part of a book on insects. The butterfly, which cannot be identified, was possibly added later.

The miniature shows a swarm of locusts devastating the countryside. Although a pest, they have also been a convenient source of food. *Leviticus* 11:22 records God's approval of this practice: 'These ye may eat, the locust after his kind ...'. When John the Baptist withdrew to the desert, he lived on locusts and honey. They can be fried, boiled, powdered and baked into cakes, flavoured with pepper and salt or, as in India, curried.

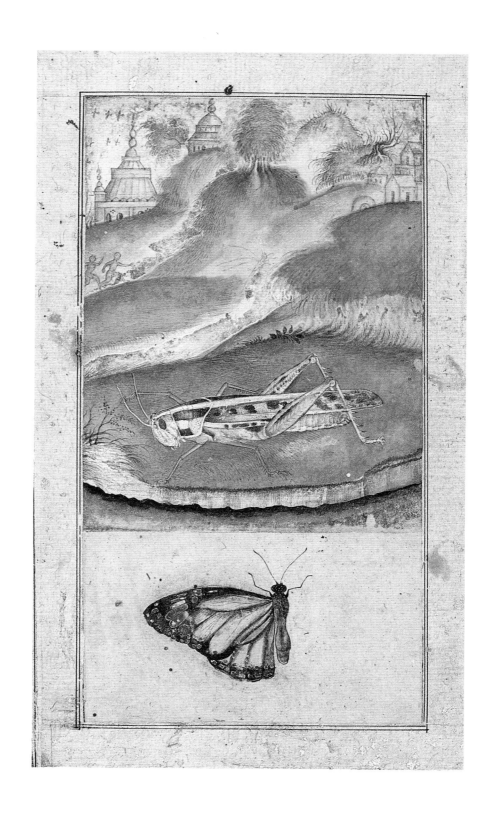

Plate 29

Shah Tahmasp and Humayan hunting together

Akbarnama. Mughal. 1603–04.
Or. 12988, folio 103. (*OMPB*)

The *Akbarnama* was written in response to the Emperor Akbar's desire for a record of the principal events of his life.

Humayan, Akbar's father, sought refuge in the mid-1540s in Persia, where this miniature depicts him hunting with Shah Tahmasp.

Hunting for the Mughals was like a military operation, involving a vast army of men to form an enclosure, many miles in diameter. Soldiers, acting as beaters, slowly advanced, gradually herding together all the animals trapped within the diminishing circle.

Here, the artist shows the terrified animals caught within this human wall: Swamp and Spotted Deer, Nilgai, Black Buck, Indian Gazelle, Indian Hare, and a trained Cheetah that has joined the kill.

منشا دبناره خاری از جا نبربر جا وش شده کورت تا مبند آذ نک شید و برلال صفاصفتی کشت و همه روز حضرت

شاه اسباب مسرت وشا دمانی تازه تبازه رترب میدا نداز احله تجربه نشیط وتفرح خاطر لشکر نگاه رفعته طرح فرمود

واز ده راه روزه را لشکر شناسی جانوران صحرا یی را را نده در چبه که او را سا وق ملاقی گوید که اول منزل سلیلنشت

بشکا سی مجمع نشده رت جهانبانی وشاه کرامی قدره باهم درنگا که در آمد آین اسپ انداختن وشکار انداختن تازه کرد وا

Plate 30

The crow deciding whether the owl should lead the assembly of birds

Husain Va'iz Kashifi *Anvari-i Suhaili*. Mughal. 1610–11.
Add. MS 18579, folio 201v. (*OMPB*)

At least sixteen artists – ten Hindus and six Muslims – collaborated in illustrating this version of the animal stories of the legendary Indian sage, Bidpay. Stories about animals whose behaviour and feelings corresponded to those of humans were circulating in South Asia long before Aesop wrote his fables. These ancient Sanskrit tales are best known in the Persian versions of the *Anvari-i Suhaili* and the *Kalila va Dimna*. Propounding moral rather than religious judgements, fables may be considered the ancestors of the bestiaries.

The feud between the crow and the owl is one of the classic stories. An assembly of birds who had agreed to elect the owl as their king were dissuaded by the crow's oratory. The artist, Ustad Husain, conveys the tensions of an election campaign; the birds look thoughtful while the owl is evidently annoyed by the crow's success. Husain's birds are so carefully drawn that it is delightfully easy to name them. Progressing downwards from the top of the miniature are Green Bee Eaters, Brown Fishing Owl, Peacock, Palm Dove, Little Egret, Common Bulbul, Hoopoe, Starling, Indian House Crow, Sarus Crane, Black Francolin, Common Myna, Pied Wagtail, Brahminy Kite, Grey Heron, Kalij Pheasant, Red-legged Partridge.

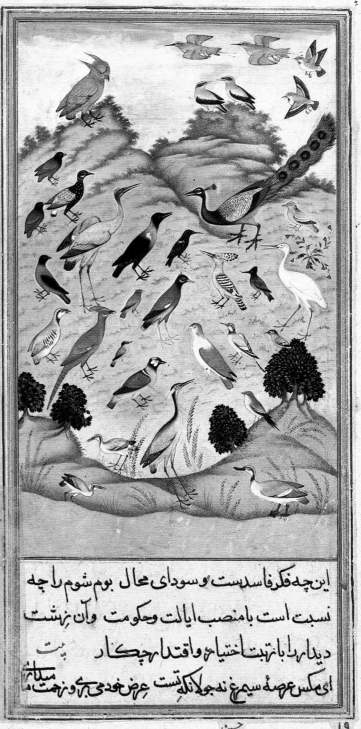

این چه فکر فاسدیست و سودای محال بوم شوم را چه
نسبت است با منصب ایالت و حکومت و آن بهشت
دیار را باز تربت اختیار و اقتدا هچ کار پت
ای مکس عرصه سیمرغ نده جولانکه نست عرض خودی بجری و زحمت م

Plate 31

Night Heron (*Nycticorax nycticorax*); Martagon Lily (*Lilium martagon*)

Dara Shikoh album. Mughal. Assembled *c*.1633–42.
Add. Or. 3129, folio 9v. (*IOLR*)

Dara Shikoh, the eldest son of the Emperor Shah Jahan and heir-apparent to the throne, gave this manuscript to his wife about 1641. All the sixty-eight miniatures of bird, flower and figure studies are set within lavish gold borders of animal and flower motifs. Only one miniature carries an artist's signature. Dara Shikoh was murdered in 1659 by his brother, Aurangzeb, who deposed his father and seized the throne. This album has miraculously survived as a poignant reminder of his tragic life.

Mughal painting is especially notable for its remarkable bird studies. Mansur, who was supreme in this genre, must surely have influenced the artist of this Night Heron.

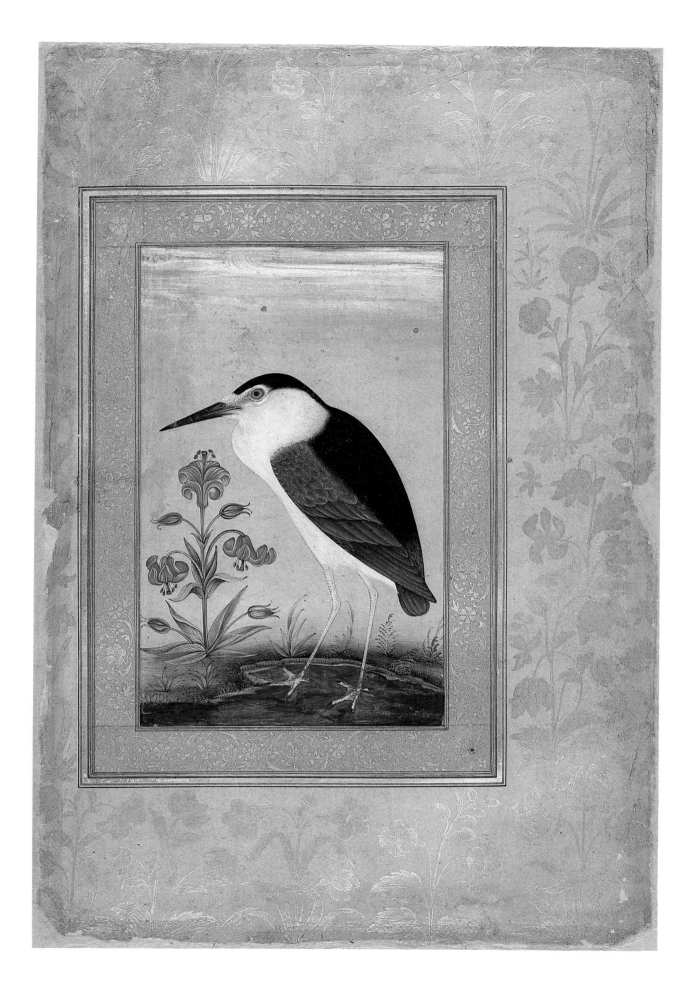

Plate 32

Crown Imperial (*Fritillaria imperialis*)

Dara Shikoh album. Mughal. Assembled c.1633–42.
Add. Or. 3129, folio 62. (*IOLR*)

The Crown Imperial is rarely figured in Persian and Mughal miniatures, yet it is a native of Persia and was cultivated in Turkish gardens for many years. Jahangir's memoirs describe a plant that attracted his attention: 'Among the flowers I saw (noticed especially) one extraordinary one. It had five or six orange flowers blooming with their heads downwards. From the middle of the flowers there came out some green leaves, as in the case of the pine-apple'.[1] Surely this was the Crown Imperial?

Mughal artists could stylise flowers almost to the point of caricature, but they seldom took similar liberties with animals and birds. Certainly the shape, line and colour of flowers more readily provide the ingredients of decorative composition. The linear qualities of plant form and particularly the sinuous lines of the vine made them ideal motifs for the decoration of buildings. Some of the best examples can be seen in Agra in the *pietra dura* work at the Taj Mahal, Itimad-ud-Daula's tomb and the Fort.

1. *The Tuzuk-i-Jahangiri; or memoirs of Jahangir*. Translated by A. Rogers, vol 2, 1914, p 134.

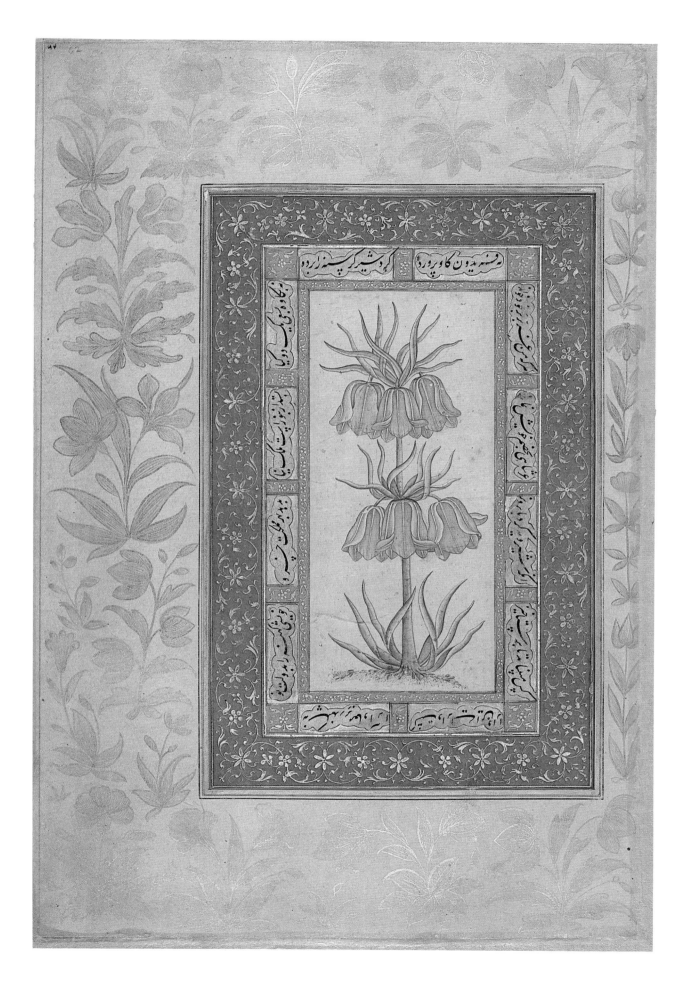

Plate 33

An elephant trampling a tiger

Attributed to Mir Kalan Khan. Faizabad. *c*.1770.
Johnson album 3, no 3. (*IOLR*)

Tigers, now an endangered species in India, were once so numerous that a hunter in Bengal in 1782 was able to shoot twenty-three in a week. Heavy elephants with long tusks were often used on tiger hunts and it was no mean feat to aim accurately from an insecure platform on the creature's rolling, pitching back. Early in its training to attack tigers, an elephant would be introduced to a stuffed skin of its adversary and taught how to thrust its tusk through the stuffing. 'The inanimate object has, perhaps, been viewed with indifference; but when a boy is put within the skin, stuffed to its utmost dimensions, and causes to proceed, at first with silence, and afterwards with loud howlings, the elephant generally in following will show some uneasiness'.[1] The elephant was withheld from attacking until a calf or other animal had been substituted. After a tiger had been killed, the elephant was encouraged to trample upon it, transfixing it with its tusks.

1. T. Williamson and S. Howett *Oriental field sports*, 1807, p 76.

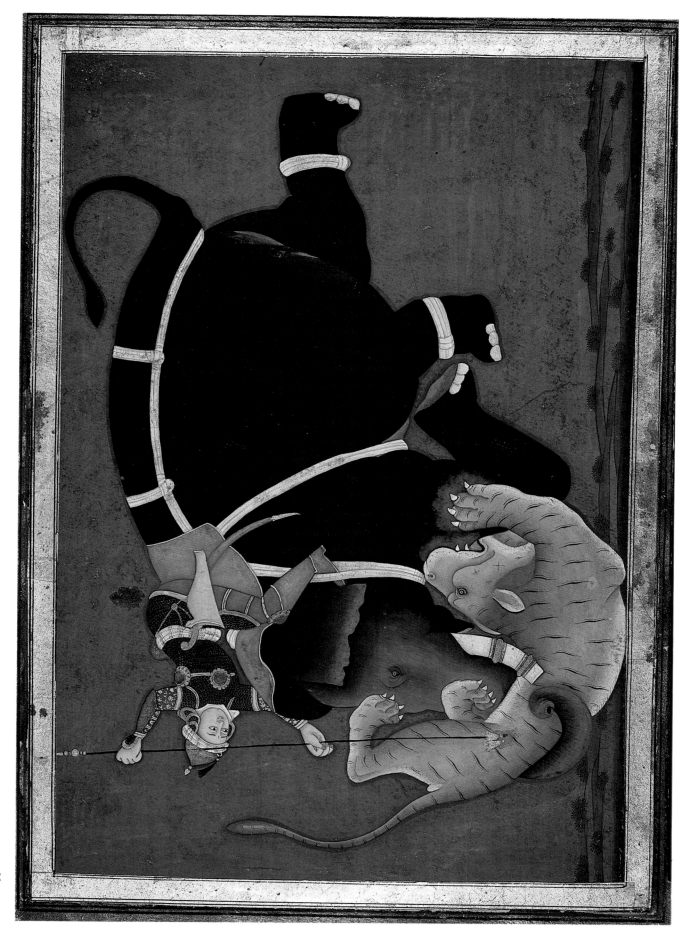

PLATE 33

Plate 34

Egg-plant, or Aubergine (*Solanum melongena*)

Thomas Hardwicke *Collection of flower paintings.* India. Late 18th and early 19th centuries.
Add. MS 11013, folio 43. (*Dept of MSS*)

Major-General Thomas Hardwicke (1755–1835) of the Bengal Artillery whilst serving in India from 1778 to 1823 assembled a truly impressive collection of natural history drawings, over a thousand of which are now in the British Library. He engaged artists to draw its flora and fauna. Some were reproduced in *Illustrations of Indian zoology* (1830–35) by J. E. Gray, who wrote that they 'were made upon the spot and chiefly from living specimens of animals – executed by English and Native Artists, constantly employed for this purpose under [Hardwicke's] own immediate superintendence.'

Plate 35

Black-throated Weaver (*Ploceus benghalensis*)

Thomas Hardwicke *Miscellaneous drawings*. India. Late 18th and
early 19th centuries.
Add. MS 10985, folio 11. (*Dept of MSS*)

Flocks of Baya weaver-birds are common throughout the whole of
the Indian sub-continent. Their long graceful nests of woven grass
suspended from branches of trees are a familiar sight in the Indian
countryside. 'The Hindoos are very fond of these birds, for their
docility and sagacity: when young they teach them to fetch and
carry; and at the time the young women resort to the public
fountains, their lovers instruct the baya to pluck the tica, or gold
ornament, from the forehead of their favourite, and bring it to their
expecting master'.[1]

The leaves in this watercolour are of the Pipal (*Ficus religiosa*), a
tree sacred to Hindus and Buddhists.

1. J. Forbes *Oriental memoirs*, vol 2, 1813, p 33.

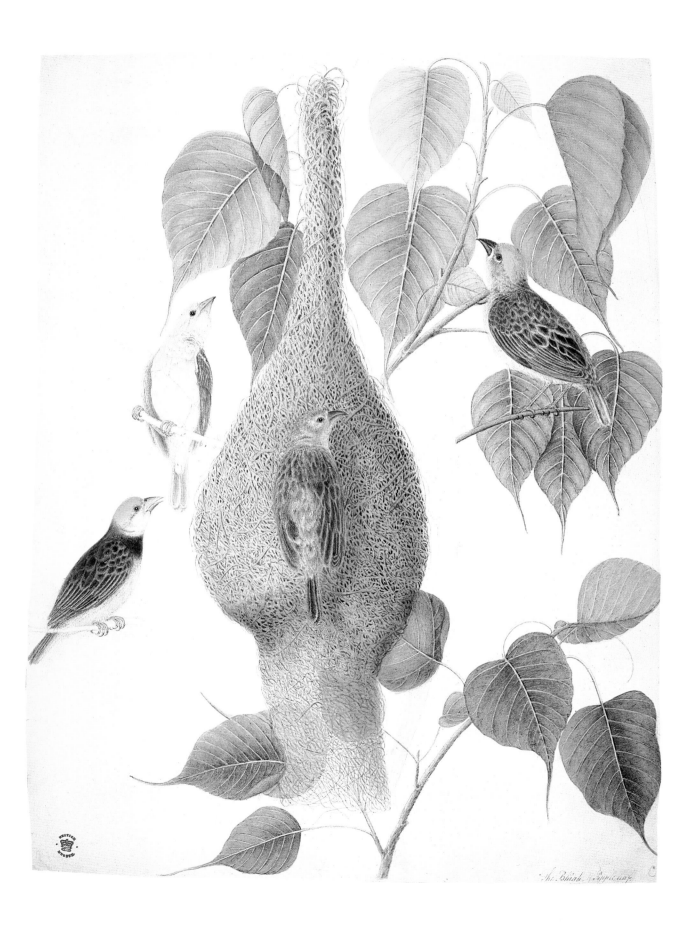

The Bihah Papia nap

Plate 36

Koala Bear (*Phascolarctos cinereus*)

Marquess Wellesley *Collection of natural history drawings*. Late 18th and early 19th centuries.
NHD 13, folio 40. (*IOLR*)

While he was Governor-General from 1798 to 1805, the Marquess Wellesley built up through commission and presentation a very large collection of drawings of the flora and fauna of the Indian sub-continent, Malaya, East Indies, and even Australia, among which is this watercolour of Koala Bears.

This solitary creature was first reported in 1798 by John Prince, Secretary to the Governor of the penal colony. This very early drawing of a Koala Bear probably reached Wellesley by one of the East Indiamen sailing between New South Wales and Bengal. One can only speculate on the identity of the artist. He could have been one of the naval personnel with artistic ability like, for instance, George Raper, a midshipman on the *Sirius*. Or perhaps a convict like Thomas Watling, an artist, transported to the penal settlement. Or even a professionalist like John William Lewin who arrived in the colony in January 1800 – 'a painter and drawer in natural history', according to the Home Secretary, the Duke of Portland, 'desirous of pursuing his studies in a country which cannot fail to improve that branch of knowledge'.

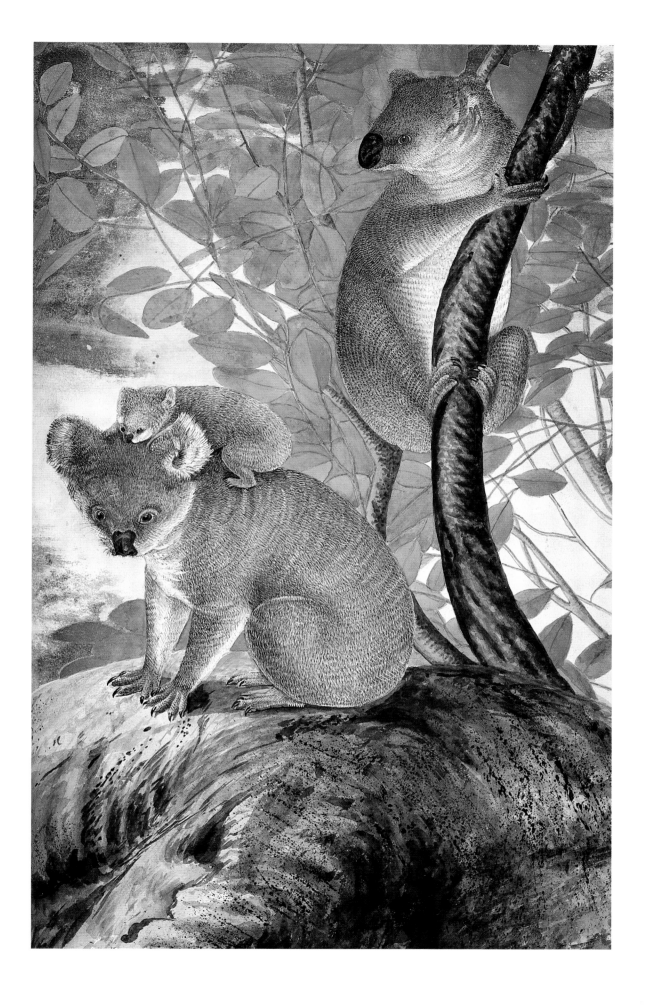

Plate 37

Indian Rhinoceros (*Rhinoceros unicornis*)

Marquess Wellesley *Collection of natural history drawings.* Late 18th and early 19th centuries.
NHD 32, folio 47. (*IOLR*)

The painting of a two-horned woolly rhinoceros, now extinct, in the caves at Lascaux, is the first pictorial record of a creature that made such an extraordinary impact on European art. The African species with two nasal horns is featured in Roman mosaics. The Indian species with a single horn (PLATE 27) was not seen in Europe until 1515 when King Emmanuel of Portugal received one as a gift from the King of Cambodia. The unfortunate animal was drowned in a shipwreck on its way to Rome as a present to Pope Leo X. Relying on a sketch, possibly by a Portuguese artist, Albrecht Dürer drew it and engraved a woodcut. Despite the seemingly armour-plated skin, the scales on the legs and the fictional dorsal spiral horn, Dürer's woodcut is a creditable achievement, accepted as a true likeness of the rhinoceros for nearly two and a half centuries, notwithstanding more accurate drawings subsequently made. It was copied in zoological treatises from C. Gesner's *Icones animalium* (1560) to T. Boreman's *Description of three hundred animals* (1769) (figure 41). It featured in the bronze reliefs on one of the doors in Pisa Cathedral, was carved in marble and decorated Meissen and Chelsea dishes.

There are anatomical inaccuracies in this watercolour by an anonymous Indian artist, but, like Dürer's woodcut or Stubbs's oil-painting, it succeeds in evoking the solidity, the strength and the obduracy of this magnificent animal.

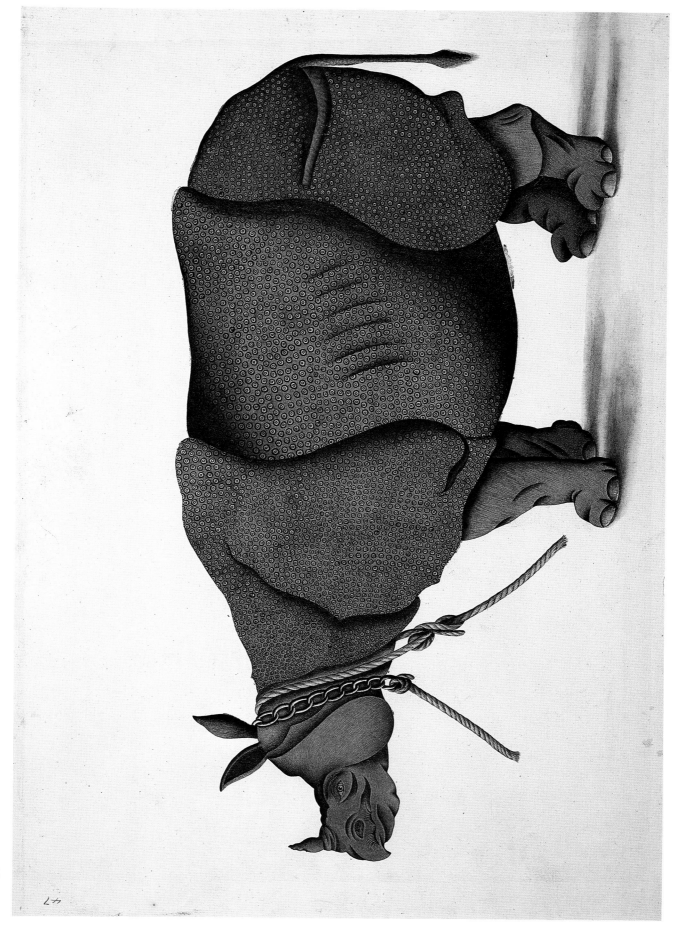

PLATE 37

Plate 38

Upland cotton (*Gossypium hirsutum*)

Marquess Wellesley *Collection of natural history drawings*. Late 18th and early 19th centuries.
NHD 19, folio 8. (*IOLR*)

The plant drawings in the Wellesley collection are not confined to the native flora of India. Plant introductions such as the Upland cotton are also figured.

Cotton has been grown for cloth in India for over 2,000 years. In the late eighteenth century the East India Company was determined to improve both the quality and quantity of Indian cotton. They selected Upland cotton, grown in Georgia in the United States from seed originally supplied to North America by the Chelsea Physic Garden in London. The Superintendent of the Calcutta Botanical Garden subsequently reported that 'the cotton is much admired by the natives'.

The unnatural stiffness of the plant in this watercolour is typical of some botanical drawings by Indians trying to draw in the Western manner.

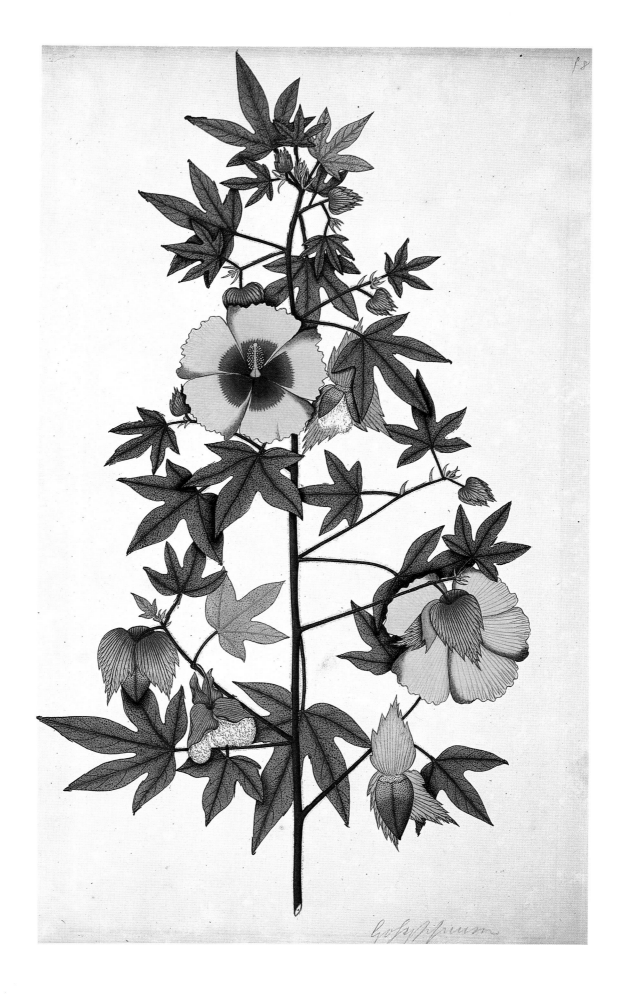

Gossypium

Plate 39

Channa barca

Francis Buchanan (later Buchanan–Hamilton). *Drawings of Gangetic fishes. c.*1798–1814
MSS Eur. E72, folio 35. (*IOLR*)

Francis Buchanan (1762–1829) of the Bengal Medical Service was engaged for much of his Indian career in survey work. Like so many of his fellow surgeons, he was a competent naturalist and an obvious choice for the post of Superintendent of Marquess Wellesley's Institution for Promoting the Natural History of India.

Buchanan employed Indian artists to record the specimens he collected; it is believed he retained the services of one particular Indian artist whom he had trained. These 103 pen-and-ink and watercolour drawings may well have been the work of this man. *Channa barca*, an edible freshwater fish, was reproduced as plate 35 in Buchanan's pioneering *Account of the fishes found in the River Ganges and its branches* (1822).

PLATE 39

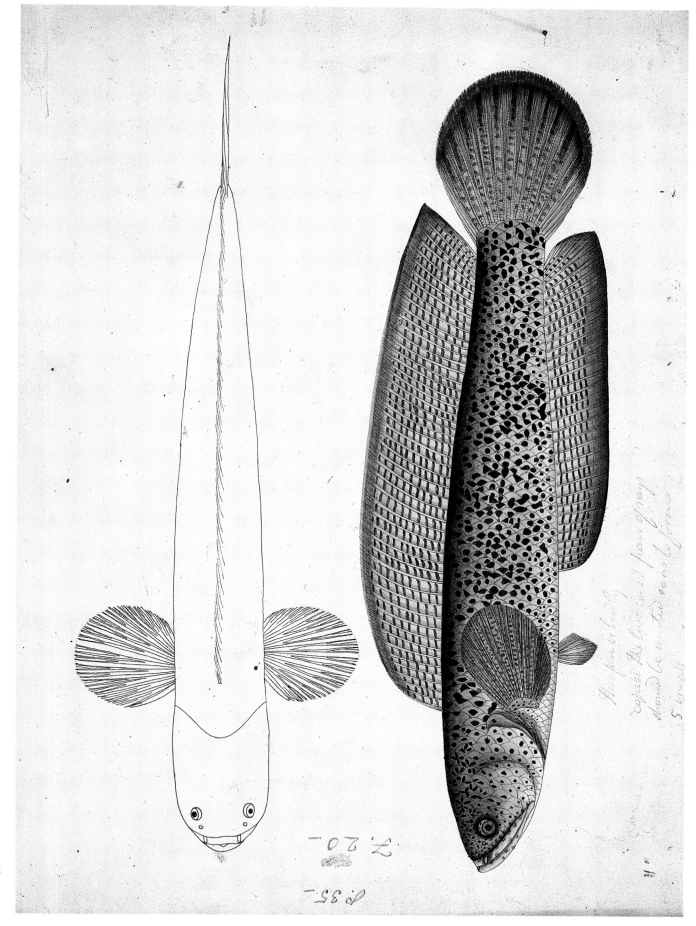

Plate 40

Peregrine Falcon (*Falco peregrinus*)

Raja Serfogee of Tanjore collection. Early 19th century.
NHD 7, folio 1014. (*IOLR*)

Raja Sarabhoji or Serfogee, ruler of Tanjore from 1798 to 1832,
employed Indian artists to paint the animals and birds in the Palace
menagerie. A selection of 117 of these watercolour drawings,
presented to the retiring British Resident in 1803, were deposited in
the East India Company museum in London four years later.
Hunting was the Raja's chief pastime, and it is not surprising that
twenty-five of the paintings are of hawks. This drawing of an
immature Peregrine Falcon, jesses attached to its legs, perched on a
patterned red cushion, may be inaccurate but it is a most attractive
composition.

Hawking, or falconry, has a long history. The Assyrians practised
it; the Holy Roman Emperor Frederick II wrote a manual on it; the
successors of Tamerlane at Samarkand and Herat gladly exchanged
horses, lions and leopards for gerfalcons from Manchuria. Asaf ud
Daulah, Nabab of Oudh, owned at least 200 hawks. A member of the
Persian royal household who wrote a treatise on hawking delivered
this advice: 'Three things you should never lend to any friend or
sportsman; your own special horse, your own special gun, and your
own special hawk. Lending any one of these is like lending your
wife'.[1]

1. Taymir Mirza *Baz-nama-yi Nasiri*, 1908.

22

No. 14.

A Black Bhyree of chuze kind

Falco peregrinus. Linn.

Mysore Coll. of Drawings

Plate 41

Cheetah (*Acinonyx jubatus*)

Raja Serfogee of Tanjore collection. Early 19th century.
NHD 7, folio 1036. (*IOLR*)

Another example from the powerful series of drawings done for the ruler of Tanjore (see also PLATE 40).

Cheetahs are among the fastest of animals, and, being amenable to training, have been used for hunting for a very long time. Kublai Khan, the Mughal Emperors, and Indian princes right up to the present century enjoyed this sport. The Renaissance rulers of Europe imported Indian cheetahs, which they found could outpace their own hunting dogs. Italian artists added them to their religious paintings, sometimes as symbols of evil. George Stubbs captured the cheetah's grace, its power and latent energy in his oil painting of the one that was presented to George III.

A hood, like the one in the drawing, was kept over the animal's eyes until the game – in India usually Black Buck or the dainty Chinkura Gazelle – had been spotted. The blindfold removed, the cheetah was released from the cart in which it had been carried, and its amazing acceleration of speed – over sixty miles an hour for a distance of about 400 metres – normally guaranteed a kill.

The cheetah is now extinct in India, where the last one was shot in 1947.

Chitta Tygor

PLATE 41

Plate 42

Bouquet of flowers

Lacquered book cover of a *Shahnama*. Persia. 1810.
Ethé 901. (*IOLR*)

Covers decorated with arabesques and floral motifs frequently protected Islamic manuscripts containing fine calligraphy and illumination. They were made of papier-maché or layers of paper glued together, with the painted design protected by layers of transparent lacquer. These painted lacquer covers were fairly common during the nineteenth-century Qajar period in Persia under the patronage of the king, Fath Ali Shah.

This *Shahnama*, or Book of Kings, commemorating the exploits of Fath Ali Shah, was made at the express command of the king himself. Roses, tulips, hyacinths, irises and plants that were manifestly a figment of the imagination, are organised in an attractive floral display.

Plate 43

Himalayan Monal Pheasant (*Lophophorus impeyanus*)

Christopher Webb Smith and Sir Charles D'Oyly. 1820s.
WD 4043, no.30. (*IOLR*)

Christopher Webb Smith (1793–1871) was a magistrate and judge in India from 1811 to 1842. At Fort William College, Calcutta, where he studied Bengali, he met the Revd William Carey, missionary, linguist and botanist. It was Carey who encouraged him to study the birds of India, and the Newton Library at Cambridge University owns his album of nearly 300 small watercolours of Indian birds which testify to the enthusiasm with which he took up this pursuit. In the preface to this album he makes the point that 'Not a single illustration has been drawn from any other work, but has been drawn from the subject'.

In 1824 Webb Smith was transferred to Patna where he met his relation, Sir Charles D'Oyly (1781–1845), the Opium Agent. D'Oyly was a compulsive artist who produced much of his work and that of his friends on a lithographic press imported from England. He and Webb Smith collaborated in drawings, Webb Smith concentrating on birds and D'Oyly adding vegetation and landscape. This watercolour is an example of their partnership which resulted in two books: *The feathered fowl of Hindostan* (1828) and *Oriental ornithology* (1829), lithographed and printed by the United Patna and Gaya Society, or Behar School of Athens.

This watercolour is framed in an embossed mount.

PLATE 43

Plate 44

(TOP) *Ficus religiosa*
(BOTTOM) *Bombax heptaphyllum*

William Henry Sykes *First report on statistics of the Dukhun.* 1826.
MSS Eur. D 141, nos.3 and 4. (*IOLR*)

W. H. Sykes (1790–1872), in his capacity as Statistical Reporter to the
Bombay Government, carried out a comprehensive survey of the
Deccan from 1824 to 1831.

This manuscript, one of a series of reports compiled during the
survey, contains pen-and-ink sketches by Sykes as well as botanical
drawings, two of which are shown in this plate, by his draughtsman,
Bombardier Llewellyn L. Fidlor of the Bombay Artillery. Sykes
records his approval of Fidlor's 'considerable talent in coloring and in
delineation. . . . The Drawings are executed on a scale from Nature
by actual measurements. They have all been examined and corrected
by myself when necessary, both in the pencil and in the color. Errors
therefore have been as carefully guarded against as possible'.

A fibre can be made from the bark of *Ficus religiosa* and native
medicines from its leaves and bark. *Bombax heptaphyllum*, one of the
largest of Indian trees, provides timber, and its bark also yields a fibre.

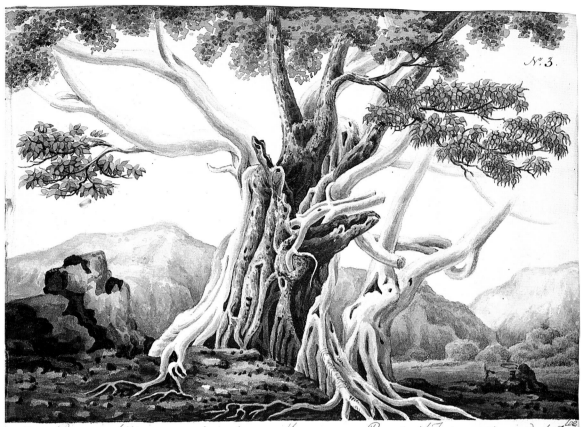

ਪਿੰਪਰੀ Peempree (Ficus) embracing the ਪਿੱਪਲ Peempul (Ficus religiosa), at Umbo
Baum her

ਪਿੰਪਰੀ Peempree Ficus. ___ embracing the ਸਾਵਰੀ Sawree (Bombax heptaphyllum) and
letting down roots from a branch. at Choke in the Konkun. Travellers
Bungalow.

Plate 45

Hairy-nosed Otter (*Lutra sumatrana*)

Sir Stamford Raffles *Natural history drawings*. Bencoolen, Sumatra.
1820s.
NHD 47, folio 50. (*IOLR*)

Sir Thomas Stamford Raffles (1781–1826), East India Company administrator, founder of Singapore, Lieutenant-Governor of Sumatra, one of the founders of the Zoological Society of London, would also be remembered as one of the outstanding naturalists of the nineteenth century had it not been for the loss of *The Fame*.

After the annexation of the former Dutch possessions in the East Indies, British officials, encouraged by Raffles, undertook scientific explorations of the islands. Raffles himself employed plant and animal collectors and Chinese artists to make a pictorial record of his own collections. Writing in 1820 from Bencoolen, Raffles announced that he had 'taken to the wilder but less sophisticated animals of our woods. Our house is on one side a perfect menagerie, on another a perfect flora'.[1] In the same year he sent home his main collections. When *The Fame* on which he was returning to England with additional collections caught fire and sank, he lost many specimens and also 2,000 natural history drawings executed, declared Raffles, 'in a style far superior to anything I had seen or heard of in Europe'.

The otter comes from a new set of drawings made at Bencoolen when Raffles returned there after the sinking of *The Fame*.

1. S. Raffles *Memoirs*, 1830, p 441.

PLATE 45

Plate 46

Naktas, or Old World Comb-ducks (*Sarkidiornis melanotos*), and Pintails (*Anas acuta*)

Fakir Lal Chand. Patna. *c*.1850

Add. Or. 2550. (*IOLR*)

At the behest of officials of the East India Company and other Europeans, Indian artists during the eighteenth and nineteenth centuries painted local life and customs in a manner now categorised as Company drawings. It was, according to Dr M. Archer who has pioneered the study of this genre of painting, 'an attempt by Indian artists to adjust their styles to British needs and to paint subjects of British appeal'.[1] By studying and copying British drawings, Indian artists gradually adopted British techniques: painting on Western paper with watercolours without gouache, muting their traditionally brilliant colours and substituting delicate blending for flat planes of colour.

Their activities tended to centre on the principal towns with European communities such as Patna where Sir Charles D'Oyly had established an artistic *côterie*. Some of the Indians there copied the drawings of D'Oyly and his friends. Fakir Lal Chand (*c*.1790–*c*.1865), for instance, copied this drawing of waterfowl by Christopher Webb Smith, the original of which is now in the Newton Library at Cambridge (PLATE 43).

1. M. Archer *Company drawings in the India Office Library*, 1972, p 1.

Plate 47

Elephant (*Elephas maximus*)

Burma. Early 19th century.
Burmese 204, folio 1. (*IOLR*)

The 'parabaik' or folding manuscript from which this drawing of a 'white' elephant is taken contains the portraits of a succession of elephants of the Burmese court. All elephants, whether wild or domesticated, were considered royal property and, consequently, it was a grave offence to kill any of them. A 'white' or rather light grey elephant was venerated by Burmese, Indians and Siamese. All white elephants, according to Miss Anna Leonowens, were revered by the Siamese, 'because they were once superior human beings, and the white elephant, in particular, is supposed to be animated by the spirit of some king or hero'.[1]

Captain Henry Yule, who was Secretary to the British Mission to the court at Ava in Burma in 1855, saw the elephant that is depicted here in a generous flush of pink. 'The present white elephant has occupied his post for at least fifty years. I have no doubt that he is the same which Padre Sangermano mentions as having been caught in 1806. . . . His colour is almost uniform all over; nearly the ground-tint of the mottled or freckled part of the trunk and ears of common elephants, perhaps a little darker. He also has pale freckles in the same parts. On the whole he is well entitled to his appellation of white'.[2]

The Burmese would respectfully remove their shoes before entering the stables or 'palace' of this privileged animal which had its own entourage of a Minister, his deputy and Secretary, etc. to serve him.

1. A. H. Leonowens *The English Governess at the Siamese Court* 1980, p 115.

2. H. Yule *A Narrative of the Mission sent by the Governor-General of India to the court of Ava in 1855* 1858, pp 133–34.

Plate 48

Krishna killing Bakasura by forcing apart its beak; two deer

Popular paintings. Puri, Orissa. *c*.1960.
Add. Or. 1957–59. (*IOLR*)

Popular paintings are the work of obscure artists and amateurs to fill the religious and domestic needs of villagers and poor people. They have a directness and freshness that equate them with the primitive art of the West. An uninhibited use of colour and a lack of sophistication in design combine in drawings of disarming simplicity and frankness. Vitality is the dominant feature, whether it be the assured rhythmic lines of Kalighat artists or the exuberance of Maithil murals. The Puri popular painters were an hereditary sub-caste of professional artists who sold their work to pilgrims from stalls adjacent to the famous Jagannatha temple. Puri paintings are now sold to tourists as well as to pilgrims.

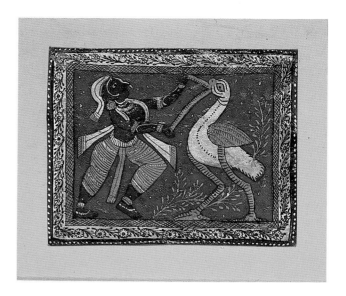

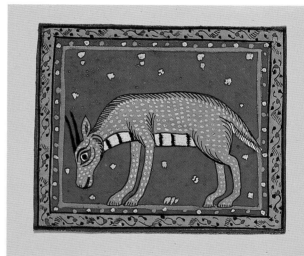

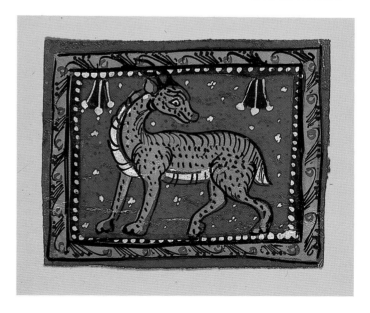

Plate 49

Butterfly (*Papilio*), Dragon-fly (*Libellulid?*) and Grasshopper (*Euconocephalus*)

Album of drawings of flowers and insects. Canton. Early 19th century. NHD 43, folio 39. (*IOLR*)

Although these insects are beautifully drawn, they cannot be named with any certainty beyond generic level. 'The disposition of the legs and the curious flexure of the wings which are characteristic features of these insect drawings are post-mortem deformations of the specimen rather than some brilliant insight into attitudes during flight'.[1]

1. P. J. P. Whitehead and P. I. Edwards *Chinese natural history drawings selected from the Reeves collection in the British Museum (Natural history)*, 1974.

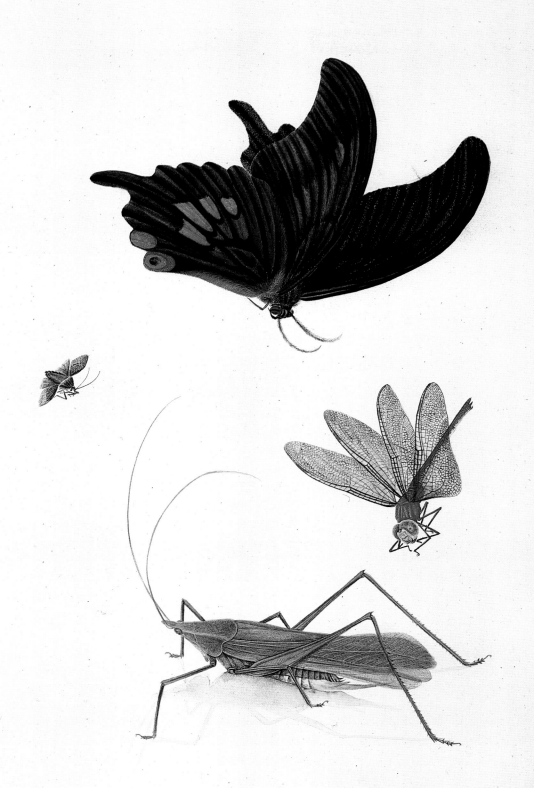

Index of Manuscripts

General Index